COVENTRY

y

Monica Lynn Clements
and Patricia Rosser Clements

Collectors

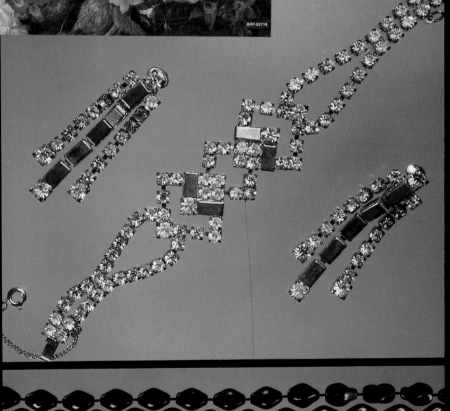

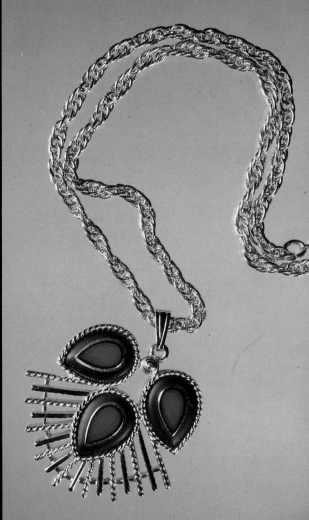

Schiffer Publishing Ltd ®

DEDICATION

This book is for the collectors of Sarah Coventry jewelry.

ACKNOWLEDGMENTS

This book would not have been possible without the support of our friends and family.

Copyright © 1999 by Monica Lynn Clements
and Patricia Rosser Clements
Library of Congress Catalog Card Number: 98-86788

Designed by "Sue"
Typeset in Zapf Chancery Bd BT/Bodini Bk BT
Photo layout by Randy Hensley

ISBN: 0-7643-0686-3
Printed in China
1 2 3 4

Published by Schiffer Publishing Ltd.
4880 Lower Valley Road
Atglen, PA 19310
Phone: (610) 593-1777; Fax: (610) 593-2002
E-mail: Schifferbk@aol.com
Please write for a free catalog.
This book may be purchased from the publisher.
Please include $3.95 for shipping.

In Europe Schiffer books are distributed by
Bushwood Books
6 Marksbury Avenue
Kew Gardens
Surrey TW9 4JF England
Phone: 44 (0) 181 392-8585; Fax: 44 (0) 181 392-9876
E-mail: Bushwd@aol.com

Please try your bookstore first.

We are interested in hearing from authors
with book ideas on related subjects.

CONTENTS

INTRODUCTION

Whether you lived in a small town or a major city in the 1950s and 1960s, a Sarah Coventry home jewelry party was never far away. Sarah Coventry jewelry parties gave women an opportunity to socialize and to purchase quality costume jewelry not found in stores. While these parties are a thing of the past, the jewelry has endured.

Even though Sarah Coventry jewelry was more exclusive than most costume jewelry, the company distributed a vast amount of its product. The jewelry has survived the test of time with its durability, and the designs have captured the attention of serious jewelry collectors. A variety of rhodium or gold metal sets adorned with plastic or glass can be found. The company also offered pieces with gemstones.

In the following pages, we have included examples of jewelry distributed by Sarah Coventry from the 1950s through the 1970s. With durable and distinctive sets and pieces for women, jewelry for children, and even a line of accessories for men, Sarah Coventry has exemplified excellence in costume jewelry.

The purpose of this book is not to set firm prices but to serve as a guide. The prices reflect observations of the authors based on their experience in both buying and selling Sarah Coventry jewelry nationwide.

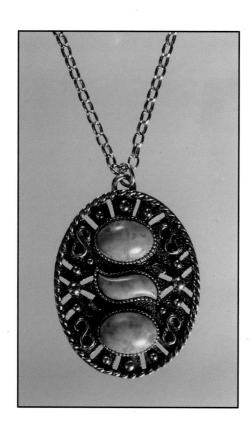

Chapter One

HISTORY

In 1949, Charles H. Stuart created Emmons Jewelers, Inc., the predecessor to Sarah Coventry, Inc. Stuart named the company after his wife, Caroline Emmons. Emmons jewelry, costume jewelry of the highest quality, was not sold in department stores or in dime stores like most costume jewelry of the day. Instead, parties in the home hosted by Emmons' fashion directors became common, causing the popularity of the company's jewelry to soar. Stuart's marketing gimmick changed costume jewelry forever. At first many of the fashion directors were men, but women began to take part in selling Emmons jewelry.

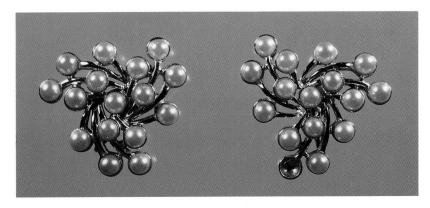

Emmons gold metal clip-on earrings with simulated pearls, 1.25". *Courtesy of Wanda Goodmon.* $50-60.

Top. Emmons rhodium and rhinestones brooch with floral motif. $55-65.
Bottom. Emmons rhodium, rhinestone, and simulated pearl bracelet. $65-75.

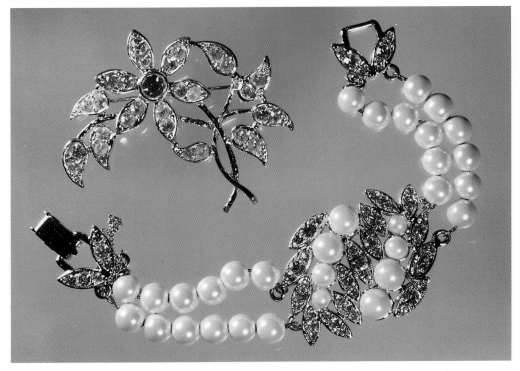

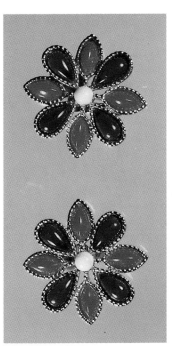

Emmons gold metal and plastic red, white, and blue patriotic earrings. $35-45.

The fashions and lifestyle of the 1950s emphasized the need for accessories. To keep up with the demand for costume jewelry, Stuart created Sarah Coventry in 1950. He took the company's name from his granddaughter. In many ways, Sarah Coventry paralleled Emmons. Stuart utilized the same concept for distributing the jewelry at home parties as he had done with Emmons jewelry. Soon Sarah Coventry was sought after by women who wanted to wear fashionable designs and high quality costume jewelry.

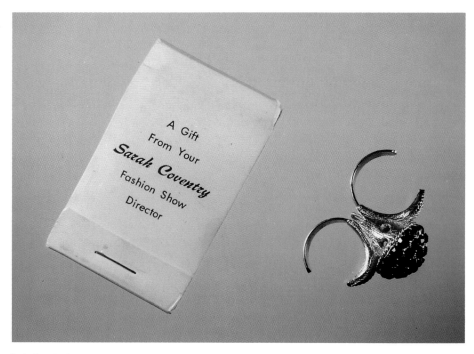

Left. Sarah Coventry sewing kit. $15-20.
Right. Gold metal scarf holder with onyx colored glass. $25-35.

Sarah Coventry gained notoriety with its designs. The sets, single pieces, and limited edition jewelry became popular accessories. Pieces of Sarah Coventry jewelry were featured on the "Queen For A Day" television show. The company also provided the crowns for the Miss Universe pageant. By the 1970s, Sarah Coventry earned recognition as the largest distributor of costume jewelry with operations in the United States, England, Canada, and Australia.

Both men and women found an opportunity to earn an income through becoming fashion directors at Sarah Coventry. By meeting the goals of sales requirements, a fashion director could advance to Unit Director. The other levels of achievement were Region Manager, Area Manager, Zone Manager, and National Vice President. The highest achievement was National Sales Manager.

The home jewelry parties continued into the 1970s. With this decade came a time when costume jewelry fell out of popularity. Changing fashions meant costume jewelry was not in demand as a necessary accessory to one's wardrobe as it once had been. As a result, the company suffered from a lack of sales along with other similar jewelry companies. Eventually, Sarah Coventry was bought by a Canadian firm. Today, the current pieces of jewelry bearing the name of Sarah Coventry are not related to the costume jewelry of the company started by Stuart.

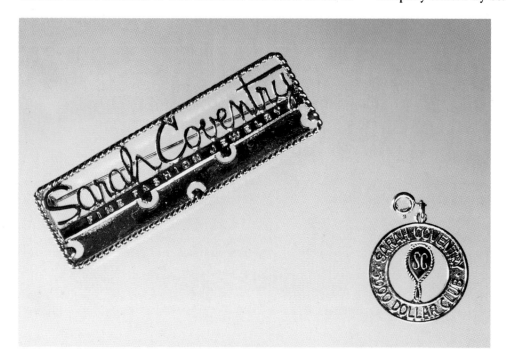

Left. Gold metal Sarah Coventry identification pin for fashion directors. $35-45.
Right. Rhodium Sarah Coventry 5000 Dollar Club award pendant. $25-35.
These items are *Courtesy of Debbie Page.*

CHARACTERISTICS OF SARAH COVENTRY JEWELRY

Through the years, Sarah Coventry offered an array of designs for the consumer interested in fine costume jewelry. Sets made of rhodium or gold metal in dazzling styles were available. Designers took their inspiration from historic jewelry such as the styles and fashions of the Victorian Era and the geometric lines of Art Deco jewelry. Also, the company sold fashionable belts along with matching jewelry to form complete sets.

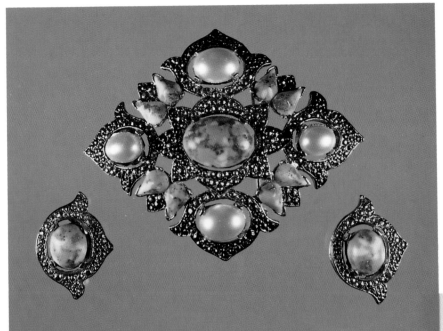

Gold metal brooch and earrings with blue plastic and simulated pearls. *Courtesy of Kenneth L. Surratt, Jr.* $95-125.

Red plastic "stones" and rhodium set with earrings and brooch. *Courtesy of Mary Liles.* $125-150.

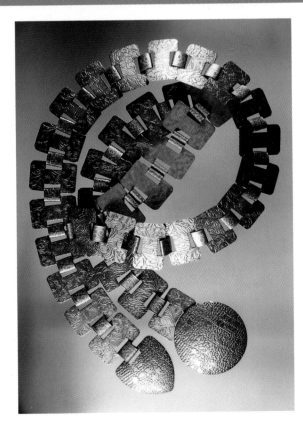

Rhodium Camelot belt. *Courtesy of Marshall A. Gordon.* $65-75.

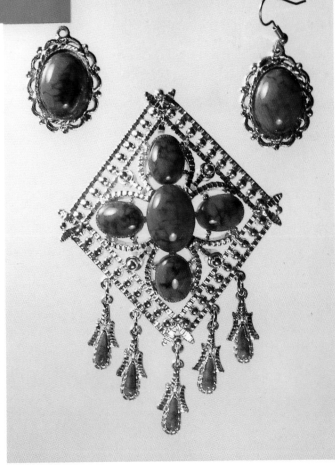

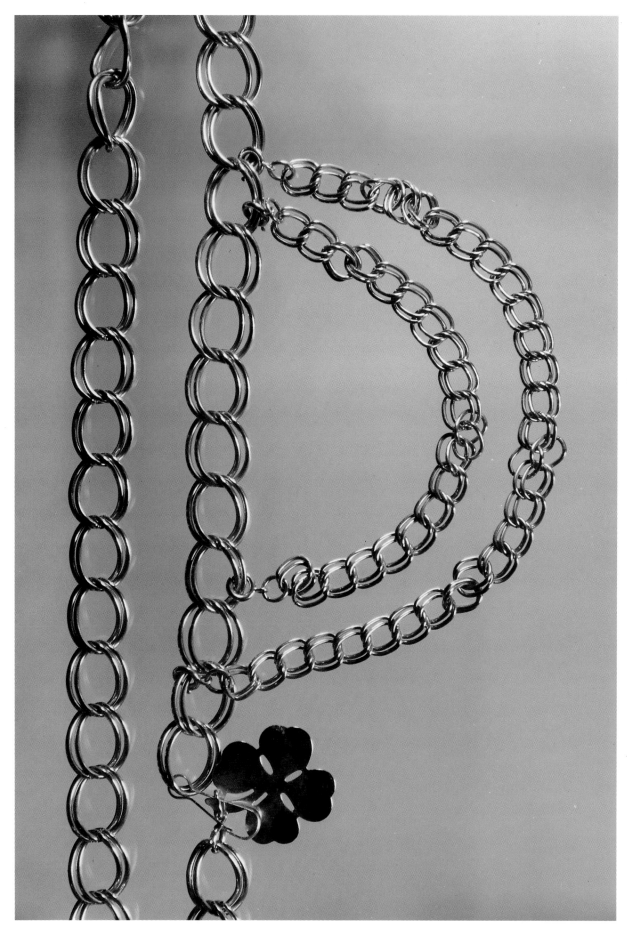

Gold metal Mood Mate 34-inch belt with four leaf clover. $55-65.

Gold metal Serpentine 32 inch belt. $55-65.

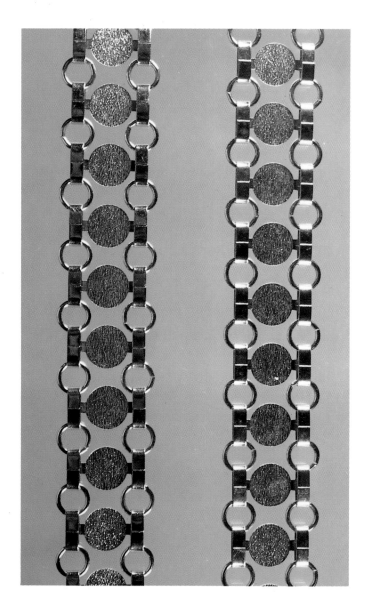

30-inch rhodium belt.
Courtesy of Mary G. Moon.
$55-65.

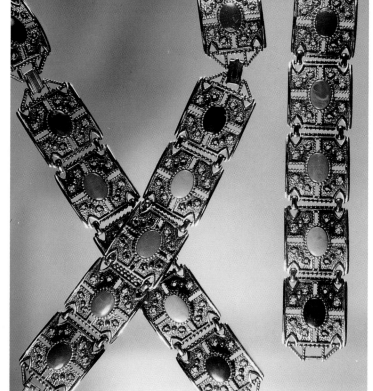

Gold metal belt and bracelet set with
colored plastic "stones." *Courtesy of
Marshall A. Gordon.* $195-225.

The colorful material used for this unique jewelry consisted of plastic or glass. However, the company also offered jewelry of genuine gemstones. Amethyst, jade, and onyx are a few examples of the common choices. Rhinestones and glass stones adorned brooches, earrings, and necklaces, and simulated pearl necklaces were typical of what fashion directors showcased at jewelry parties.

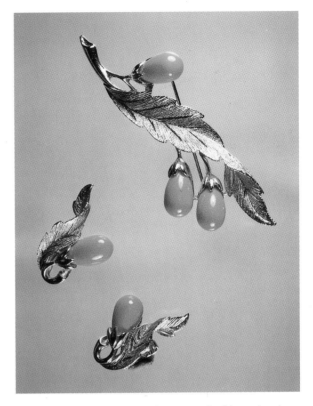

Bittersweet set with brooch and earrings of gold metal and red plastic cabochons. *Courtesy of Carol Gordon.* $125-150.

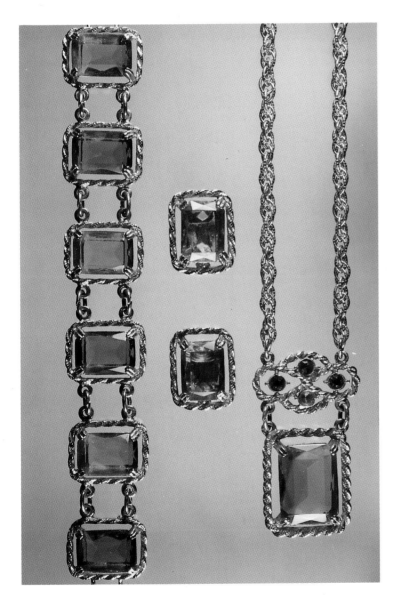

Set of Wild Honey bracelet, earrings, and pendant with twisted gold metal and prong set faux topaz faceted stones. *Courtesy of Carol Gordon.* $275-295.

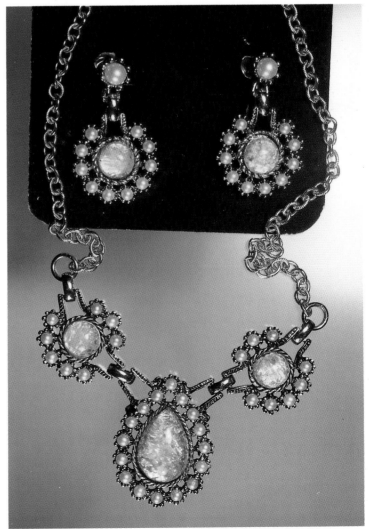

Empress earrings and necklace set with opalescent stones and simulated pearls, 15-chain. *Courtesy of Carol Gordon.* $195-225.

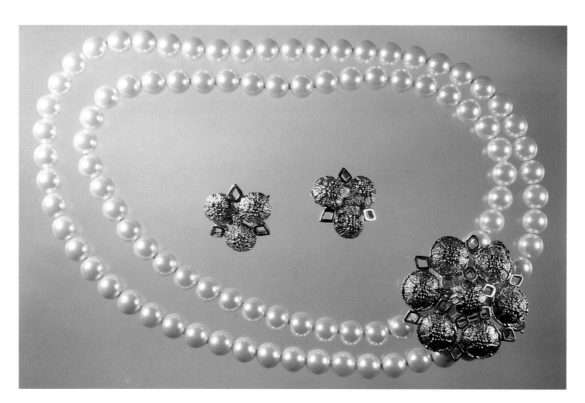

Fashion Rite simulated pearls with gold metal necklace and gold metal clip-on earrings. *Courtesy of Carol Gordon.* $175-195.

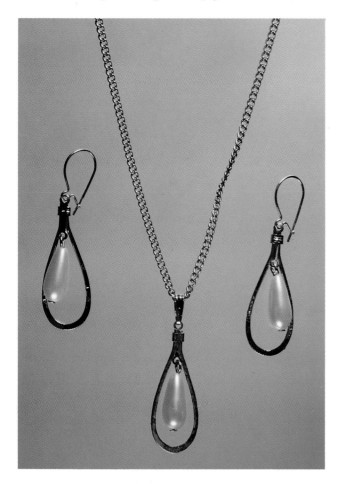

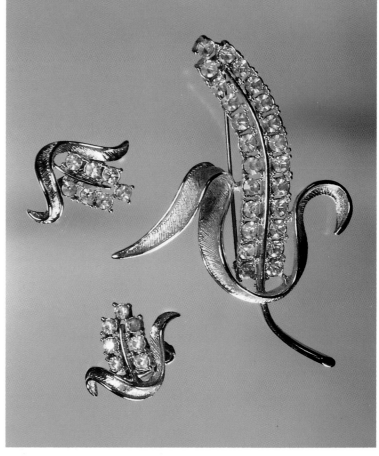

Set of pierced earrings and pendant with simulated pearl drops and gold metal, 15-inch chain. *Courtesy of Jessica J. Gordon.* $125-150.

Radiance brooch and clip-on earrings of gold metal and rhinestones. $195-225.

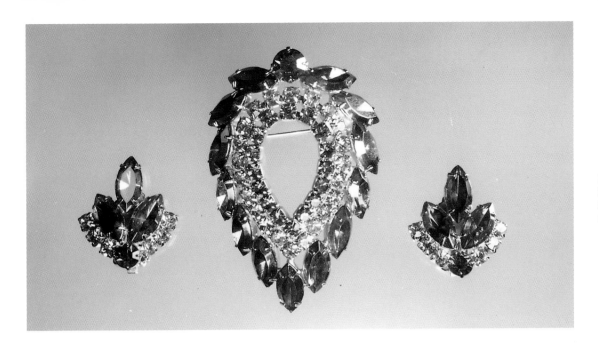

Blue Lagoon rhodium brooch and earrings with faux sapphire stones and rhinestones. $195-225.

Clients at home jewelry parties had a large selection of nature jewelry from which to choose. Sets, pendants, brooches, and earrings in such motifs as flowers or leaves made for beautiful additions to anyone's jewelry collection. Fruit such as cherries or apples exemplified popular subjects for the jewelry as well. Many of the nature motifs were made of rhodium or gold metal, and enameled pieces were plentiful.

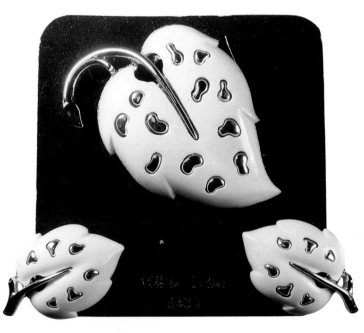

White Velvet enameled metal brooch and earrings with leaf motif. *Courtesy of Marshall A. Gordon.* $95-125.

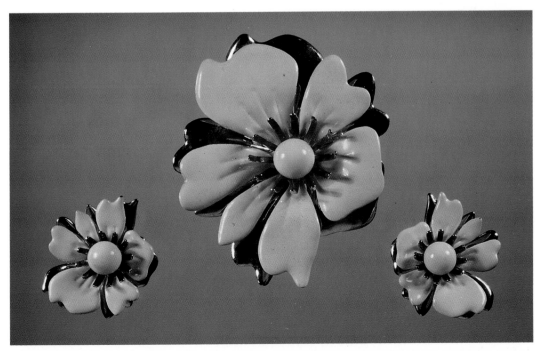

Springtime gold metal and enamel clip-on earrings and brooch with floral motif. $150-175.

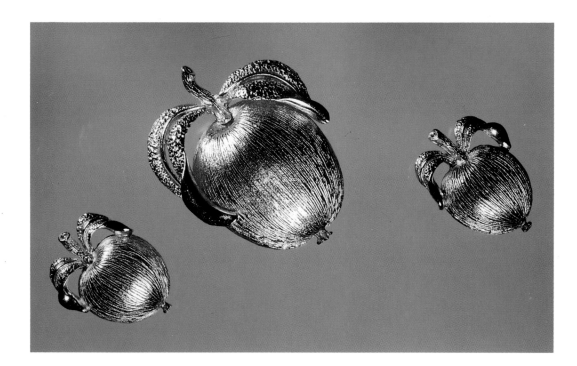

Rhodium apple with leaves clip-on earrings and brooch set. *Courtesy of Wanda Goodmon.* $95-125.

The company sold a variety of crosses. While the Maltese cross was a popular choice, Victorian crosses experienced a resurgence through Sarah Coventry. The company came out with a line of limited edition crosses and added new pieces frequently. Modern looking crosses with less ornate designs also became popular.

1975 Limited Edition ornate "PEACE" gold metal cross with simulated pearl, 3.25" x 2.25". *Courtesy of Chris Terry.* $95-125.

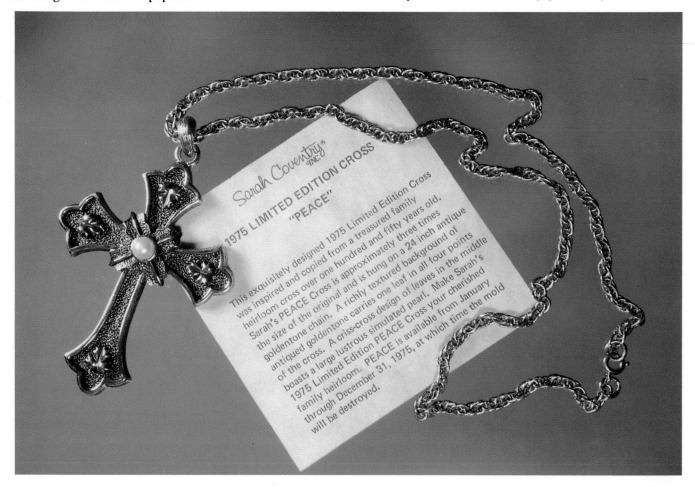

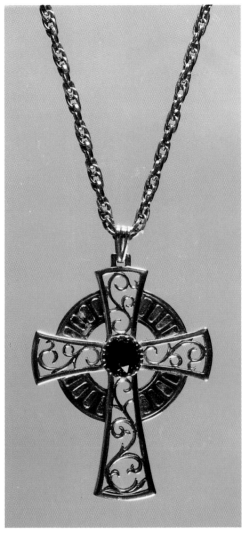

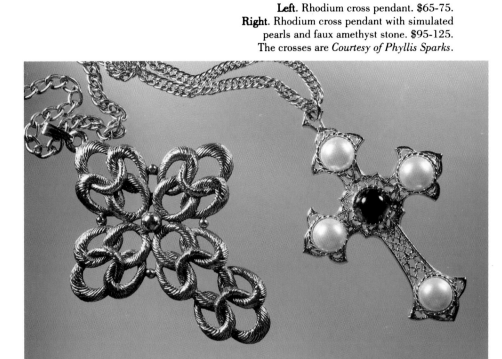

Left. Rhodium cross pendant. $65-75.
Right. Rhodium cross pendant with simulated pearls and faux amethyst stone. $95-125.
The crosses are *Courtesy of Phyllis Sparks*.

Gold metal cross pendant with prong set faux onyx cabochon. $95-125.

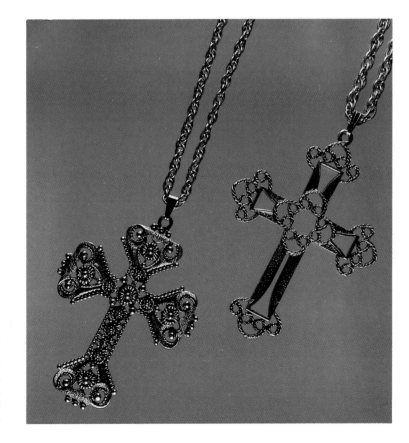

Left. Rhodium cross pendant, 2" x 2.5".
$95-125.
Right. Limited edition Victorian style gold metal cross pendant, 2.5" x 3.5".
$95-125.
The crosses are *Courtesy of Mary Ellen DeLaughter*.

Widely distributed by Sarah Coventry, figural jewelry became common during the 1960s and 1970s. This less formal style of jewelry depicted animals and people and gave a whimsical touch to accessories. Figural styles on pendant necklaces were also used for children's jewelry.

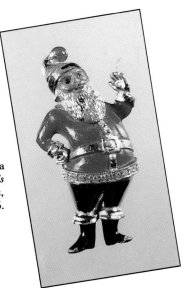

Rhodium enameled Santa pin. *Courtesy of Jennie's Antique Mall, Texarkana, Texas.* $45-55.

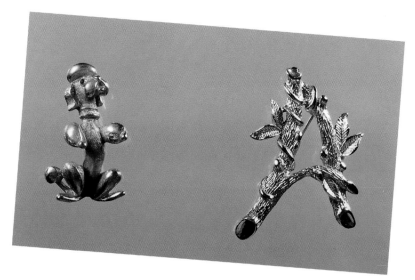

Left. Gold metal poodle pin with dark stones for eyes. $25-35.
Right. Gold metal initial "A" pin. $25-35.

Left. Rhodium Madame Butterfly pin. $35-45.
Top center. Rhodium Shaggy Dog pin. $25-35.
Right. Rhodium Peace bird pin. $35-45.

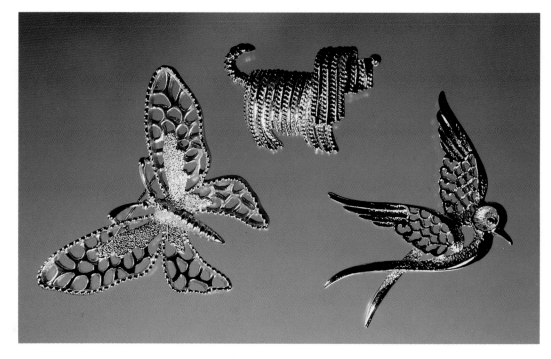

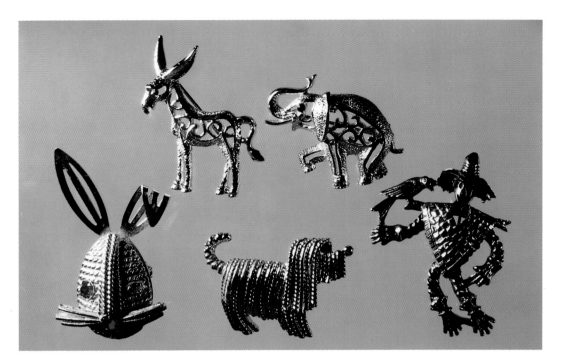

Top left. Gold metal donkey pin. $25-35.
Top right. Gold metal elephant pin. $25-35.
Bottom left. Gold metal bunny with faux ruby stones. $35-45.
Bottom center. Gold metal Shaggy Dog pin. $25-35.
Bottom right. Gold metal scarecrow with bird pin.
$35-45.

Versatility helped to make Sarah Coventry jewelry a household name, and the company provided unique designs to give women options. For example, interchangeable parts on pendants, earrings, and rings gained popularity. In certain sets, two bracelets could be joined to form a necklace or add length to a necklace. With colorful lariat necklaces, women were even able to chose the length and shape of their necklaces.

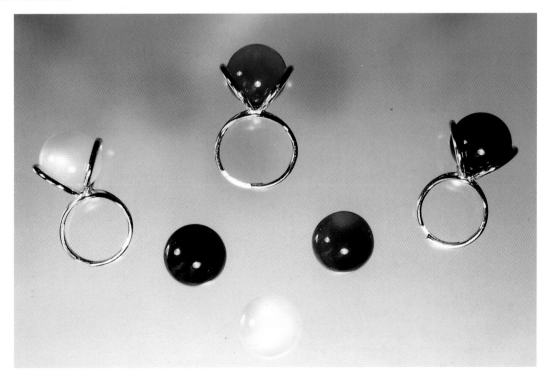

Gold metal rings with interchangeable plastic balls in a variety of
colors. $35-45 each.

Gold metal earrings with plastic interchangeable parts in a variety of colors. *Courtesy of Mary Ellen DeLaughter*. $55-65 for each pair.

Gold metal earrings with plastic interchangeable parts. *Courtesy of Marshall A. Gordon*. $75-95.

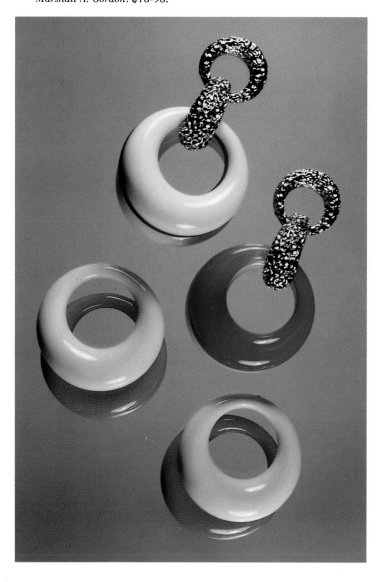

Multi-strand rhodium necklace with two rhodium bracelets. Bracelets can be connected to form a choker. *Courtesy of Mary Ellen DeLaughter*. $195-225.

Gold metal belt with colored plastic beads. $45-55.

Silver mesh belt with tassel. $45-55.

The company offered specialized types of jewelry. Sarah Coventry developed a line of men's jewelry that included tie clips and cuff links. For women, the company designed interesting initial pins. Through its line of Bicentennial jewelry, Sarah Coventry showcased fashionable patriotic designs in red, white, and blue. The company provided colorful Christmas jewelry. Because plastic accessories proved quite fashionable in the 1960s, Sarah Coventry presented beads and other pieces in plastic. For children, the company distributed whimsical pieces, birthstone jewelry, and pendants with mottoes. Sarah Coventry also made available watches for women.

Until its popularity waned in the 1970s, Sarah Coventry was one of the leading distributors of costume jewelry. The company provided affordable jewelry for men, women, and children. This collectible line has endured because of its quality workmanship and unique designs.

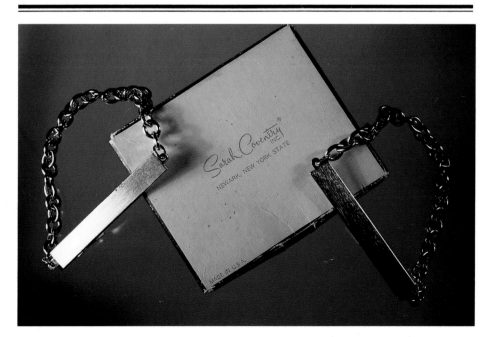

Left. President's Choice 2-inch rhodium tie clip with 5.5-inch chain. $25-35.
Right. President's Choice 2-inch gold metal tie clip with 5.5-inch chain. $25-35.

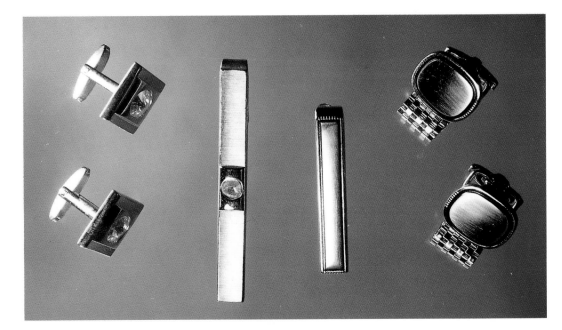

Left and **center left**. Gold metal cuff links and tie clip with blue crystals. $50-60.
Center right and **right**. Rhodium tie clip and cuff links set. $45-55.

Left. One pair of gold metal cuff links and tie tac. $45-55.
Right. One pair of gold metal cuff links and tie tac in geometric shape. $45-55.

Gold metal Western style cuff links. $45-55.

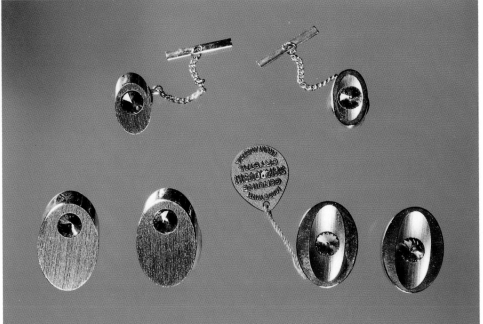

Left. Rhodium tie tac and cuff links set with blue "Genuine SWAROVSKI Crystals From Austria." $55-65.
Right. Rhodium tie tac and cuff links with green "Genuine SWAROVSKI Crystals From Austria." $55-65.

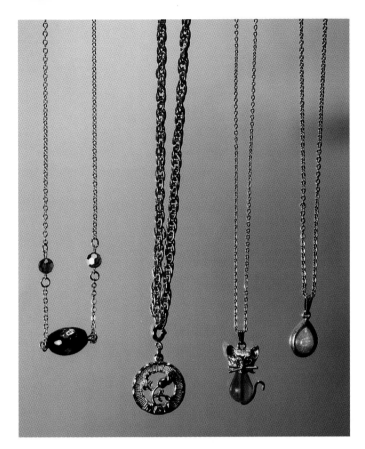

Left. Gold metal 16-inch necklace with faux emerald stones. $35-45.
Center left. Gold metal 24-inch "MOM" pendant necklace with floral motif. $25-35.
Center right. Gold metal 24-inch pendant necklace with cat motif. $35-45.
Right. Gold metal 16-inch pendant necklace with opal. $45-55.
The pendant necklaces are *Courtesy of Wendy Page*.

Left. Gold metal pendant necklace with mother-of-pearl pendant depicting floral motif. $45-55.
Center. Gold metal pendant necklace with turtle. $30-40.
Right. Rhodium pendant necklace depicting girl on swing. $45-55.
The pendant necklaces are *Courtesy of Wendy Page*.

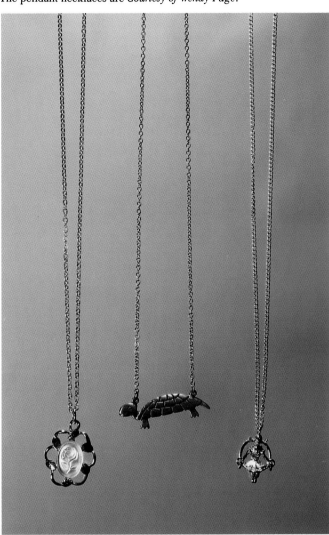

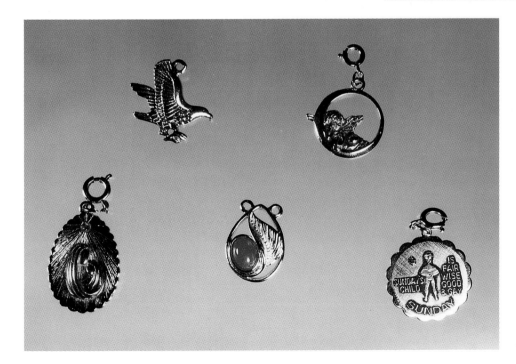

Top left. Rhodium eagle pendant. $35-45.
Top right. Limited Edition gold metal cherub pendant. $35-45.
Bottom left. Limited Edition gold metal pendant with pink glass stone depicting mother and child. $45-55.
Bottom center. Gold metal pendant with ruby red plastic "stone." $35-45.
Bottom right. Rhodium Sunday's child pendant. $45-55.
The pendants are *Courtesy of Wendy Page*.

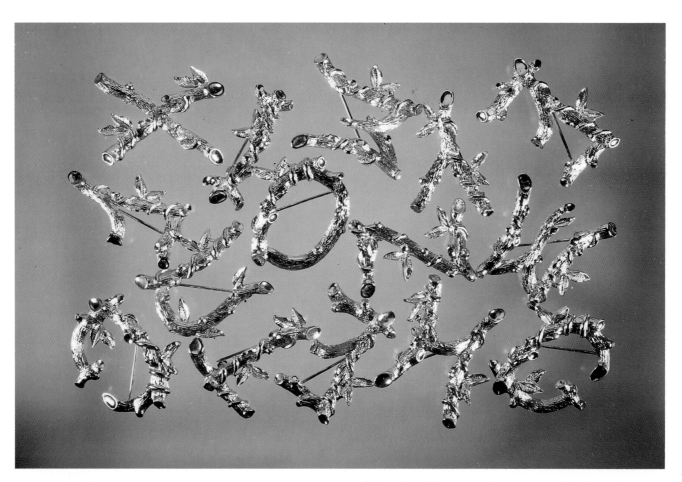

Above: Sarah's ABC's gold metal initial pins. $25-35 each.

Below: Three Cheers set with three pairs of rhodium clip-on earrings with red, white, and blue plastic, and 2.5-inch rhodium pendant with red, white, and blue plastic with 24-inch chain. $225-250.

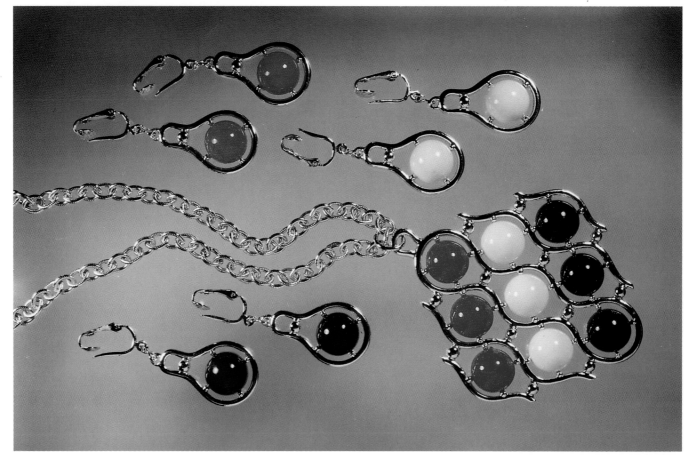

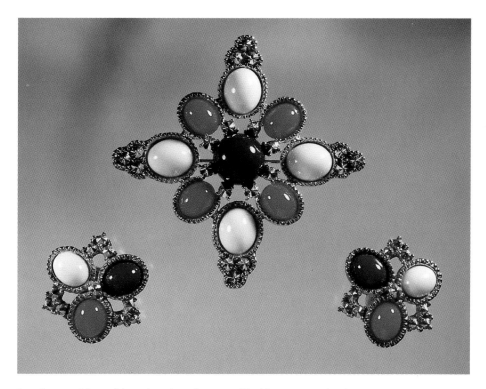

Americana gold metal brooch and earrings set with rhinestones and red, white, and blue plastic. $195-225.

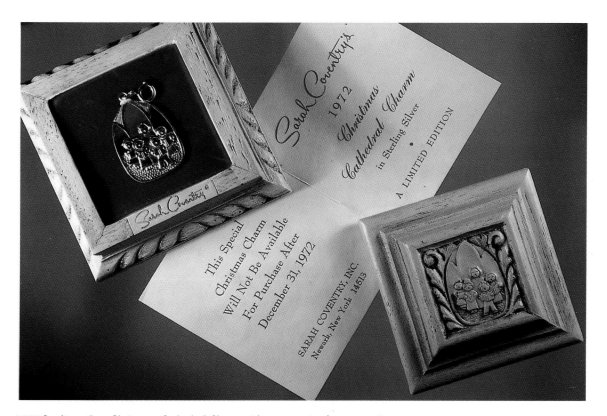

1972 Sterling silver Christmas Cathedral Charm with presentation box. $55-65.

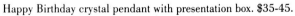

Happy Birthday crystal pendant with presentation box. $35-45.

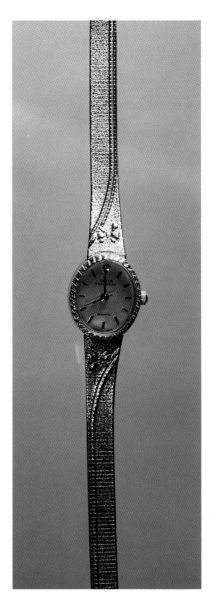

Sarah Coventry rhodium watch. $65-75.

Chapter Two

SETS

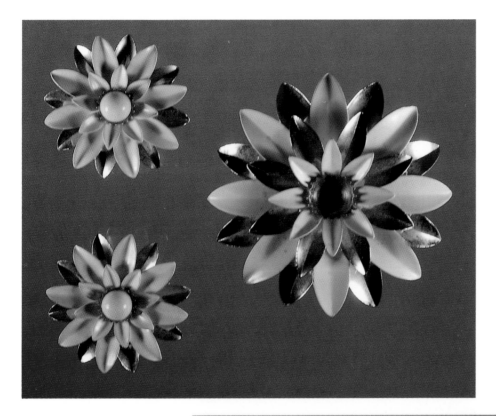

Rhodium and enameled metal earrings and brooch set with white plastic "stones" (white "stone" missing from center of brooch). $65-75 as is.

Gold metal with red and blue plastic clip-on earrings and brooch set. $175-195.

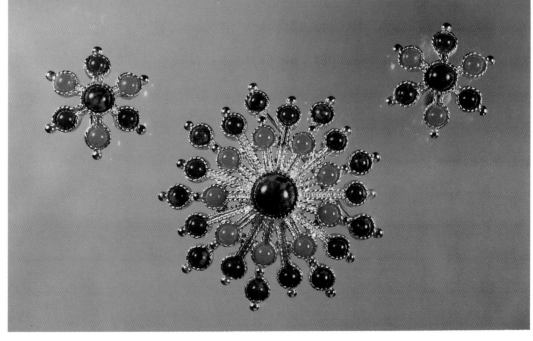

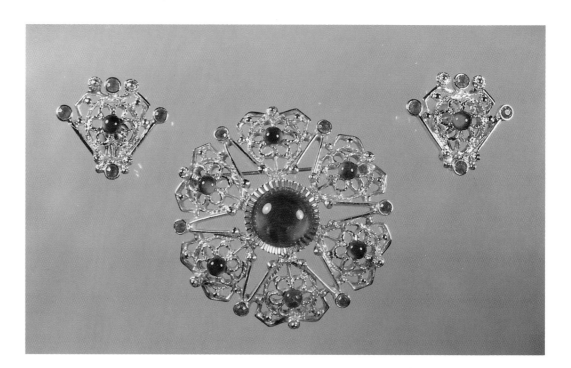

Clip-on earrings and brooch set with gold metal and faux ruby stones. $150-175.

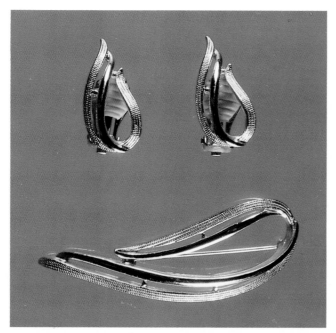

Rhodium leaf shaped clip-on earrings and brooch set. $85-95.

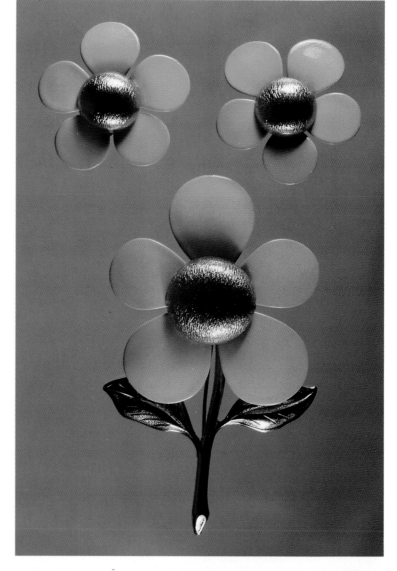

Gold metal and yellow enameled flower earrings and brooch set. $95-125.

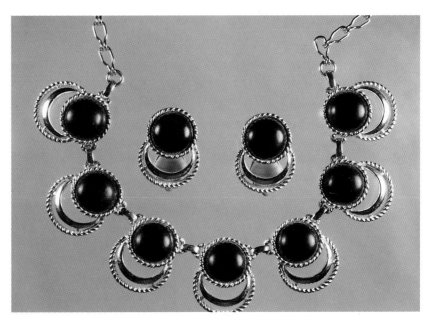

Necklace and clip-on earrings set of rhodium with faux onyx stones. $150-175.

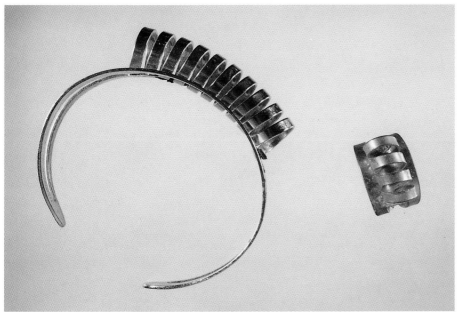

Gold metal bracelet and ring. $75-95.

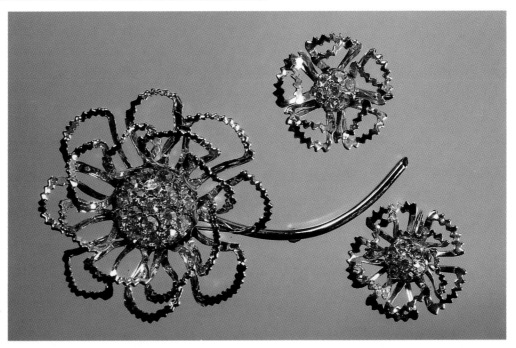

Allusion gold metal brooch and earrings set with aurora borealis stones. $175-195.

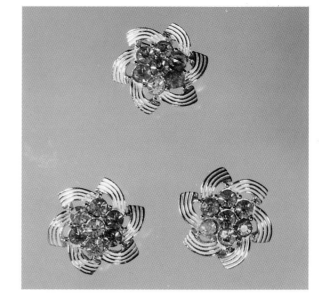

Gold metal earrings and brooch set with colored "stones." *Courtesy of Kenneth L. Surratt, Jr.* $95-125.

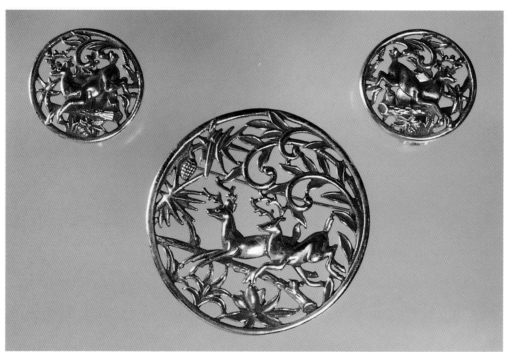

Rhodium earrings and brooch set with deer motif. *Courtesy of Mary G. Moon.* $195-225.

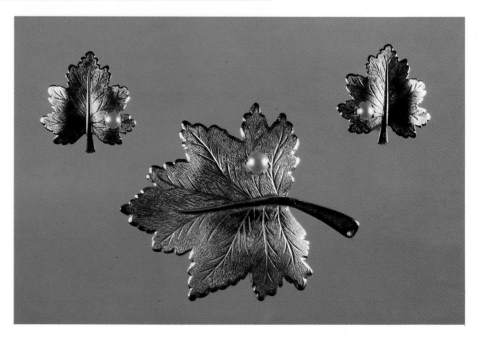

Clip-on gold metal earrings and brooch set with leaf motif and simulated pearls. $95-125.

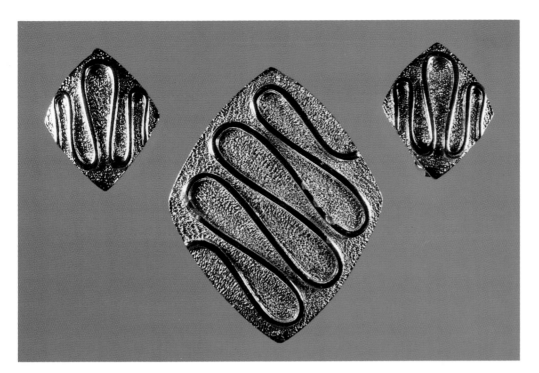

Silvery Nite geometric shaped rhodium clip-on earrings and brooch set. $125-150.

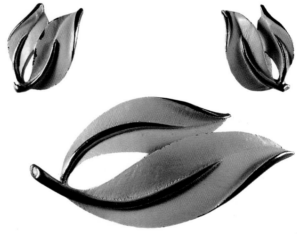

Enameled rhodium leaf shaped clip-on earrings and brooch set. $95-125.

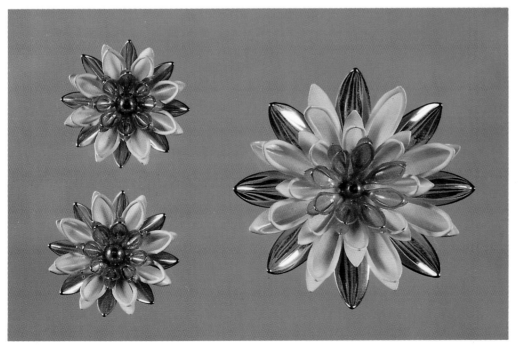

White enameled and gold metal clip-on earrings and brooch set with floral motif. $95-125.

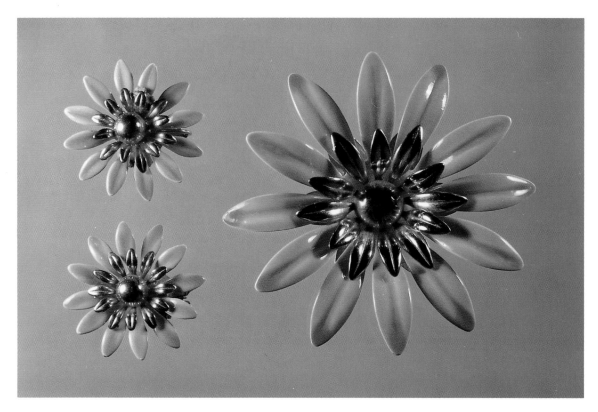

Floral clip-on earrings and brooch set with enameled and gold metal petals. $150-175.

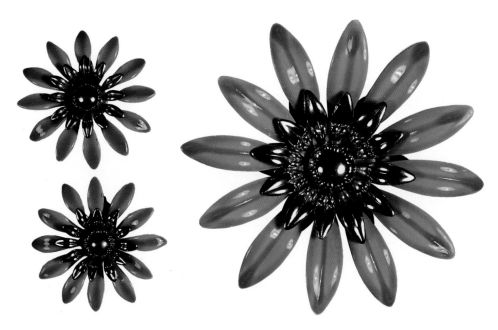

Floral clip-on earrings and brooch set with enameled green and gold metal petals. $150-175.

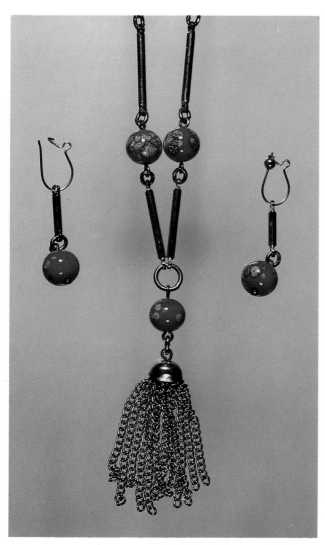

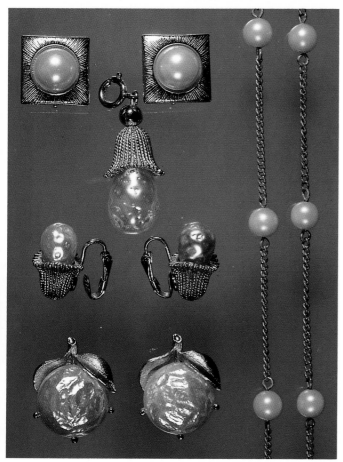

Left and **right**. Gold metal pierced drop earrings with cloisonné red balls. **Center**. Gold metal necklace with cloisonné red balls and tassel. $95-125.

Gold metal clip-on earrings and brooch with flower and leaf motif. $75-95.

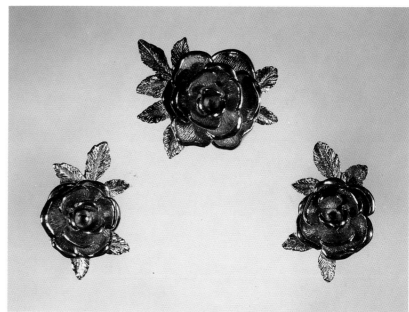

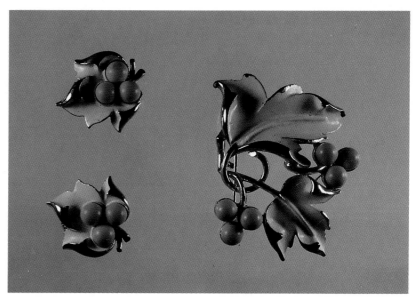

Gold metal enameled leaf earrings and brooch set with blue plastic balls. $125-150.

Top. Pearlized earrings. $45-55.
Center left. Pendant and clip-on pearlized earrings. $85-95.
Bottom left. Pearlized clip-on earrings with gold metal leaves. $55-65.
Right. Necklace with simulated pearls. $45-55.

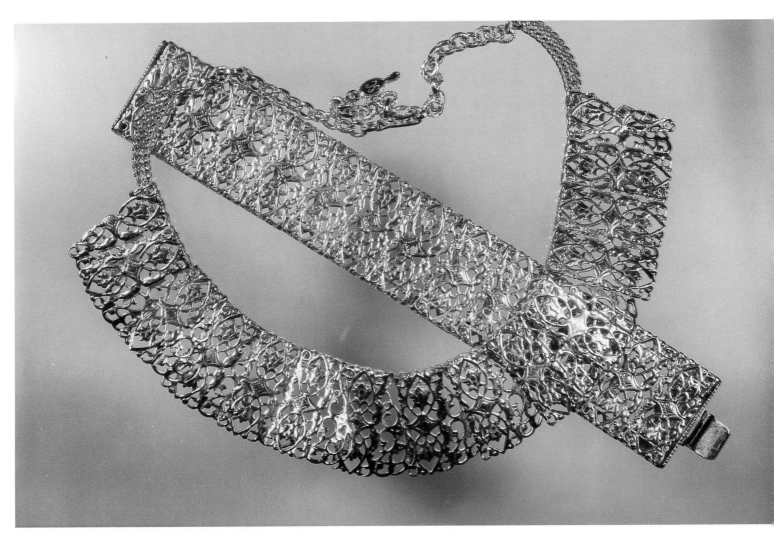

Gold metal necklace and bracelet. $175-195.

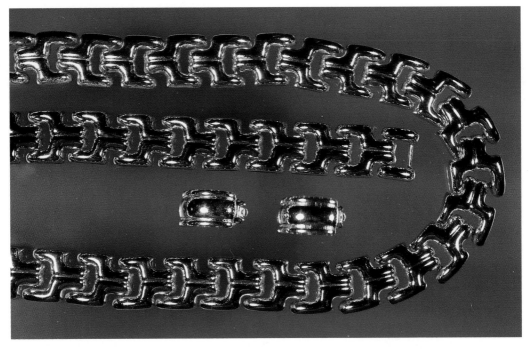

Gold metal necklace, bracelet, and earrings set. $195-225.

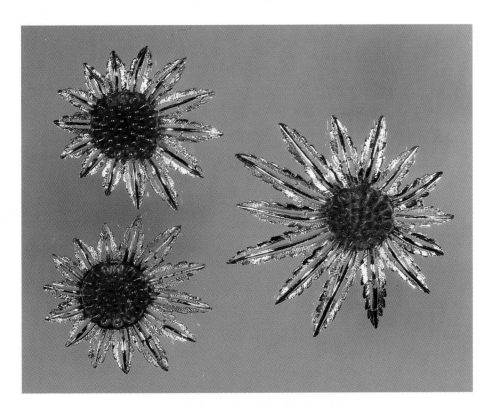

Gold metal and plastic floral clip-on
earrings and brooch set. $125-150.

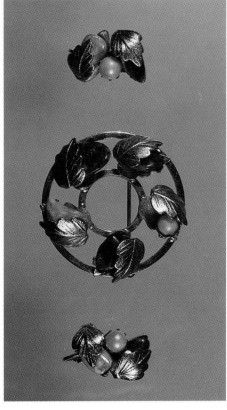

Earrings and brooch set with gold metal
leaves, agate stones, and simulated pearls.
$125-145.

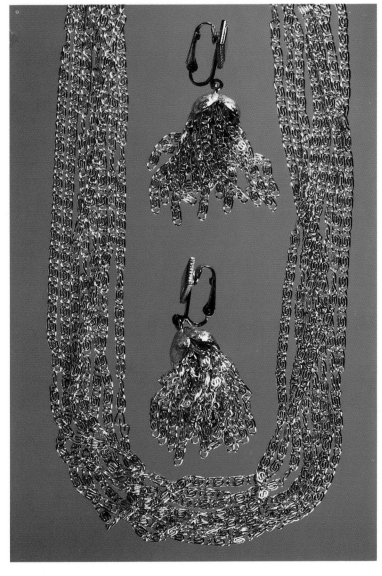

Rhodium set of clip-on earrings and 17-
inch multi-strand necklace. $90-100.

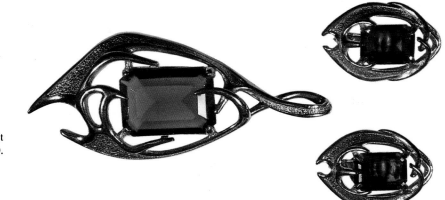

Gold metal clip-on earrings and pendant
set with faux topaz stones. $60-80.

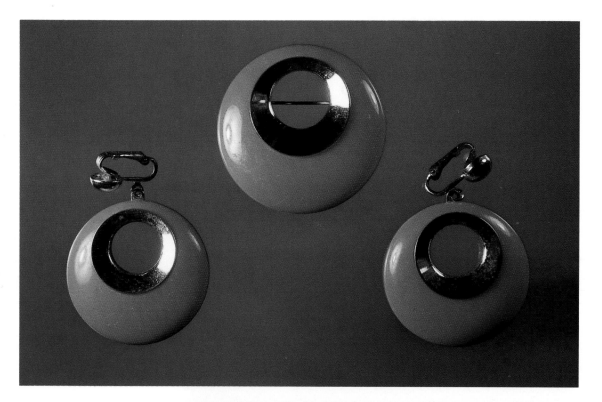

Orange plastic and gold metal
clip-on earrings and brooch
set. $65-95.

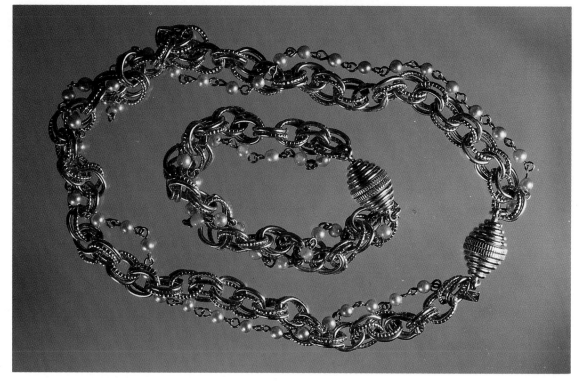

Matching gold metal
16-inch necklace and
7-inch bracelet with
simulated pearls.
$90-110.

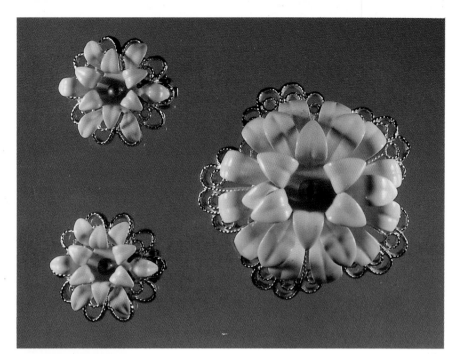

Gold metal and enameled clip-on flower earrings and brooch set. $60-80.

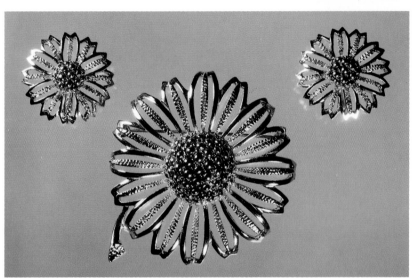

Rhodium earrings and brooch set in floral design with metal balls. *Courtesy of Wanda Goodmon.* $65-90.

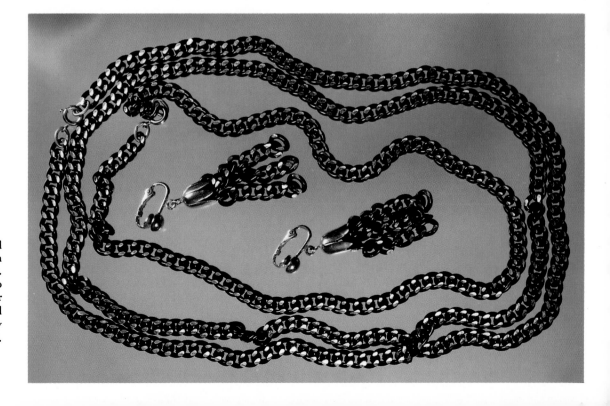

Rhodium set of 16-inch and 38-inch necklaces and 2-inch tasseled clip-on earrings. Necklaces can be attached to form one long necklace or short necklace can be doubled to become a bracelet. *Courtesy of Wanda Goodmon.* $95-125.

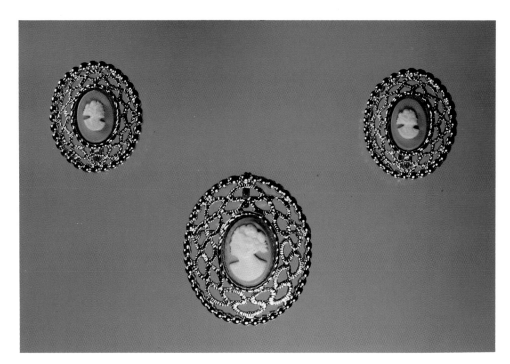

White on blue plastic cameo set with earrings and brooch depicting
motif of Psyche, bride of Cupid, with butterfly wing in hair. *Courtesy of
Wanda Goodmon.* $65-75.

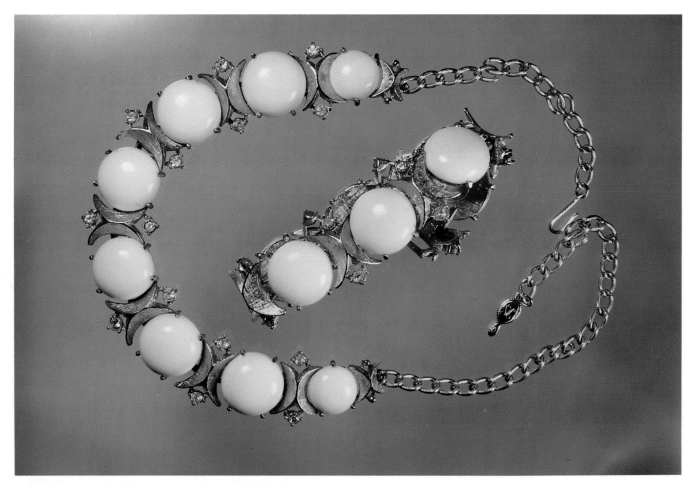

Gold metal 16-inch necklace and 7-inch bracelet with prong set white
plastic "stones." $95-125.

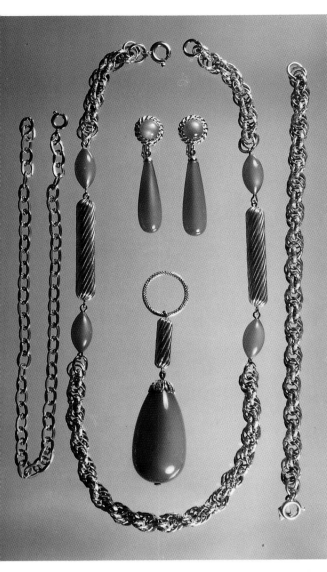

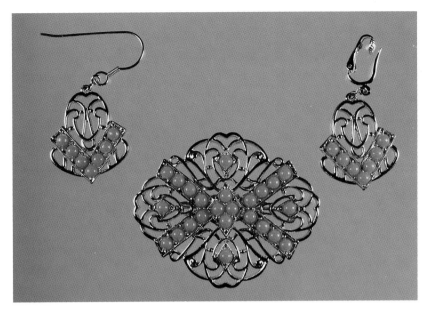

Gold metal brooch and earrings set with plastic orange beads. *Courtesy of Kenneth L. Surratt, Jr.* $80-95.

Plastic and gold metal set with 12-inch extender, drop earrings, 18.5-inch necklace, 3.5-inch pendant, and 7-inch bracelet. $175-195.

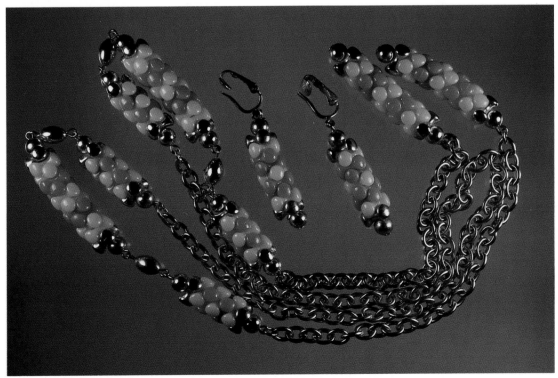

Gold metal necklace and clip-on earrings set with colored plastic beads. *Courtesy of Kenneth L. Surratt, Jr.* $95-125.

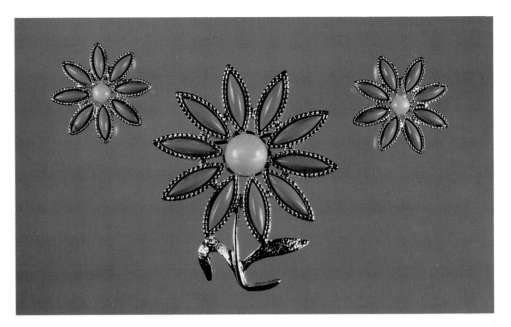

Rhodium and plastic clip-on earrings and brooch set in floral design. *Courtesy of Kenneth L. Surratt, Jr.* $90-110.

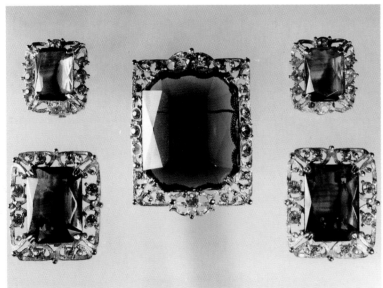

A selection of earrings and brooch from the Celebrity series with prong set smoke colored faceted "stones" and rhinestones set in rhodium. *Courtesy of Mary Ellen DeLaughter.* $195-225.

Gold metal bracelet with spring clasp and gold metal adjustable ring with colored plastic "stones." *Courtesy of Phyllis Sparks.* $125-150.

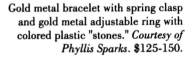

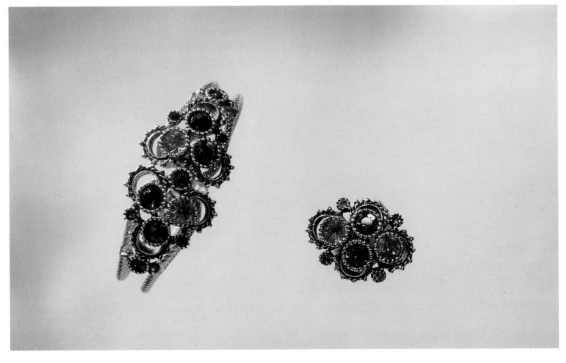

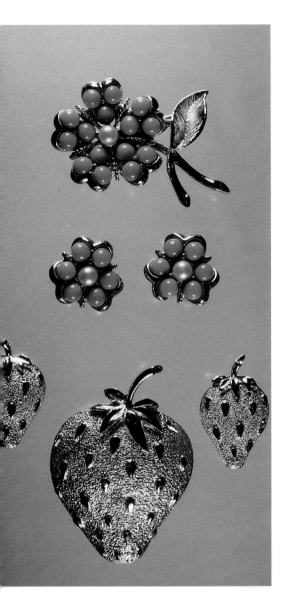

Top. Rhodium, plastic turquoise, and simulated pearl earrings and brooch floral set. $75-95.
Bottom. Rhodium strawberry earrings and brooch set. $65-75.
The jewelry is *Courtesy of Mary Ellen DeLaughter.*

Left and **right**. Gold metal pendants/brooches with tassels and faux jade stones. $55-65 each.
Center. Gold metal clip-on earring with tassel and faux jade stone. $35-45 for the pair.
The jewelry is *Courtesy of Phyllis Sparks.*

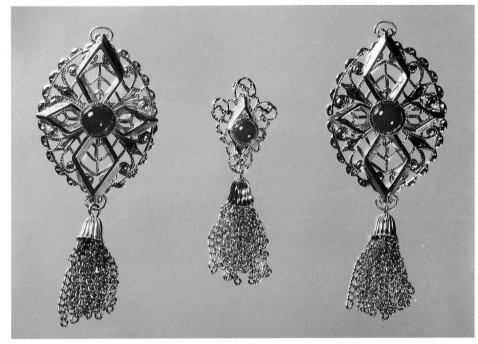

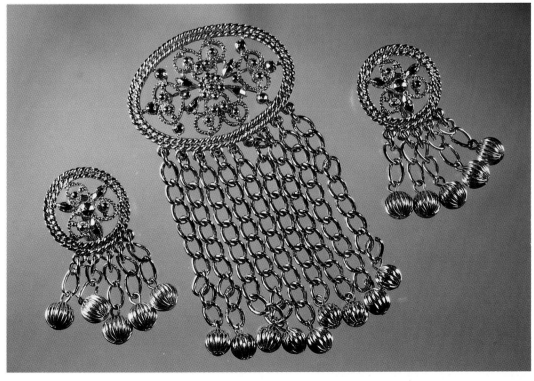

Rhodium Fashion in Motion set with earrings and brooch. *Courtesy of Marshall A. Gordon.* $110-125.

Rhodium Bird of Paradise brooch and earrings set with colored glass and rhinestones. *Courtesy of Marshall A. Gordon.* $150-175.

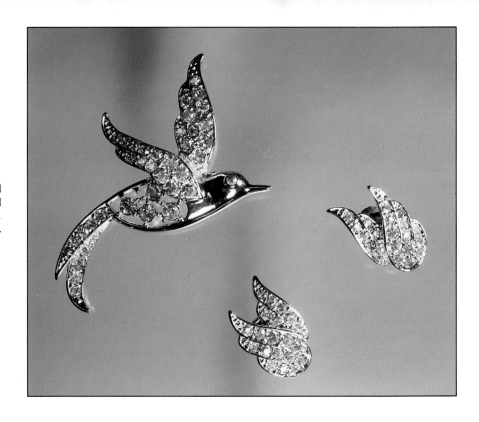

Rhodium and gold metal Garland brooch and earrings set. *Courtesy of Marshall A. Gordon.* $95-125.

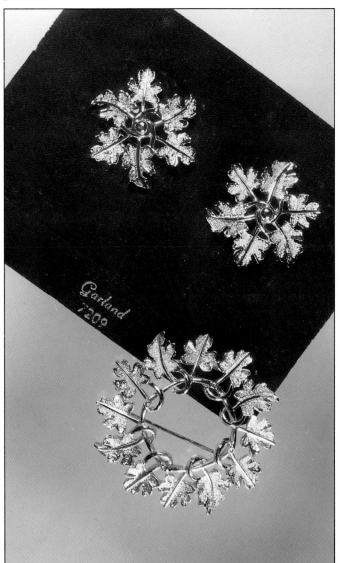

Gold metal and rhinestones Candlelite set of earrings and two necklaces. *Courtesy of Marshall A. Gordon.* $195-225.

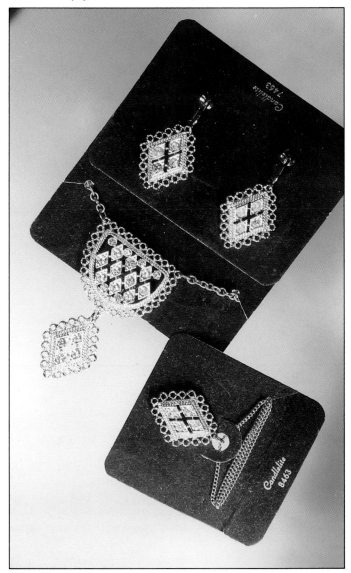

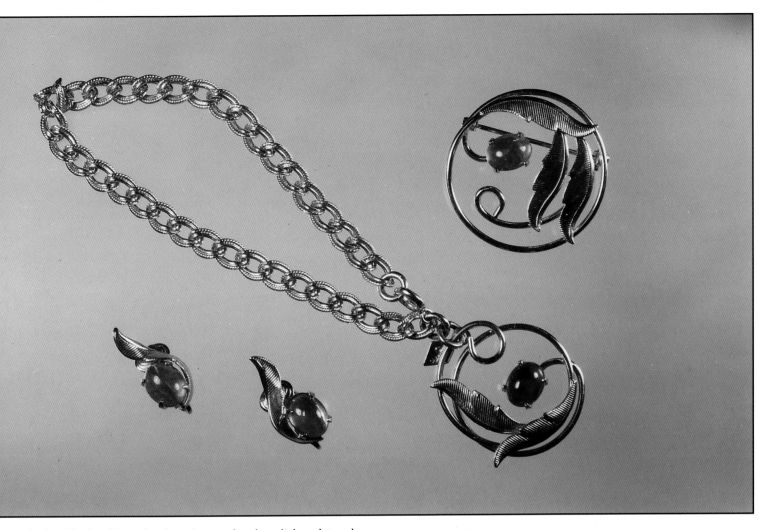

Lord and Lady gold metal and genuine amethyst brooch, bracelet, and earrings. *Courtesy of Carol Gordon.* $225-250.

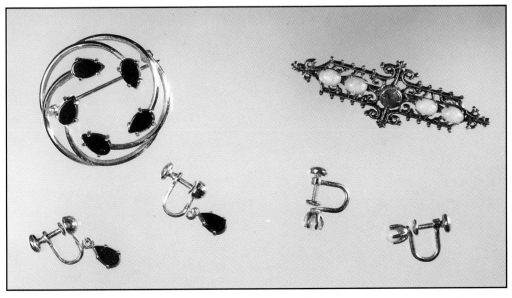

Left. Gold metal and black onyx brooch and earrings set. $150-175.
Right. Gold metal, genuine opal, and red cabochon brooch and genuine opal earrings. $145-165.
The jewelry is *Courtesy of Carol Gordon.*

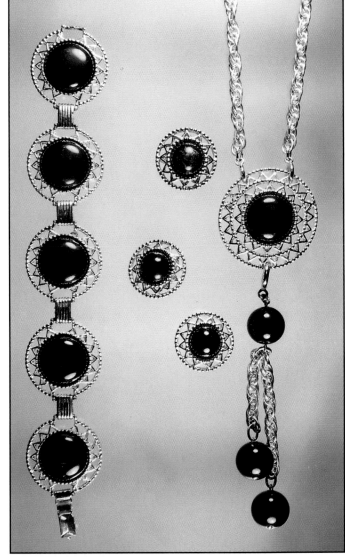

Left. Gold metal rose brooch with genuine jade leaves. $65-85.
Right. Gold metal earrings with genuine jade stones. $75-95.
The jewelry is *Courtesy of Carol Gordon*.

Rhodium and black faux onyx set with
bracelet, earrings, ring, and pendant
with 30-inch chain. *Courtesy of Carol
Gordon*. $150-175.

Rhodium and clear glass set with
necklace, bracelet, and earrings.
Courtesy of Carol Gordon. $150-175.

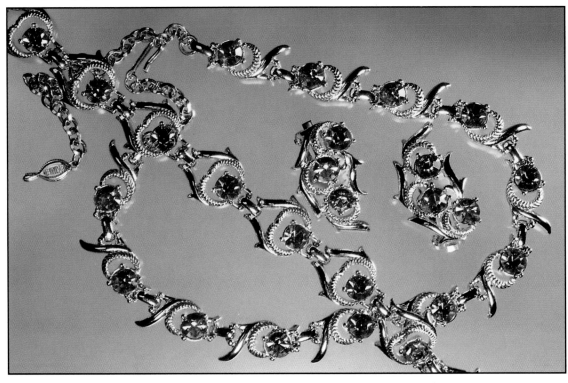

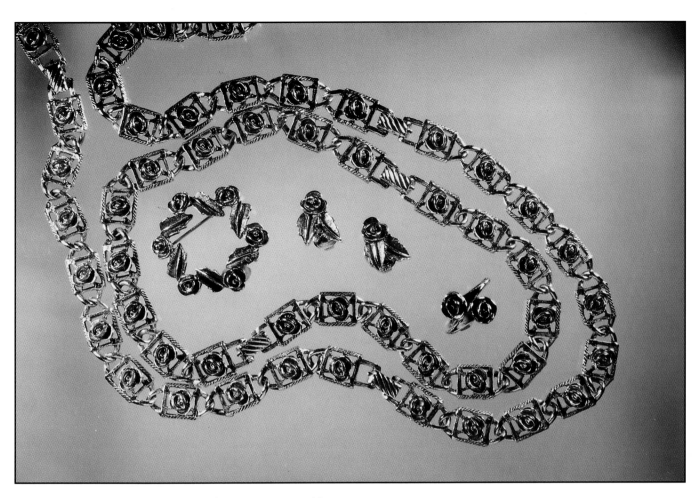

Sterling silver Antique Rose set with brooch, earrings, ring, necklace, and bracelet. Bracelet can be attached to necklace to form a longer strand. $180-210.

Northern Lights gold metal set with earrings, bracelet, and ring. *Courtesy of Carol Gordon.* $90-110.

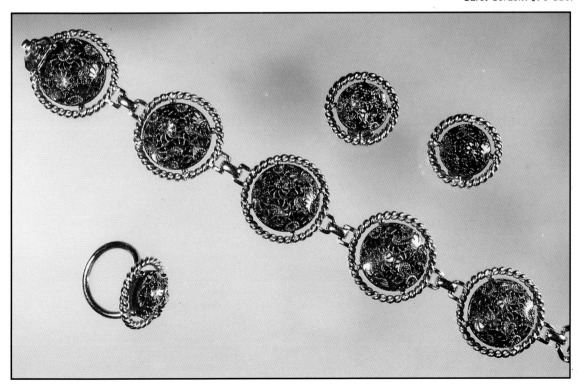

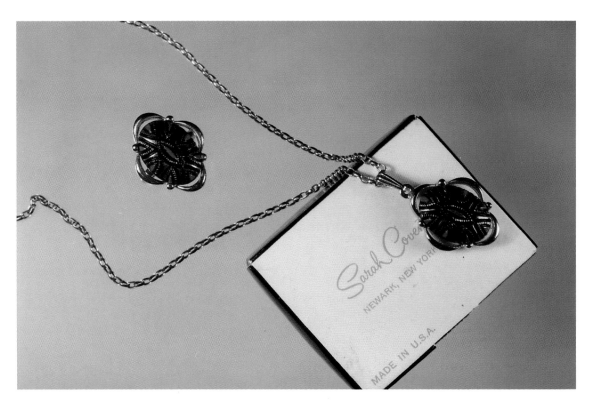

Colorful Egyptian gold metal and enameled brooch and pendant.
Courtesy of Jessica J. Gordon. $95-125.

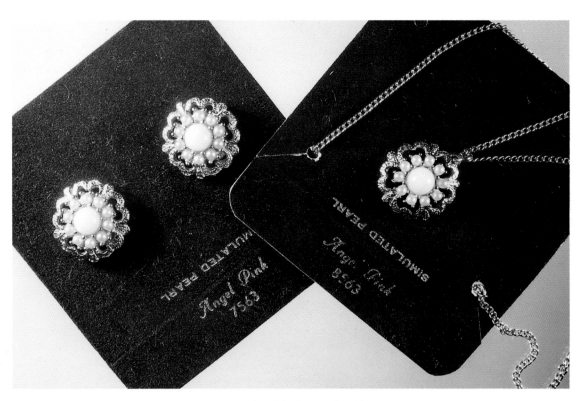

Angel Pink set with gold metal, simulated pearls, and pink cabochon earrings and pendant with 16-inch chain. *Courtesy of Carol Gordon.* $125-150.

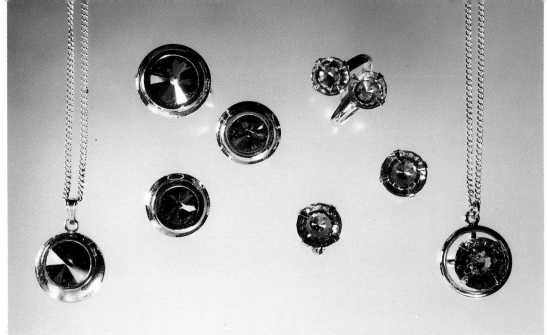

Left. Liquid Lights rhodium and blue stone set with pendant, earrings, and ring. $195-225.
Right. Gold metal Over the Rainbow ring, earrings, and pendant set with rhinestones and rose zircon. $195-225.

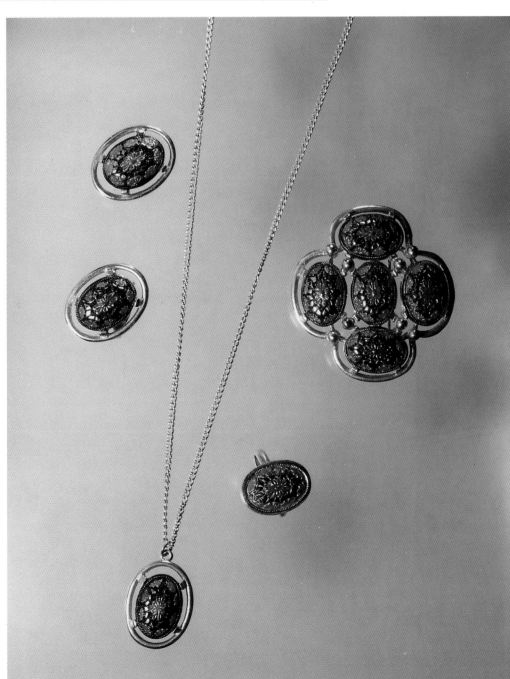

Gold metal and enameled Light of the East mosaic set with earrings, brooch, ring, and pendant. $225-250.

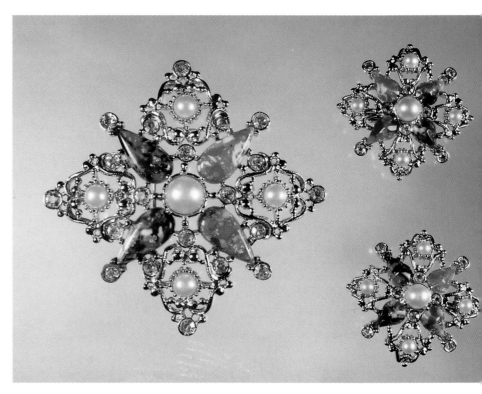

Galaxy brooch and earrings set with gold metal, multicolored plastic, simulated pearls, and blue glass. *Courtesy of Marshall A. Gordon.* $150-175.

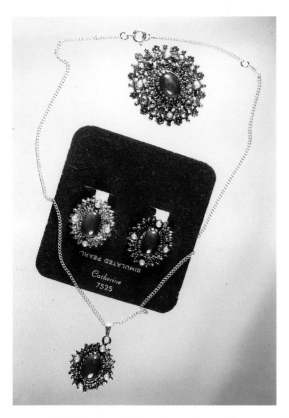

Catherine set with brooch, earrings, and pendant with gold metal, faux amethyst cabochons, and simulated pearls. *Courtesy of Marshall A. Gordon.* $175-195.

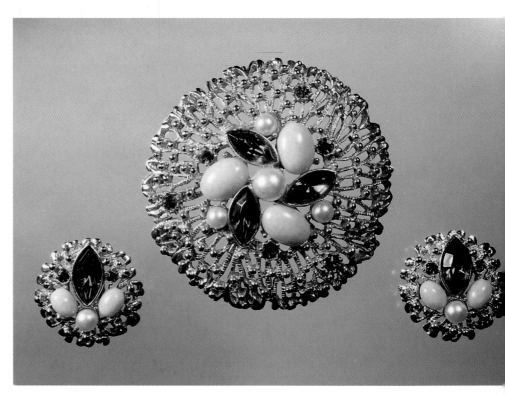

Earrings and brooch set with gold metal, faux topaz cabochons, pink plastic, and simulated pearls. *Courtesy of Margaret McRaney.* $125-145.

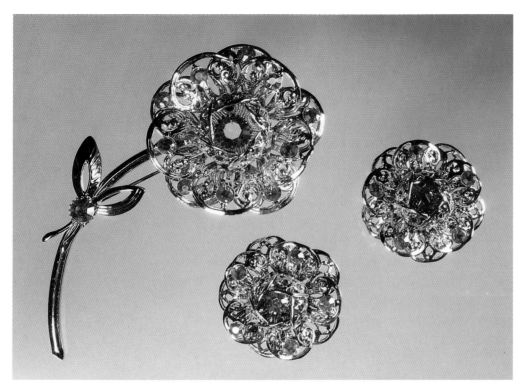

Gold metal Fashion Splendor brooch and earrings set with faux amber stones, faux ruby stones, and rhinestones. $195-225.

Gold metal and jade set with bracelet, pendant with 14-inch chain, and two pairs of pierced earrings. *Courtesy of Jessica J. Gordon.* $295-325.

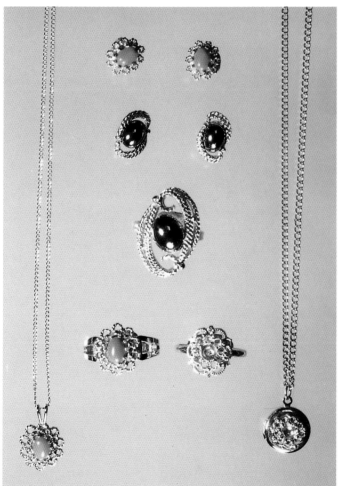

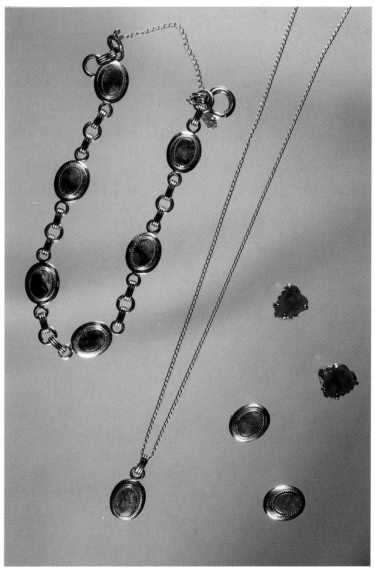

Left and **center**. Gold metal and turquoise set with earrings, ring, and pendant. $195-225.
Center. Gold metal and onyx stone earrings and pendant set. $95-125.
Right. Gold metal and clear stone pendant and ring set. $95-125.
The jewelry is *Courtesy of Jessica J. Gordon.*

Mother-of-pearl cameo ring, earrings, and pendant set. *Courtesy of Jessica J. Gordon.* $175-195.

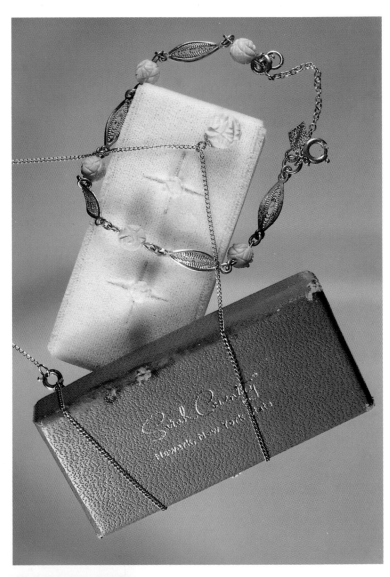

Gold metal and carved bone set with bracelet, earrings, and pendant with rosette motif. *Courtesy of Jessica J. Gordon.* $125-150.

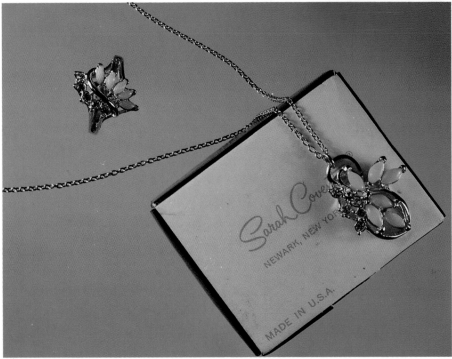

Ring and pendant set made of gold metal, genuine sapphire stones, and opals. *Courtesy of Jessica J. Gordon.* $195-225.

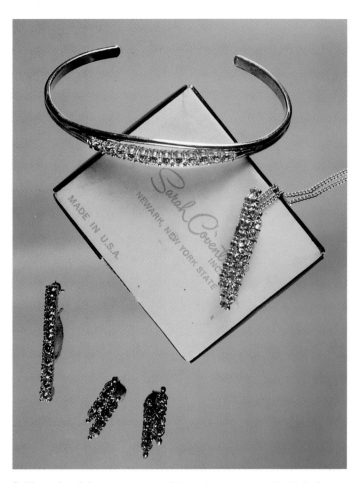

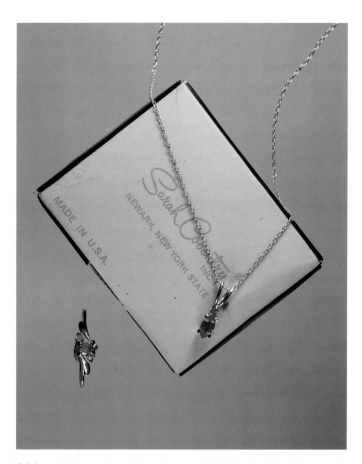

Gold metal garnet ring and pendant set with 15-inch chain. *Courtesy of Jessica J. Gordon.* $95-125.

Gold metal and rhinestones set with bracelet, pendant with 14-inch chain, bar pin, and earrings. *Courtesy of Jessica J. Gordon.* $175-195.

Gold metal 36-inch necklace and 7- inch bracelet. *Courtesy of Mary Ellen DeLaughter.* $55-75.

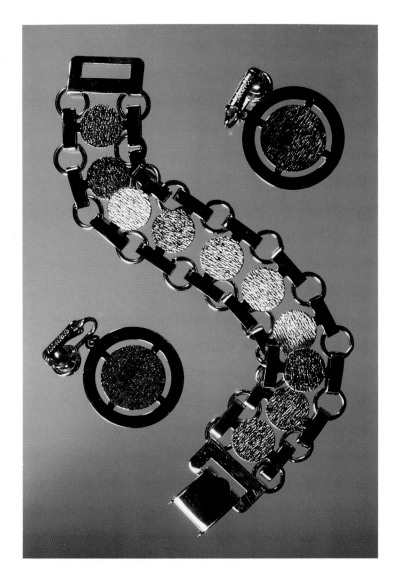

Rhodium bracelet and clip-on earrings set. $75-95.

Gold metal necklace and bracelet set. $90-125.

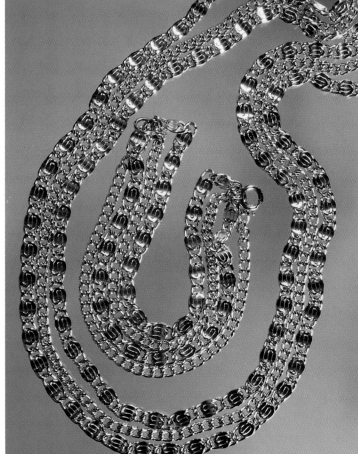

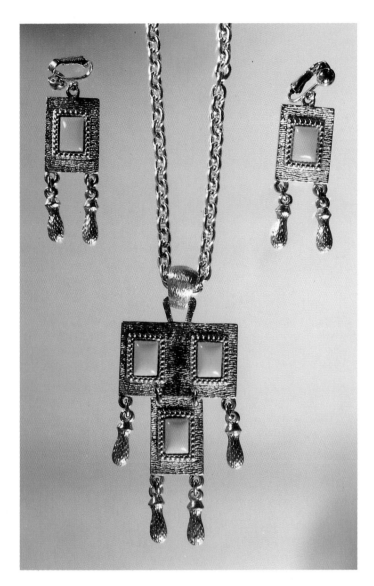

Gold metal and plastic turquoise earrings and necklace with 34-inch chain. $125-150.

Ming Garden earrings and necklace with 34-inch chain in gold metal and faux jade design. $165-195.

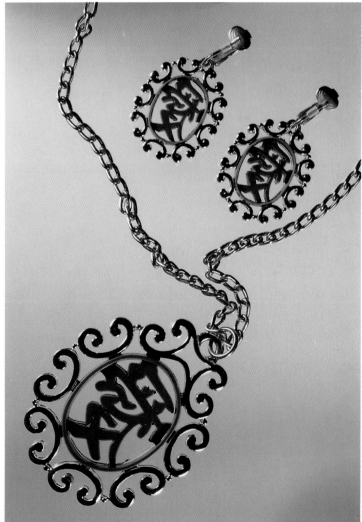

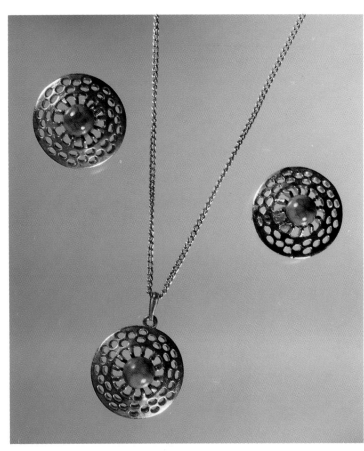

Aztec set with gold metal and plastic turquoise
earrings and necklace with 18-inch chain.
$125-150.

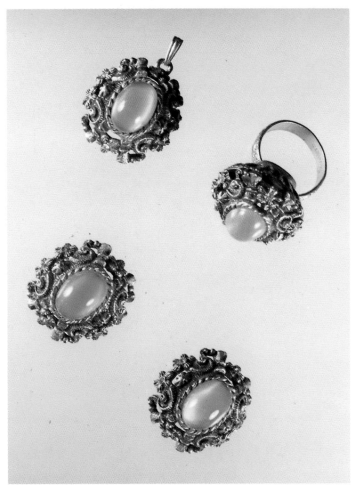

Azure Skies gold metal and plastic set
with pendant and 17-inch chain, ring,
brooch, and clip-on earrings. $250-275.

Gold metal and plastic turquoise set with
pendant, ring, and clip-on earrings. $195-225.

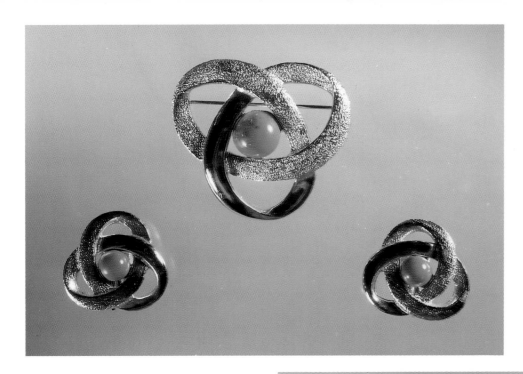

Orbit brooch and earrings set with rhodium and green plastic. $125-150.

Orbit brooch and earrings set with gold metal and red plastic. *Courtesy of Marshall A. Gordon.* $125-150.

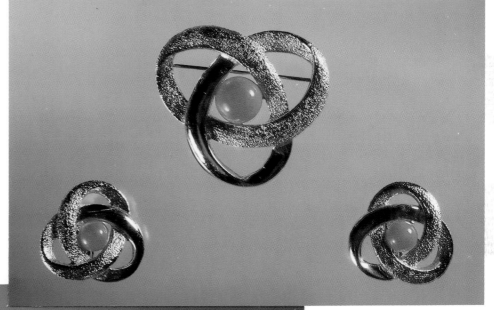

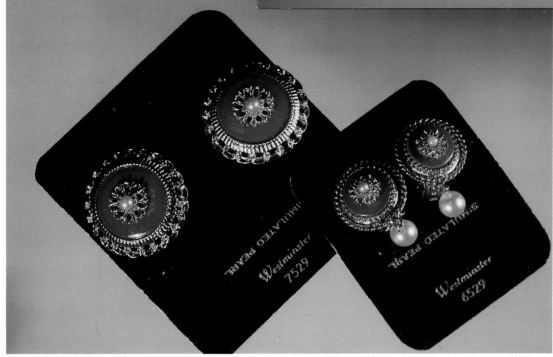

Two brooches and one pair of earrings from the Westminster set with gold metal, red plastic, and simulated pearls. $125-150.

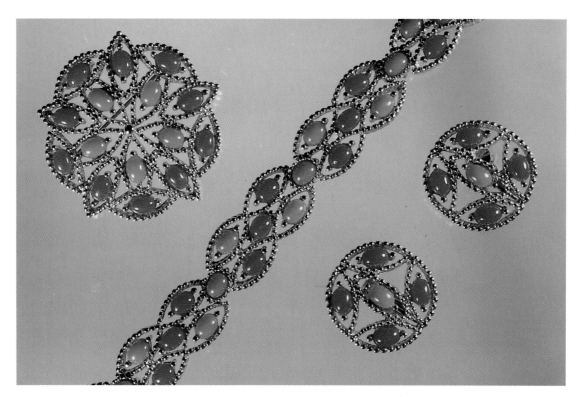

Acapulco earrings, bracelet, and brooch set of gold metal and plastic.
$195-225.

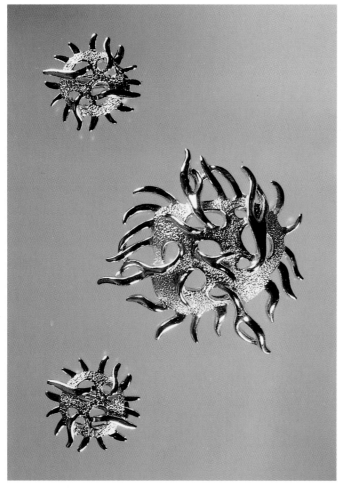

Rhodium Sea Urchin earrings and brooch set. $150-175.

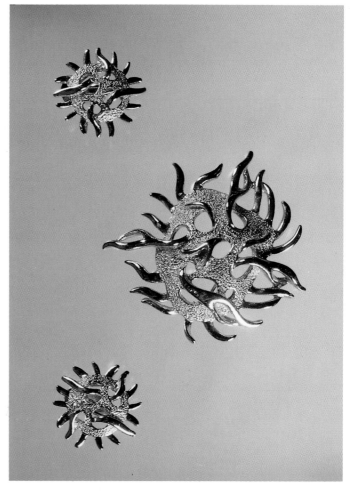

Gold metal Sea Urchin earrings and brooch set. $150-175.

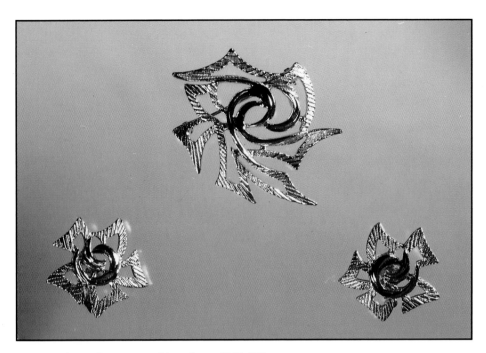

Rhodium Oriental earrings and brooch set. $125-150.

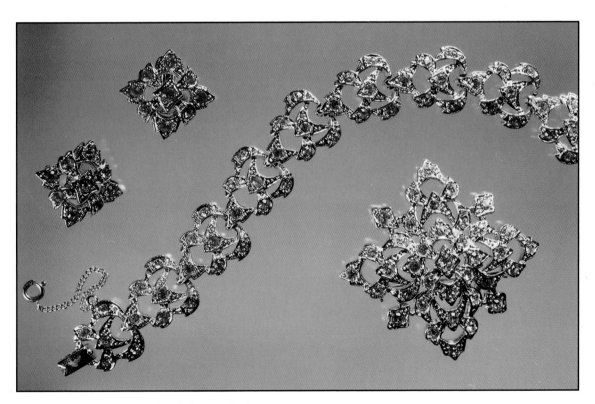

Rhodium and rhinestone Leading Lady set with clip-on earrings,
bracelet, and brooch. $225-250.

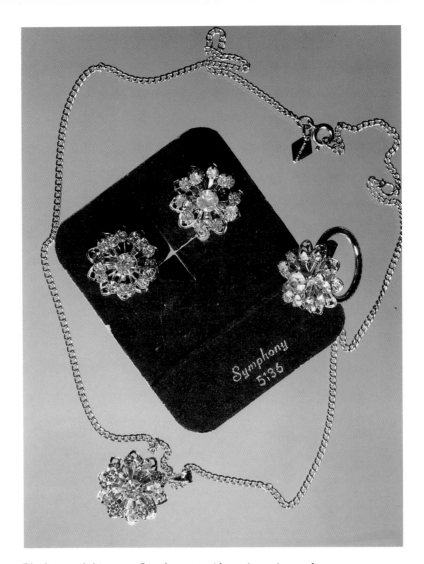

Rhodium and rhinestone Symphony set with earrings, ring, and pendant. $195-225.

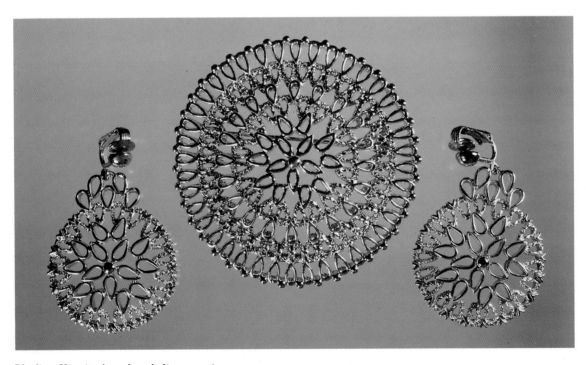

Rhodium Venetian brooch and clip-on earrings set. $150-175.

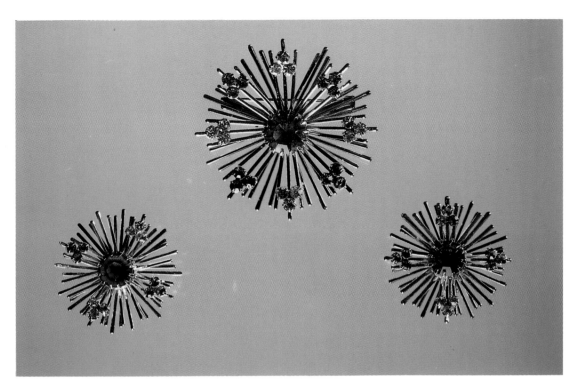

Rhodium, rhinestone, and faux sapphire Blue Snowflake set with brooch and clip-on earrings. $150-175.

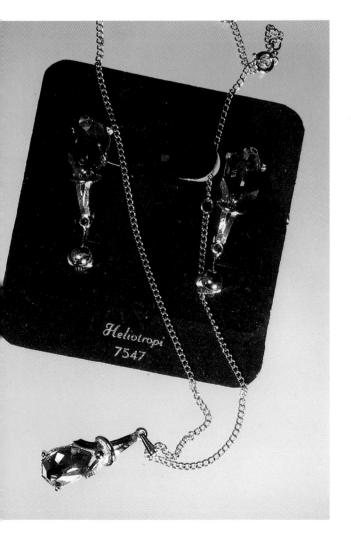

Royal Velvet brooch and earrings set with rhodium and faux amethyst stones. $120-140.

Gold metal and faux amethyst Heliotropi set with earrings and pendant with 18-inch chain. $150-175.

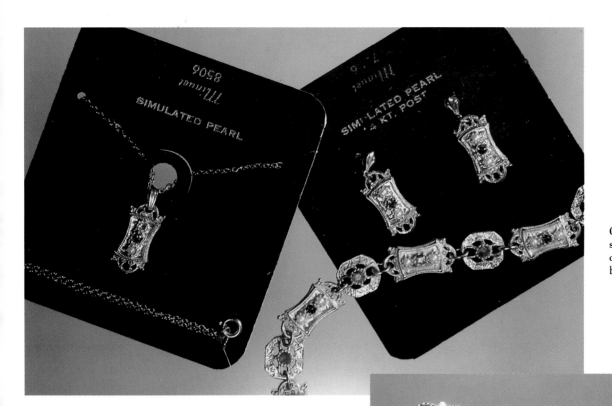

Gold metal and plastic Minuet set with pendant with 18-inch chain, pierced earrings, and bracelet. $95-125.

Gold metal Ceylon set with earrings and ring adorned with plastic beads. $90-110.

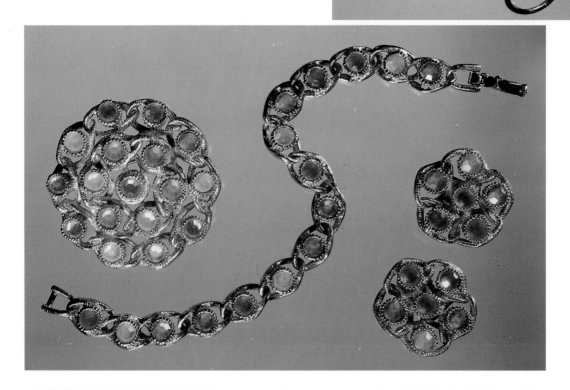

Moon Lites brooch, bracelet, and earrings set of gold metal and colorful plastic "stones." $150-165.

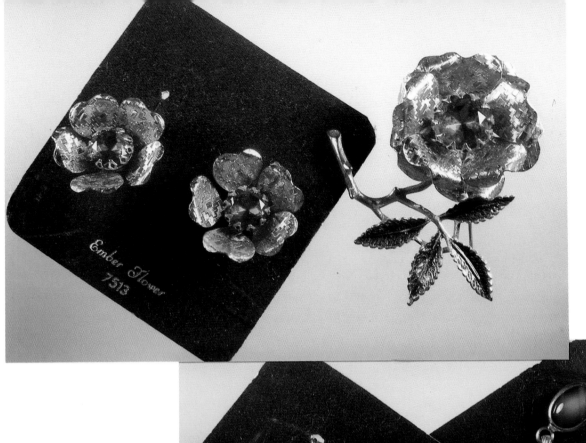

Ember Flower earrings and brooch set with gold metal, faux topaz, and enameled green leaves. $145-165.

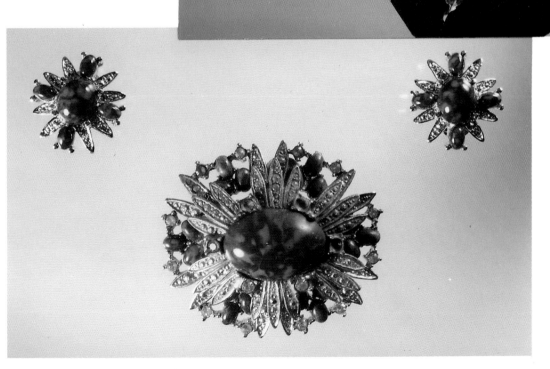

Gold metal and faux amber Wood Nymph set with ring and 8-inch bracelet. $125-150.

Rhodium, rhinestone, and blue plastic Anniversary set with earrings and brooch. $140-165.

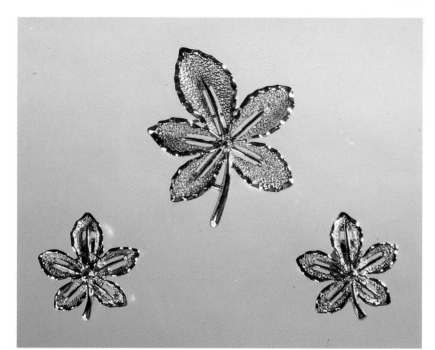

Gold metal Joy set with brooch and earrings in leaf motif. $75-95.

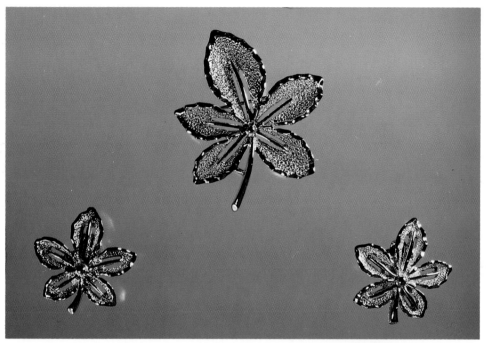

Rhodium Joy set with brooch and earrings in leaf motif. $125-150.

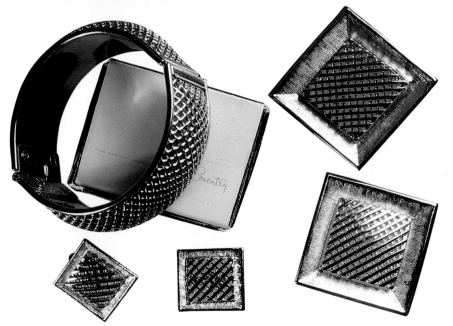

Rhodium Criss Cross set with two brooches, earrings, and bracelet. $115-130.

Rhodium Fashion Mobile necklace and earrings set. $65-80.

Rhodium Tranquility set with earrings and pendant with 25-inch chain. $150-175.

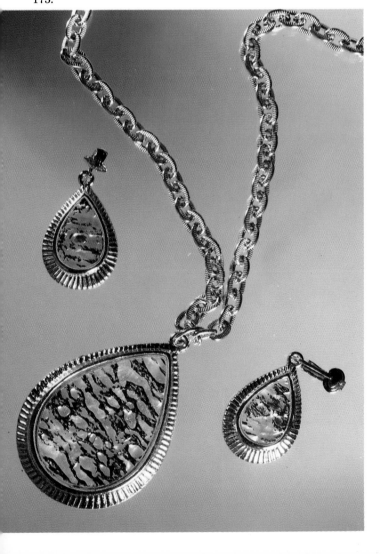

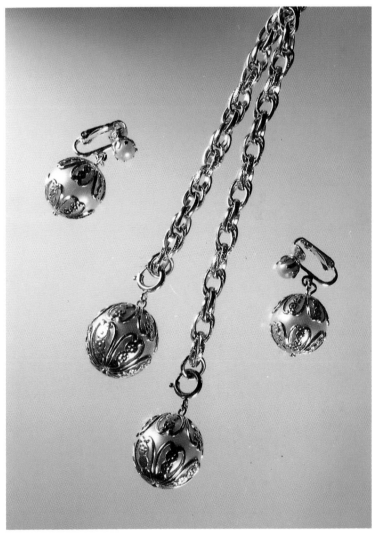

Simulated pearl and rhodium set with clip-on earrings and 41-inch necklace which can also be worn as a belt. $90-120.

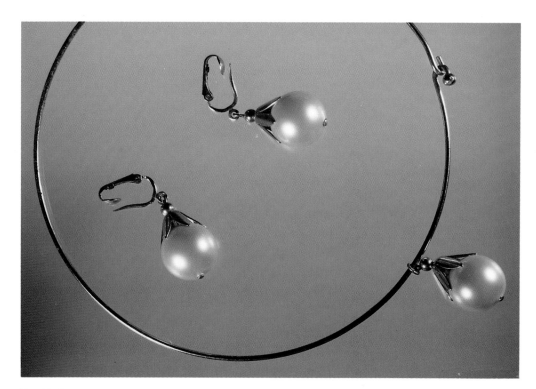

New Mode gold metal and simulated pearl set with clip-on earrings and pendant on wire necklace. $95-115.

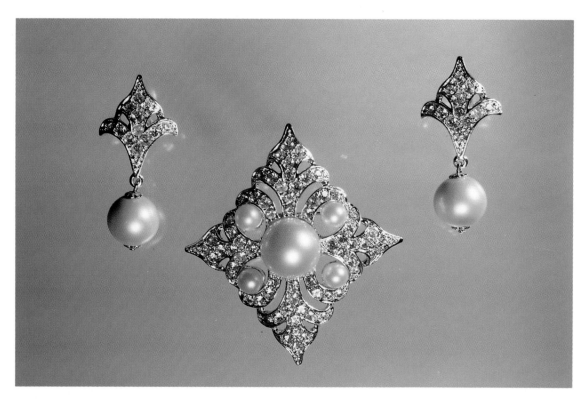

Rhodium, rhinestone, and simulated pearl Persian Princess earrings and brooch set. $150-175.

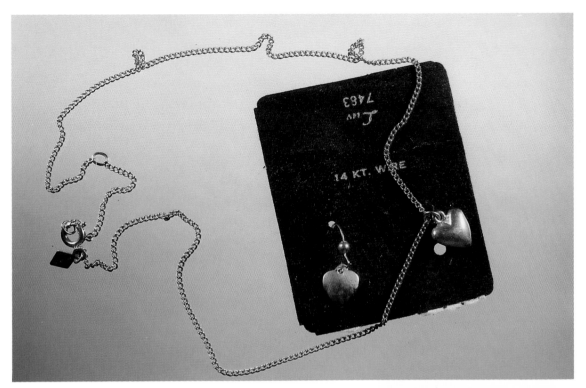

Gold metal heart shaped Luv set with one earring (one earring is missing) and pendant. $70-75 for complete set.

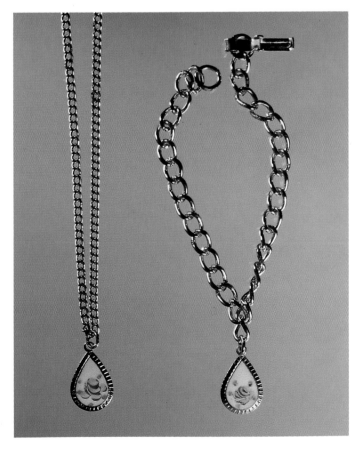

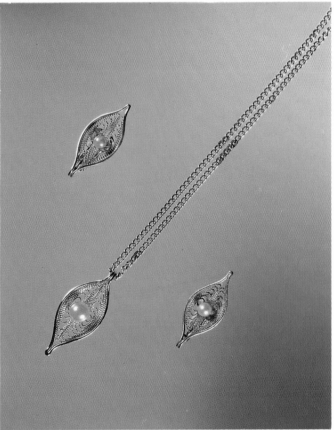

Serene gold metal set with filigree work and simulated pearl earrings and pendant with 18-inch necklace. $95-110.

Primrose set with 14-inch necklace and bracelet. $75-95.

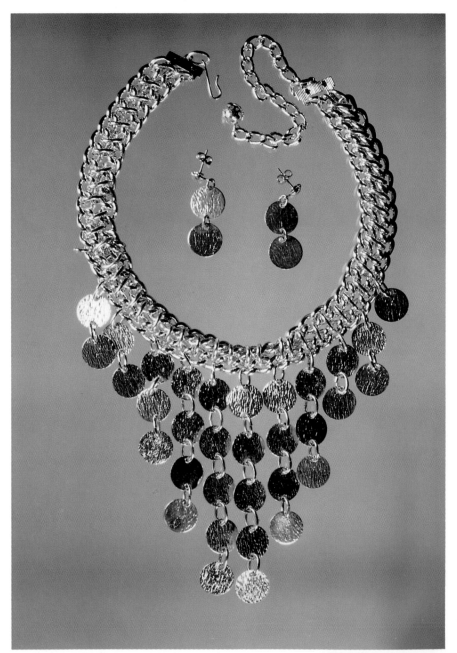

Pyramid Treasures set with rhodium earrings and bib necklace. $95-110.

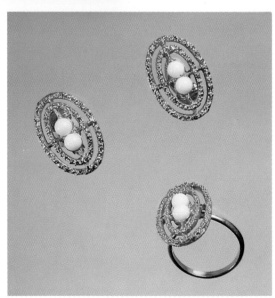

Soft Swirl gold metal and plastic "pearl" earrings and ring set. $75-95.

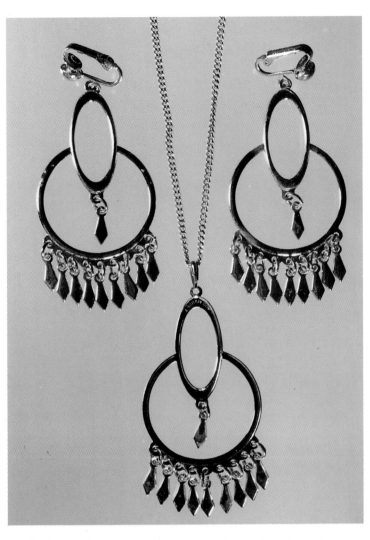

Gold metal Flamenco set with clip-on earrings and pendant with 18-inch chain. $150-175.

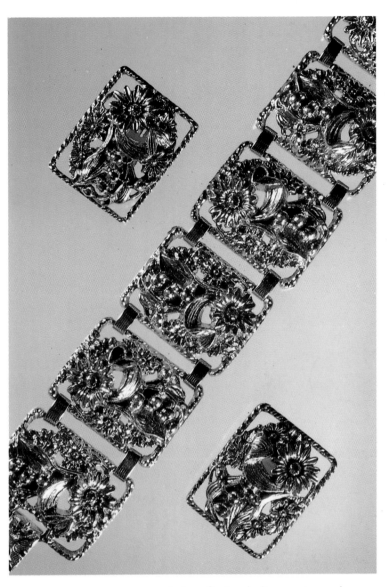

Antique Garden rhodium earrings and bracelet set. $140-165.

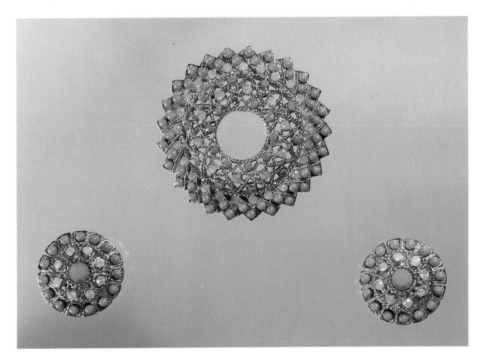

Age of Aquarius gold metal, rhinestone, and plastic clip-on earrings and brooch set. $150-175.

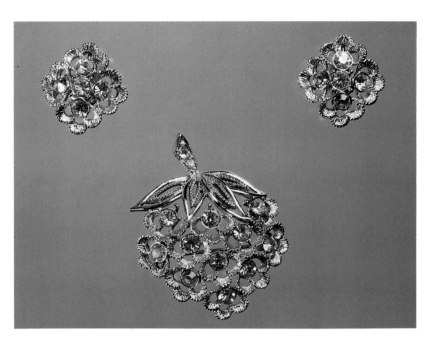

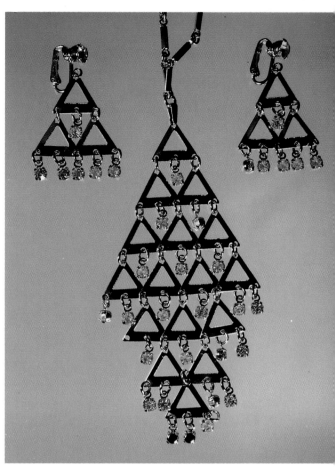

Rhodium and rhinestone Sparkling Burgundy set with earrings and brooch. $110-125.

Eleganté set with gold metal and rhinestone earrings and 5-inch pendant with 18-inch chain. $95-110.

Golden Ice gold metal and rhinestone set with dangle earrings and bracelet. $175-195.

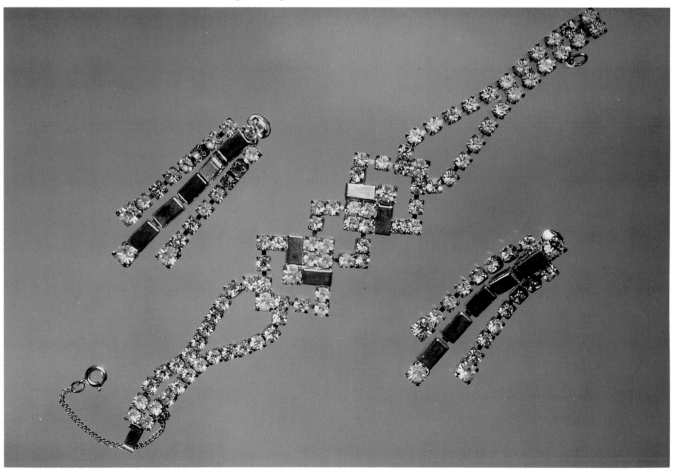

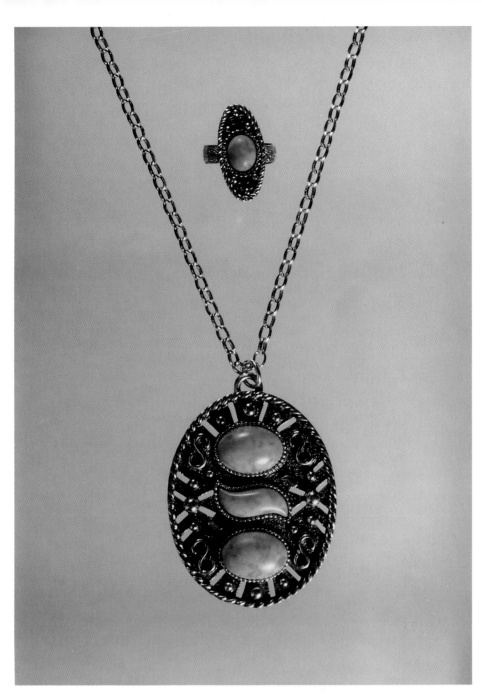

Rhodium and plastic "turquoise" set with ring and pendant with 24-inch necklace. $125-150.

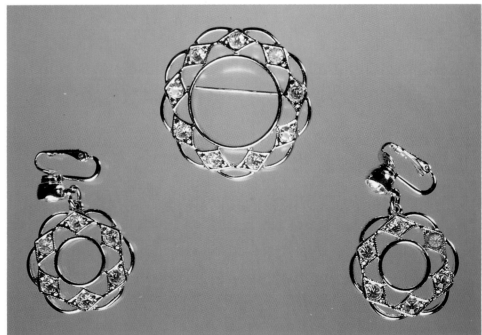

Sparkle Circle set with rhodium and rhinestone brooch and clip-on earrings. $125-150.

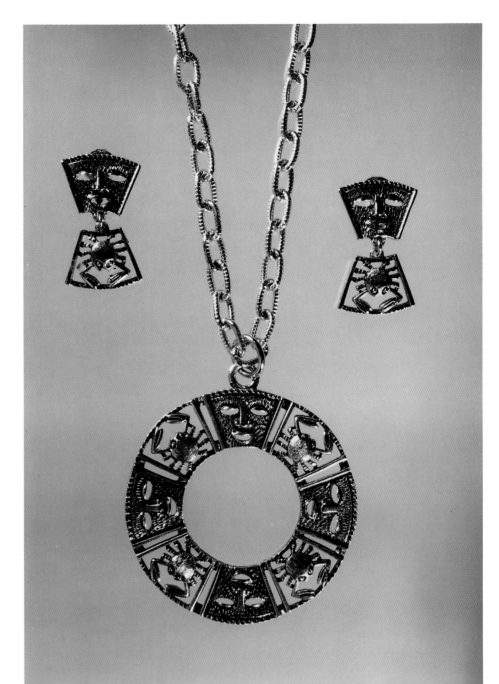

Rhodium Cancer set with earrings and
pendant with 24-inch chain. $135-150.

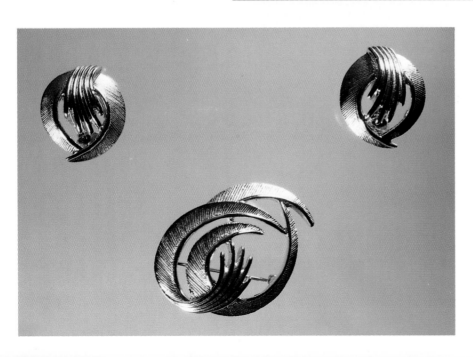

Saucy Silver rhodium earrings and brooch set.
$95-110.

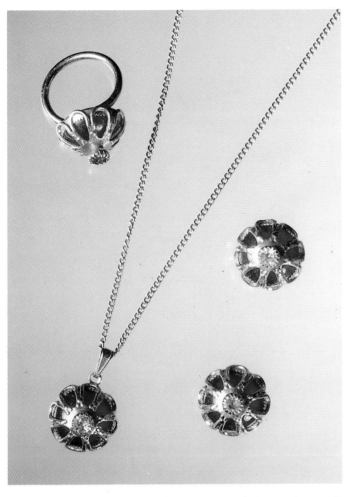

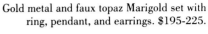
Gold metal and faux topaz Marigold set with ring, pendant, and earrings. $195-225.

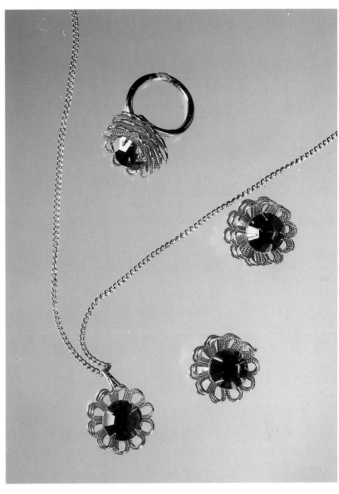

Gold metal, faux ruby stone, and rhinestone set with ring, earrings, and pendant with 16-inch chain. $195-225.

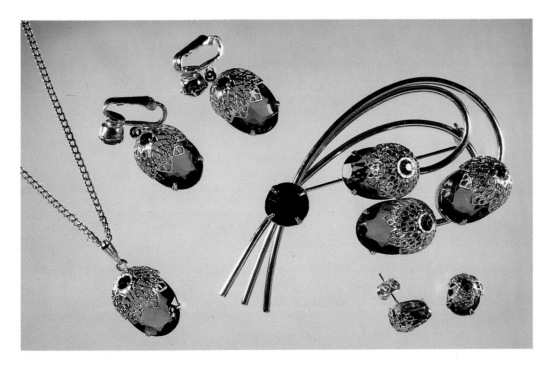

Gold metal and plastic Touch of Elegance set with pendant, clip-on and pierced earrings, and brooch. $250-275.

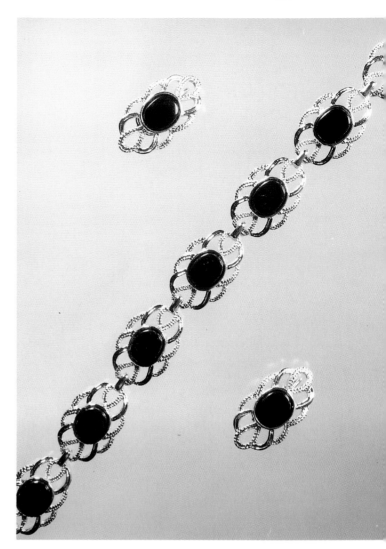

Rhodium Black Reflections earrings and bracelet set with faux onyx stones. $195-225.

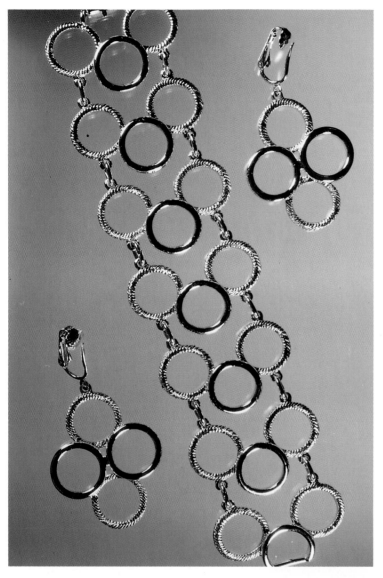

Fancy Free rhodium set with clip-on earrings and bracelet. $95-110.

Pearl Swirl set with gold metal and simulated pearl clip-on earrings and bracelet. $75-95.

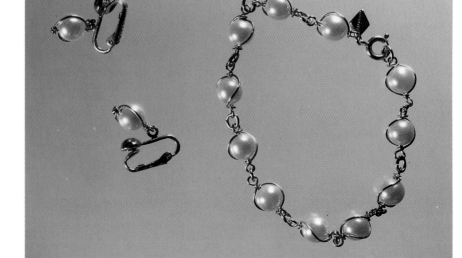

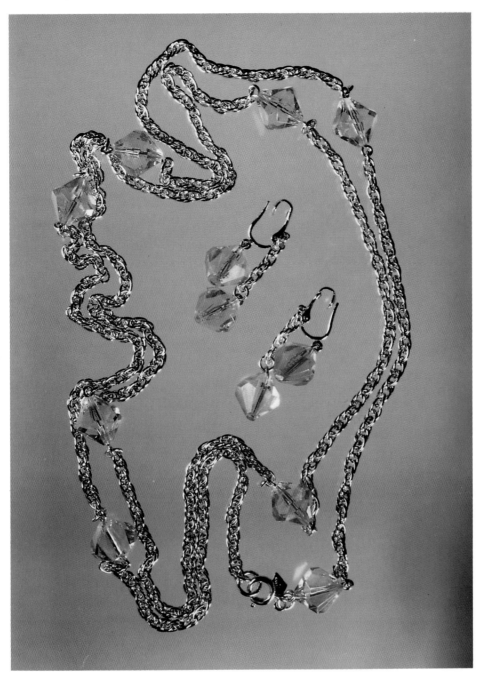

Pastel Glo set with gold metal and plastic clip-on earrings and 50-inch necklace. $125-150.

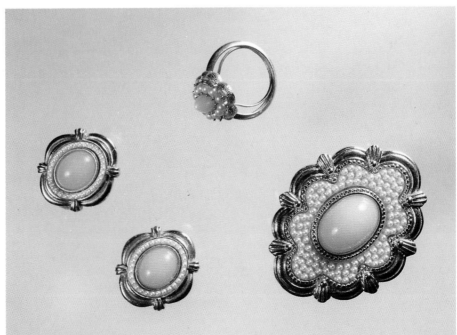

Gold metal, simulated pearl, and plastic set with earrings, ring, and brooch. *Courtesy of Mary Liles*. $225-250.

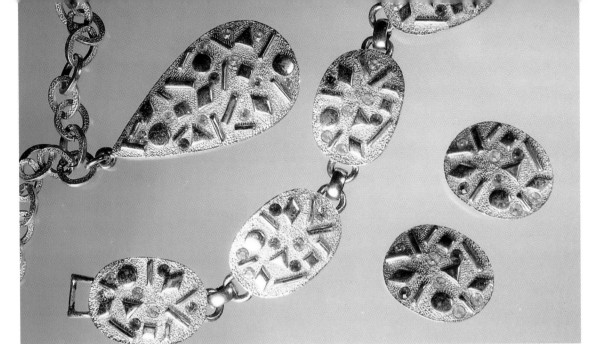

Plastic "stones" and gold metal set with pendant, bracelet, and earrings. *Courtesy of Mary Liles.* $125-150.

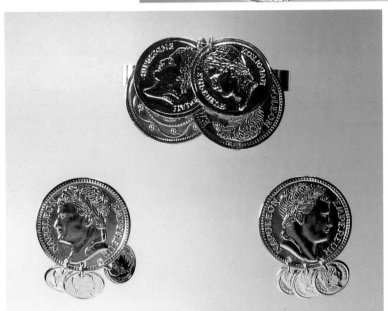

Silver metal coin set with brooch and earrings. $65-85.

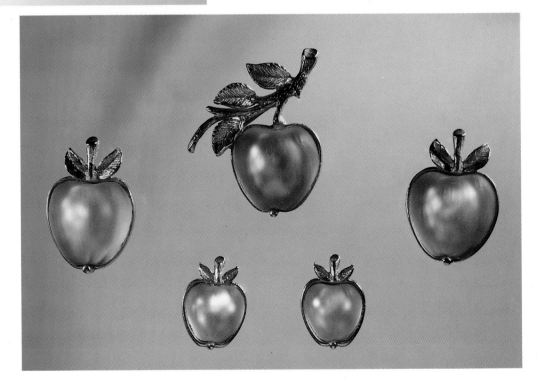

Two pairs of Delicious pearlized and gold metal earrings with matching brooch set. $125-150.

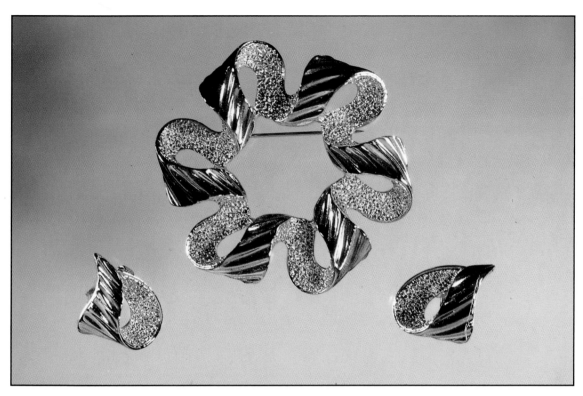

Gold metal Ribbonette set with brooch and earrings. $90-110.

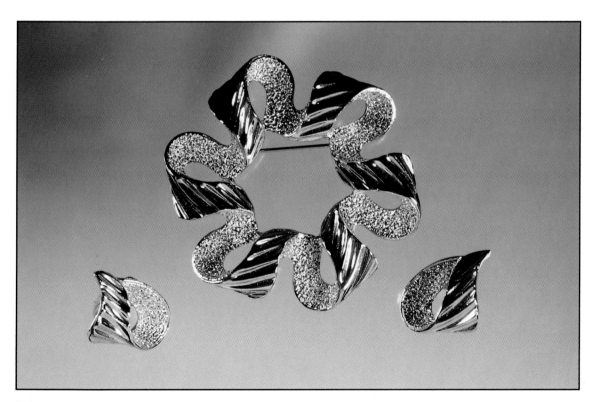

Rhodium Ribbonette set with brooch and earrings. $90-110.

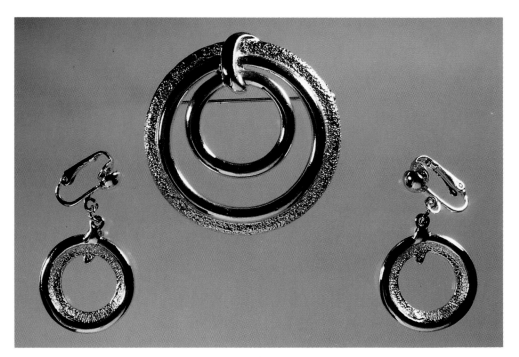

Rhodium Circlet brooch and
earrings set. $85-95.

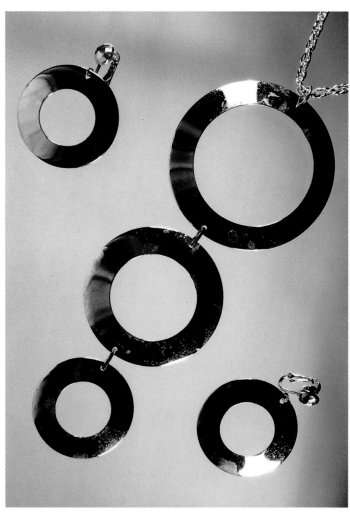

Wooded Beauty gold metal and plastic
leaf earrings and brooch set. $95-125.

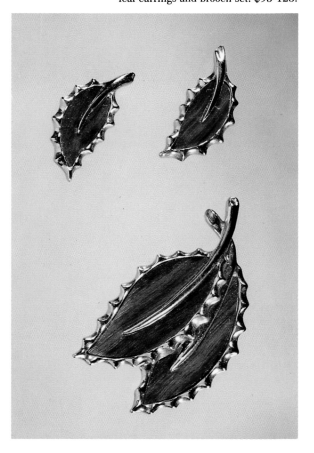

Mini-Midi-Maxi gold metal necklace and earrings set. $75-85.

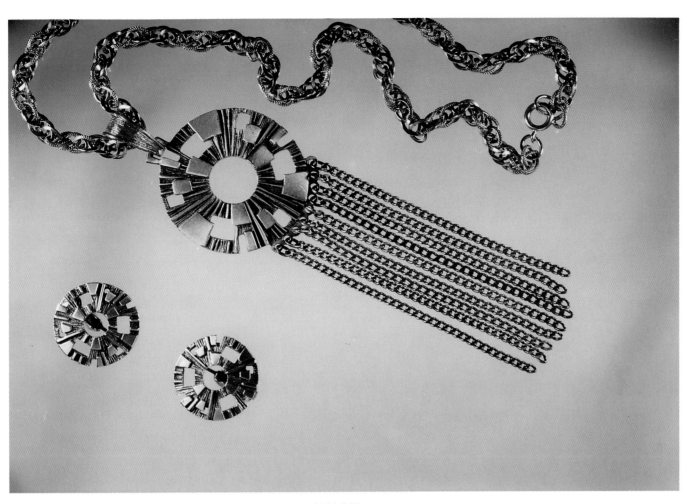

Pewter Spanish Moss set with necklace with tassels and earrings. $110-125.

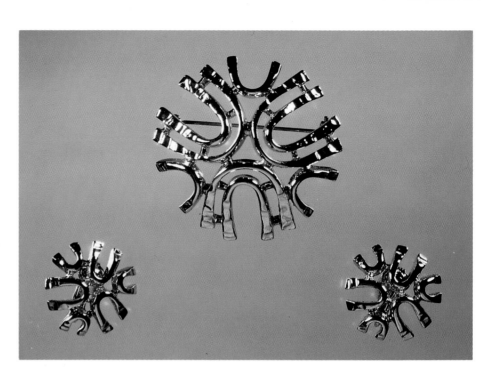

Gold metal Sea Sprite brooch
and earrings. $65-95.

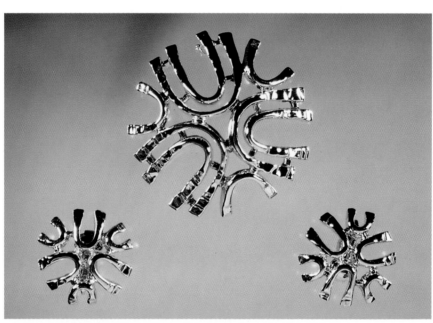

Rhodium Sea Sprite brooch and earrings.
$65-95.

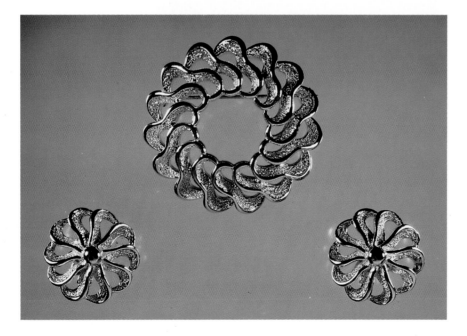

Rhodium Fashion Round earrings
and brooch. $60-90.

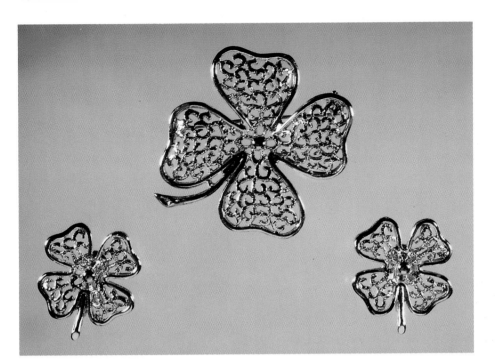

Gold metal Filigree Clover
earrings and brooch. $60-90.

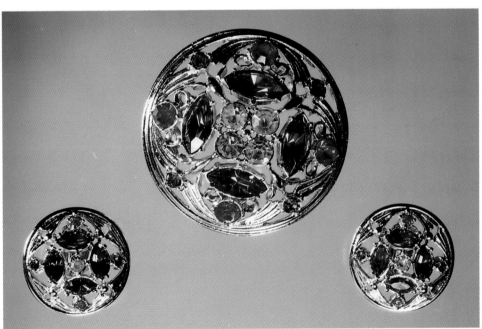

Rhodium and glass earrings and
brooch. $75-95.

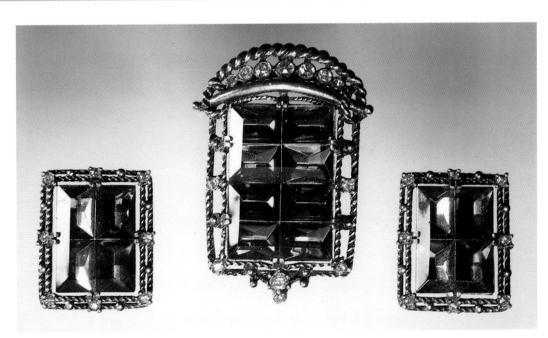

Rhodium Midnight Magic earrings and
brooch with smoke colored glass and
pink rhinestones. $80-90.

Gold metal and plastic set with earrings
and brooch with tassel. $75-95.

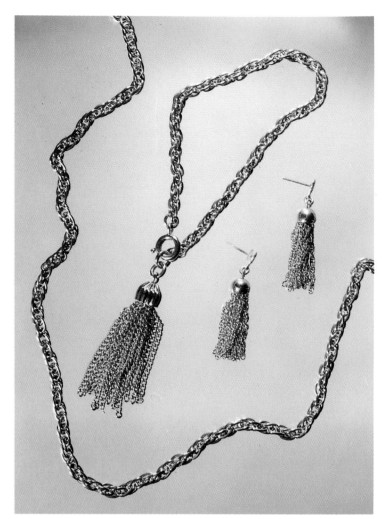

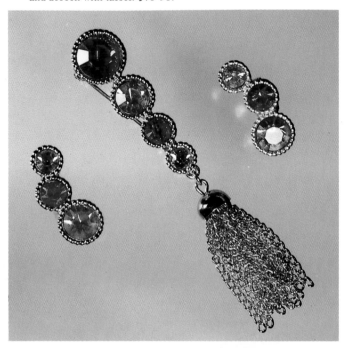

Golden Tassel set with gold metal
bracelet, pierced earrings, and 28-inch
chain. $95-125.

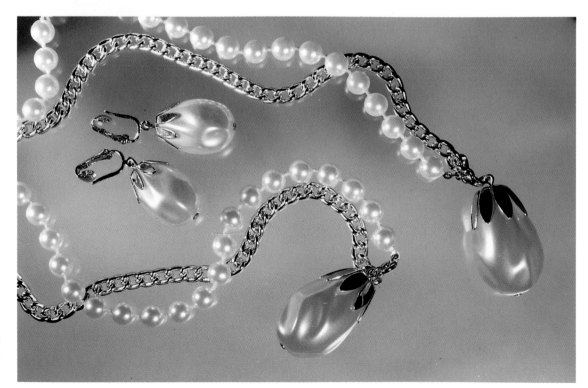

Rhodium On Stage
simulated pearl set with
clip-on earrings and 36-
inch belt. $95-115.

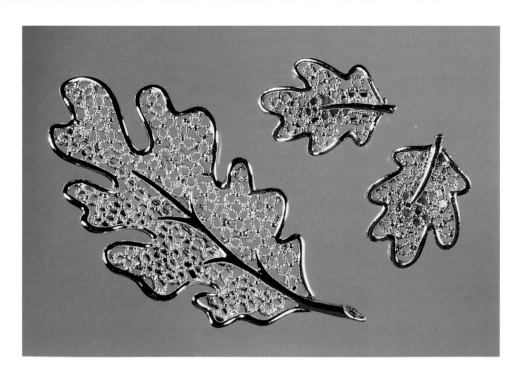

Rhodium brooch and clip-on earrings with filigree and leaf motif. $65-75.

Gold metal earrings and link bracelet with simulated pearls and genuine jade stones with leaf motif. $95-110.

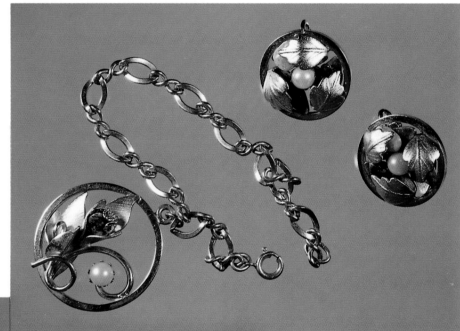

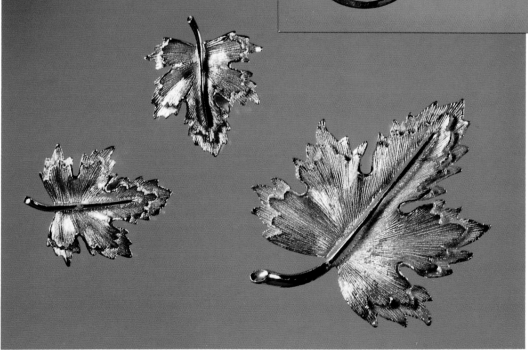

Leaf motif set with rhodium and gold metal clip-on earrings and brooch. $125-150.

RINGS

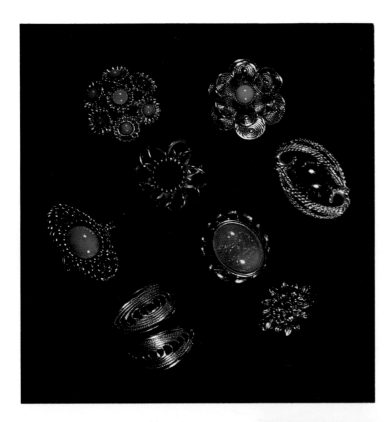

Gold metal Angel Pink ring with plastic "stone" surrounded by simulated seed pearls. *Courtesy of Kaye Crowe.* $35-45.

Top. Rhodium ring with floral motif. $35-45.
Upper left. Rhodium with black prong set faux onyx "stone." $45-55.
Upper center. Rhodium ring with iridescent blue plastic. $30-40.
Upper right. Silver metal ring. $25-35.
Lower left. Rhodium ring with plastic turquoise "stone." $35-45.
Lower center. Rhodium ring with faux onyx. $45-55.
Lower right. Rhodium ring with plastic "stone." $40-50.
Bottom. Gold metal ring with colored plastic "stones." $45-55.

Top left. Gold metal ring with faux topaz "stone." $55-65.
Top right. Satin Sand gold metal ring with two plastic cabochons. $45-55.
Center. Dazzler gold metal ring with faux topaz "stone." $45-55.
Bottom left. Space Age gold metal rhodium ring with simulated pearl. $45-55.
Bottom right. Saturn gold metal ring. $35-45.

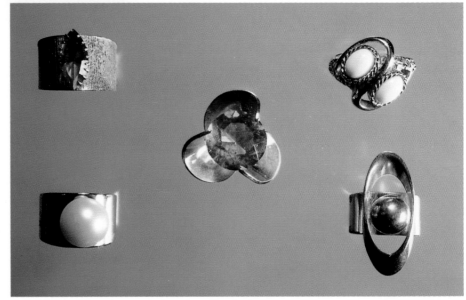

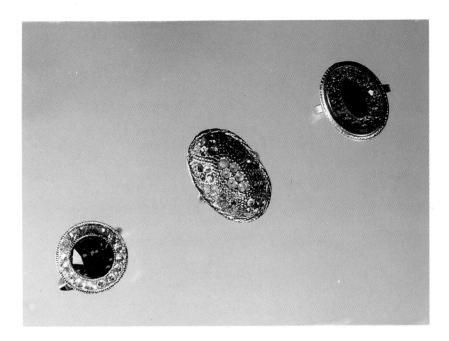

Left. Gold metal ring with faux onyx "stone." $35-45.
Center. Rhodium ring with plastic and glass "stones." $45-55.
Right. Rhodium ring with faux emerald and rhinestones. $25-35.
The rings are *Courtesy of Mary Ellen DeLaughter*.

Top. Gold metal ring with faux onyx "stone." $45-55.
Center left. Rhodium ring with faux onyx. $35-45.
Center. Rhodium birthstone ring with rhinestones and faux emeralds. $45-55.
Center right. Rhodium ring with rhinestones and faux sapphires. $55-65.
Lower center. Rhodium ring with faux amethyst. $35-45.
The rings are *Courtesy of Debbie and Wendy Page*.

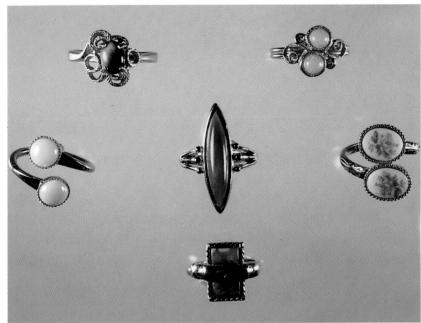

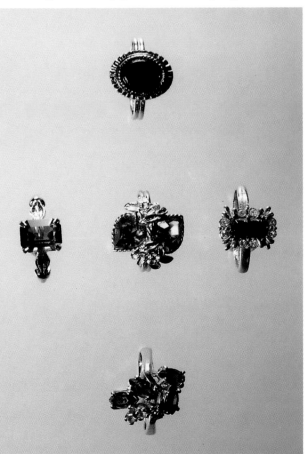

Top left. Gold metal ring with cinnamon colored plastic cabochon. $25-35.
Top right. Gold metal ring with two opals. $55-65.
Center left. Rhodium ring with two white plastic cabochons. $35-45.
Center. Gold metal ring with jade colored plastic "stone." $35-45.
Center right. Gold metal ring with floral design. $25-35.
Bottom center. Rhodium ring with green and blue plastic "stones." $35-45.
The rings are *Courtesy of Debbie and Wendy Page*.

Gold plated ring with glass "stone" and rhinestones. $55-65.

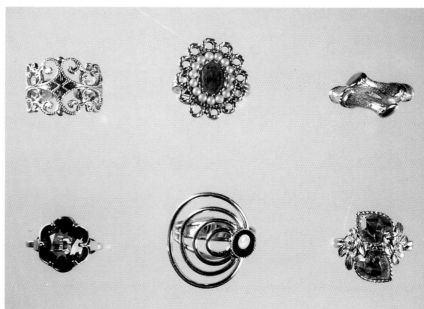

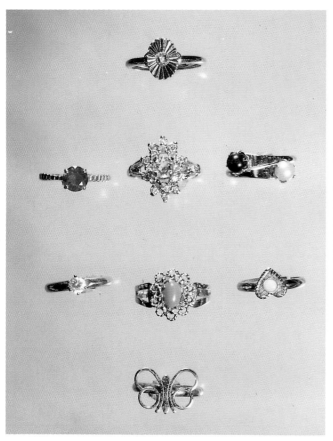

Top left. Rhodium mesh work ring. $35-45.
Top center. Adjustable gold metal ring with simulated pearls and faux ruby. $45-55.
Top right. Rhodium bamboo ring. $25-35.
Lower left. Rhodium ring with faux amethyst. $45-55.
Lower center. Adjustable rhodium ring with faux onyx. $35-55.
Lower right. Rhodium birthstone ring with rhinestones and faux ruby. $55-65.
The rings are *Courtesy of Phyllis Sparks*.

Top left. Gold metal ring with colored stones, rhinestones, and faux opals. $55-65.
Top right. Rhodium ring with iridescent plastic. $30-40.
Center. Rhodium ring with faux onyx. $55-65.
Lower left. Gold metal ring with rhinestones. $45-65.
Lower right. Rhodium ring with rhinestones. $45-65.
The rings are *Courtesy of Debbie and Wendy Page*.

Top. Gold metal ring with glass center. $35-45.
Upper left. Gold metal ring with faux ruby stone. $35-45.
Upper center. Gold metal ring with rhinestones. $55-65.
Upper right. Rhodium ring with black and white simulated pearls. $45-55.
Lower left. Rhodium ring with rhinestone. $35-45.
Lower center. Rhodium ring with turquoise plastic "stone." $45-55.
Lower right. Gold metal heart shaped ring with faux opal. $55-65.
Lower center. Rhodium ring with butterfly motif. $25-35.
The rings are *Courtesy of Jessica J. Gordon*.

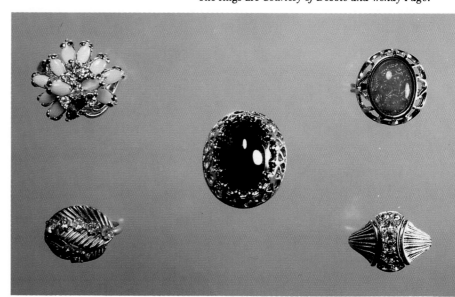

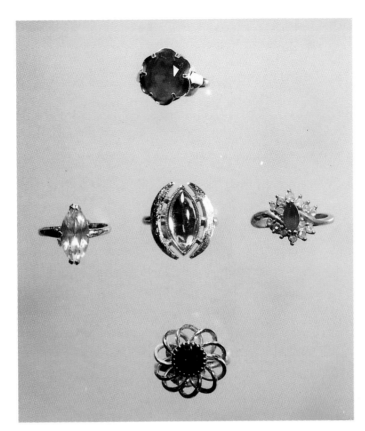

Top. Sterling silver birthstone ring with imported glass ruby. $55-65.
Left. Rhodium ring with glass. $45-55.
Center. Rhodium ring with faux amethyst. $55-65.
Right. Gold metal ring with faux ruby and rhinestones. $45-55.
Bottom. Rhodium ring with faux onyx. $45-55.
The rings are *Courtesy of Jessica J. Gordon*.

Top. Gold metal ring with pink plastic cabochon. $35-45.
Center left. Gold metal ring with rhinestones and two faux onyx "stones." $55-65.
Center. Rhodium ring with prong set turquoise plastic "stone." $45-55.
Center right. Gold metal ring with rhinestones and faux onyx "stone." $55-65.
Lower center. Gold metal ring with blue plastic cabochon. $35-45.
The rings are *Courtesy of Jessica J. Gordon*.

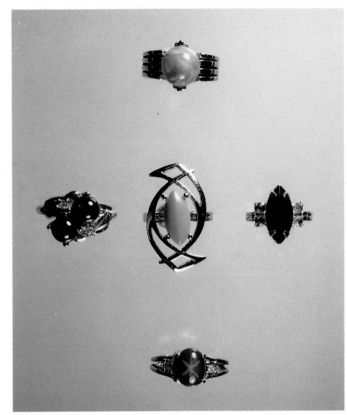

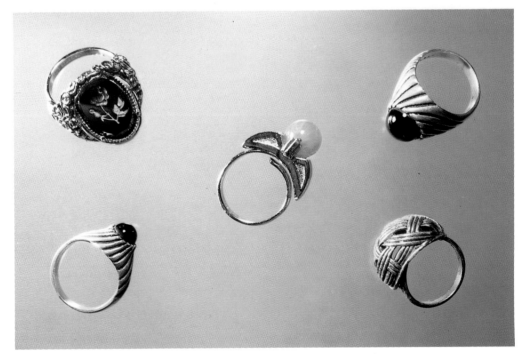

Top left. Rhodium ring with intaglio depicting floral motif. The top flips to reveal turquoise and glass underneath. $75-85.
Top right. Sterling silver ring with large onyx cabochon. $65-75.
Center. Rhodium ring with pink plastic. $35-45.
Bottom left. Sterling silver rhodium ring with small onyx cabochon. $45-55.
Bottom right. Golden Weave gold metal ring with criss cross design. $35-45.

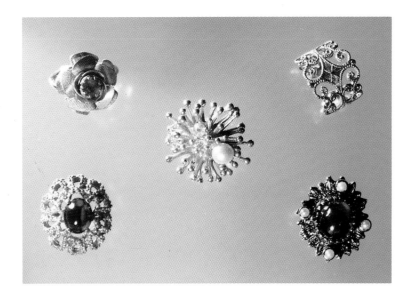

Top left. Rosette gold metal ring with faux ruby. $45-55.
Top right. Golden Lace gold metal ring. $35-45.
Center. Sea Treasure gold metal ring with simulated pearl and crystal. $45-55.
Bottom left. Crimson Lites gold metal ring with faux ruby cabochon. $55-65.
Bottom right. Ring with faux amethyst and four seed pearls. $45-55.

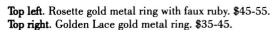

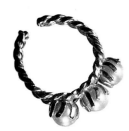
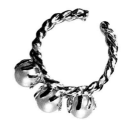

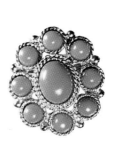
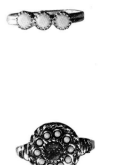
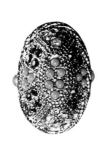

Left. Blue Sun rhodium ring with plastic and glass stones. $45-55.
Top center. Gold metal ring with faux ruby and turquoise plastic stones. $35-45.
Bottom center. Gold metal ring with turquoise plastic stones. $25-35.
Right. Shangri-La gold metal ring with turquoise plastic cabochons. $45-55.

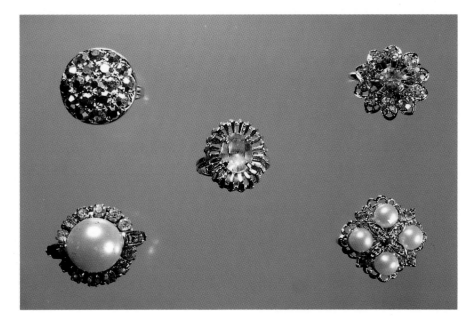

Top left. Trio ring with gold metal and three prong set simulated pearls. $45-55.
Top right. Trio ring with rhodium and three prong set simulated pearls. $45-55.
Center. Day and Night rhodium ring with simulated pearl and black simulated pearl. $35-45.
Bottom left. Rhodium ring with simulated pearl and clear stones. $45-55.
Bottom right. Gold metal ring with twisted rope effect and simulated pearl. $45-55.

Top left. Sparkle Mountain round rhodium ring with rhinestones. $55-65.
Top right. Symphony rhodium ring with rhinestones. $45-55.
Center. Rhodium ring with prong set faux sapphire. $45-55.
Bottom left. Rhodium ring with simulated pearl surrounded by clear stones. $55-65.
Bottom right. Camelot rhodium ring with four simulated pearls and clear stones. $65-75.

Chapter Four

EARRINGS

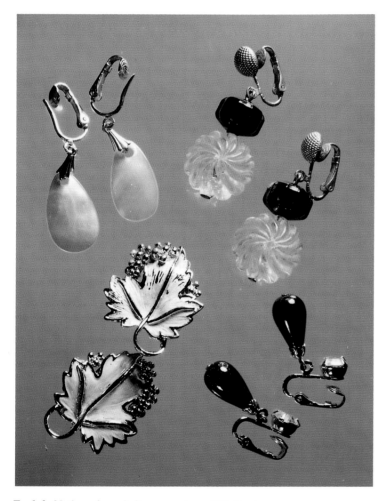

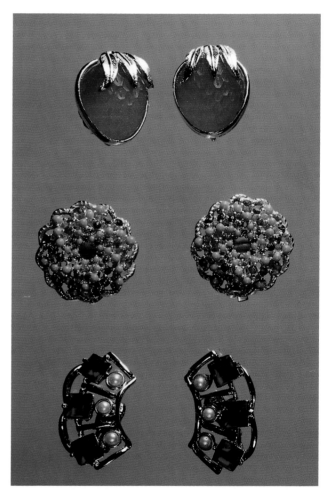

Top left. Mother-of-pearl clip-on earrings. $35-45.
Top right. Plastic dangle clip-on earrings. $25-35.
Bottom left. Enameled rhodium clip-on earrings with leaf motif. $35-45.
Bottom right. Hematite and rhinestone clip-on earrings. $45-55.

Top. Gold metal and plastic clip-on strawberry earrings. $25-35.
Center. Gold metal clip-on earrings with colored plastic "stones." $35-45.
Bottom. Gold metal clip-on earrings with faceted faux rubies and simulated pearls. $45-55.

Gold metal drop earrings with black glass. $45-55.

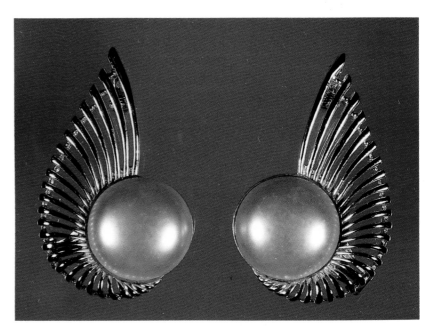

Simulated pearl and gold metal clip-on earrings. $95-125.

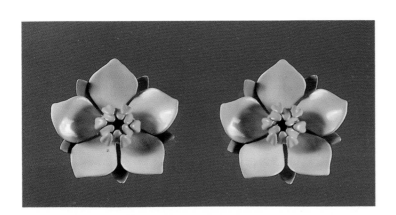

Clip-on enameled green, white, and yellow floral metal earrings. $45-55.

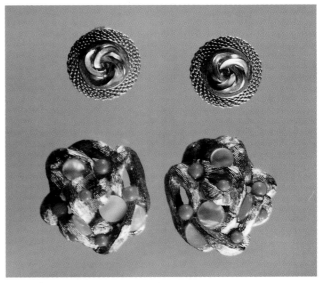

Top. Gold metal circular clip-on earrings. $45-65.
Bottom. Gold metal clip-on earrings with red plastic balls and mother-of-pearl stones. $45-55.

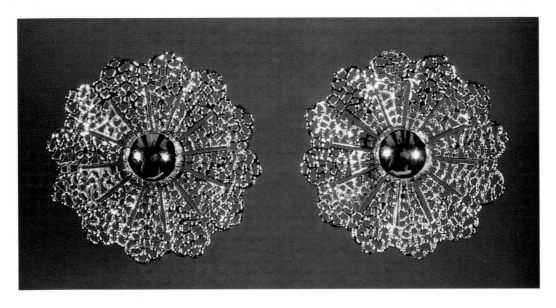

Rhodium clip-on earrings. $45-55.

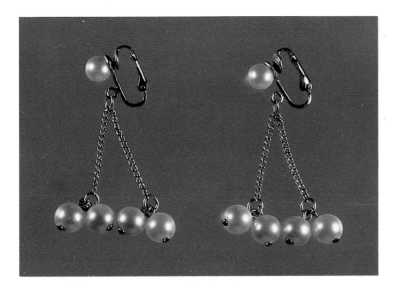

Clip-on drop earrings with simulated pearls. $55-65.

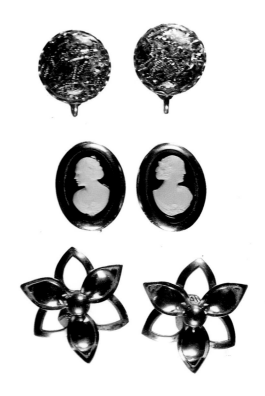

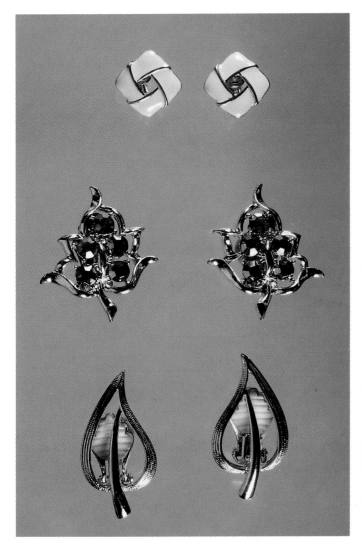

Top. Metal multicolored clip-on earrings. $35-45.
Center. White on black plastic cameo earrings depicting woman's portrait. $75-95.
Bottom. Gold metal floral earrings. $45-55.

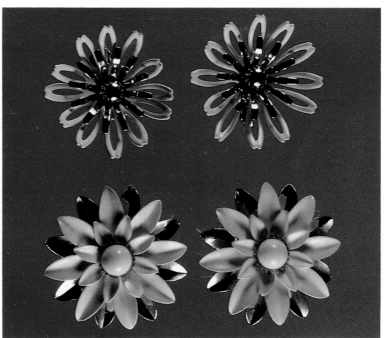

Top. Gold metal and white enameled earrings. $35-45.
Center. Rhodium earrings with faux amethyst "stones." $55-75.
Bottom. Rhodium leaf clip-on earrings. $35-45.
The jewelry is *Courtesy of Kenneth L. Surratt, Jr.*

Top. Rhodium and enameled silver and white clip-on earrings. $45-65.
Bottom. Rhodium and enameled earrings with white and silver colored petals and white plastic balls at center. $55-75.

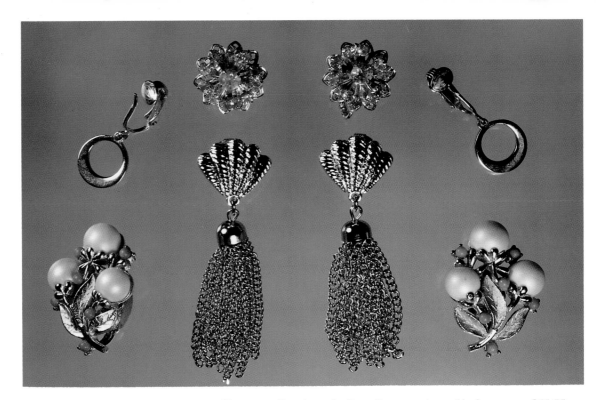

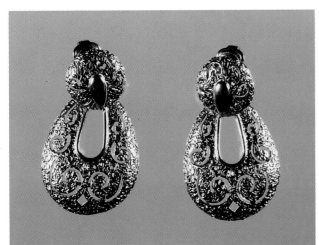

Top center. Symphony rhodium clip-on earrings with clear stones. $55-75.
Top left and **right**. Gold metal clip-on earrings. $45-65.
Center. Rhodium clip-on earrings with tassels. $55-75.
Bottom left and **right**. Rhodium earrings with simulated pearls and turquoise plastic "stones." $65-75.

Rhodium clip-on earrings. *Courtesy of Kenneth L. Surratt, Jr.* $60-70.

Top. Rhodium hoop earrings. $30-40.
Left and **right**. Rhodium pierced earrings with plastic faux lapis stones. $65-85.
Lower left and **right**. Rhodium pierced earrings. $40-50.
The earrings are *Courtesy of Mary Ellen DeLaughter*.

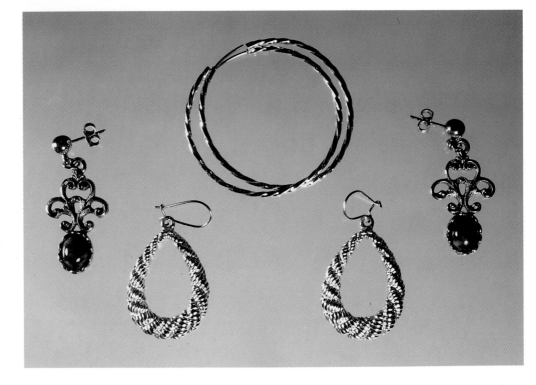

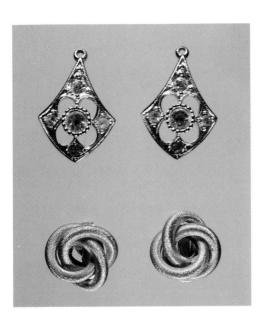

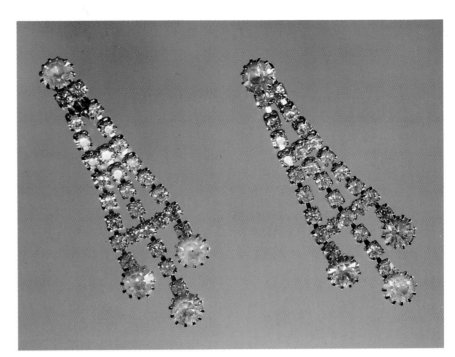

Top. Rhodium earrings with rhinestones. $45-55.
Bottom. Gold metal earrings. $35-55.
The earrings are *Courtesy of Mary Ellen DeLaughter*.

Top. Northern Lights rhodium clip-on earrings. $45-65.
Center. Gold metal clip-on earrings. $55-75.
Bottom. Florentine rhodium clip-on earrings. $45-65.
The earrings are *Courtesy of Phyllis Sparks*.

Gold metal dangle earrings with rhinestones.
Courtesy of Marshall A. Gordon. $95-125.

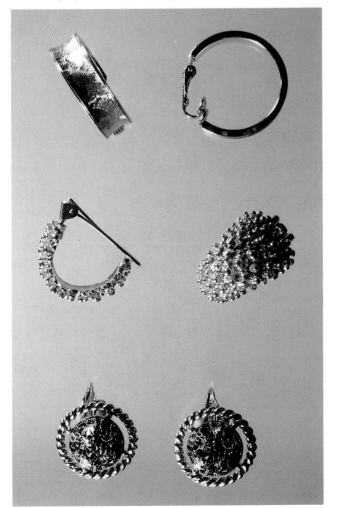

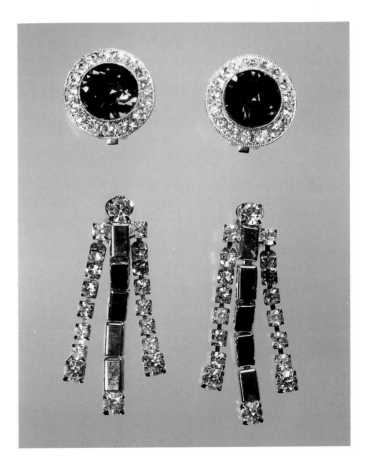

Top. Royal Velvet rhodium clip-on earrings with rhinestones and faux amethyst "stones." $75-95.
Bottom. Golden Ice gold metal and rhinestone dangle earrings. $75-95.
The earrings are *Courtesy of Phyllis Sparks*.

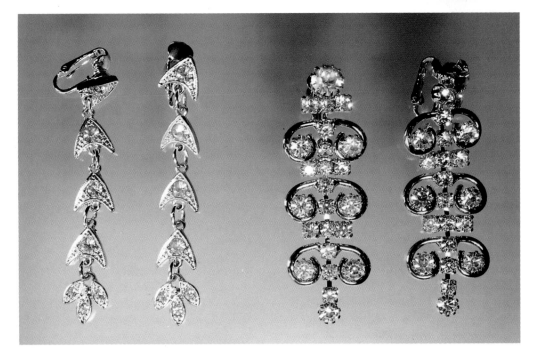

Left. New York rhodium and rhinestone clip-on dangle earrings. $75-95.
Right. Gold metal clip-on earrings with prong set rhinestones. $95-125.

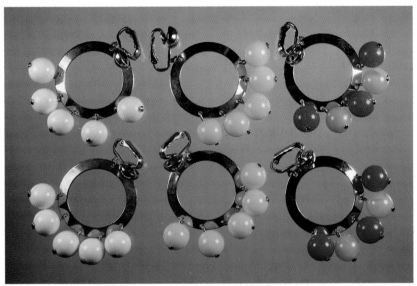

Three pairs of Carnival clip-on gold metal earrings with white, yellow, and pink plastic beads. $35-45 for each pair.

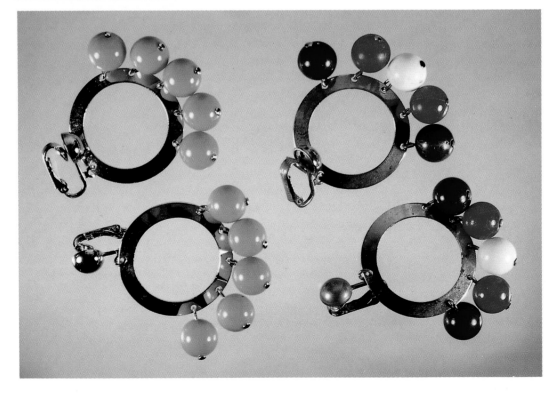

Two pairs of Carnival clip-on gold metal earrings with azure and red, white, and blue plastic beads. $35-45 for each pair.

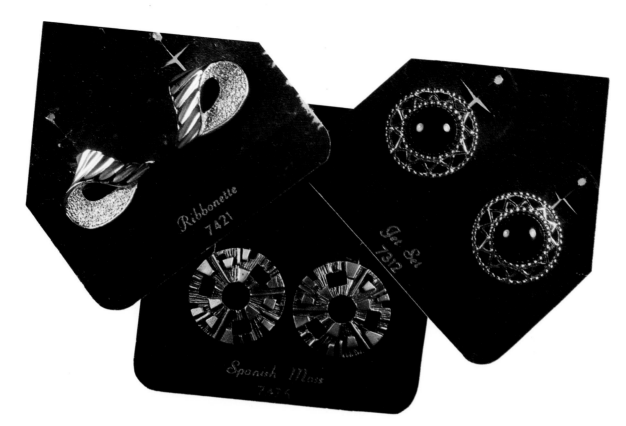

Left. 1-inch pair of rhodium Ribbonette earrings. $35-45.
Center. 1.25-inch pair of rhodium Spanish Moss earrings.
$35-45.
Right. 1-inch pair of Get Set rhodium earrings with faux onyx
stones. $45-55.

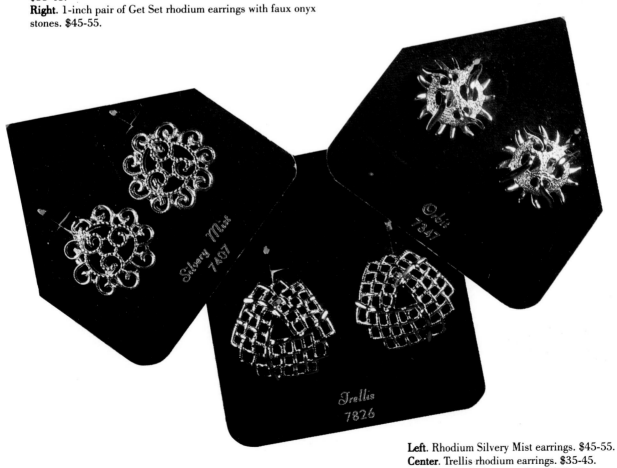

Left. Rhodium Silvery Mist earrings. $45-55.
Center. Trellis rhodium earrings. $35-45.
Right. Orbit rhodium earrings. $35-45.

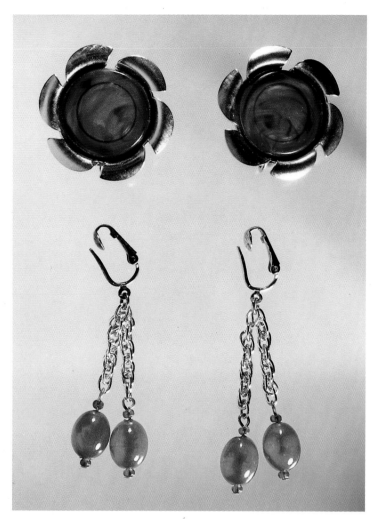

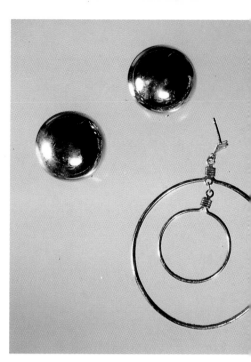

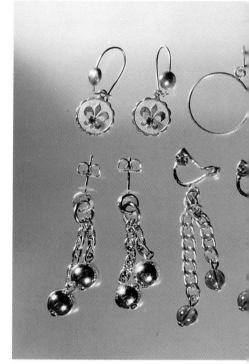

Top. Faux amber earrings with gold metal frames. $45-55.
Bottom. Americana gold metal clip-on dangle earrings with plastic beads. $25-35.

Top left. Clip-on Wisteria dangle earrings with plastic. $45-55.
Top center. Ember Time pierced dangle earrings with gold metal and faux amber "stones." $35-45.
Top right. Dangle earrings with amethyst "stones." $55-65.
Bottom center. Austrian Lites gold metal earrings with plastic. $55-65.

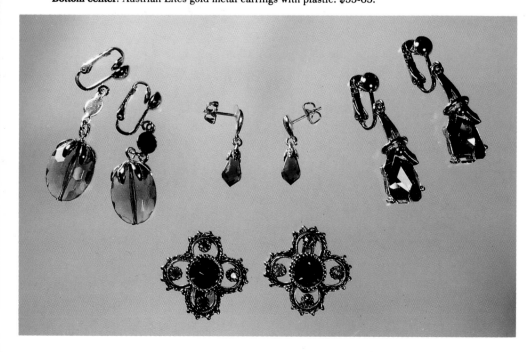

Left:
Left. Casual Classic gold metal earrings. $35-45.
Center. Gold metal Hoop La earrings. $35-45.
Right. Gold metal earrings with faceted and prong set amethyst stones. $55-65.

Center left:
Top left. Gold metal Fleur de Lis pierced earrings. $35-45.
Top center. Gold metal Golden Hoop pierced earrings. $25-35.
Top right. Coin Trio gold metal pierced earrings. $35-45.
Bottom left. Ball & Chain rhodium pierced earrings. $25-35.
Bottom center left. Ember Chains gold metal earrings with faux amber. $35-45.
Bottom center right. One gold metal dangle earring (matching earring is missing). $35-45 for pair.
Bottom right. Ball & Chain gold metal pierced dangle earrings. $25-35.

Bottom left:
Left. Gold metal and simulated pearl Caged Pearl clip-on earrings. $45-55.
Top center. Rhodium and simulated pearl Button Pearl clip-on earrings. $35-45.
Right. Rhodium and simulated pearl Caged Pearl clip-on earrings. $45-55.
Bottom center. Chain Ability rhodium and simulated pearl pierced earrings. $35-45

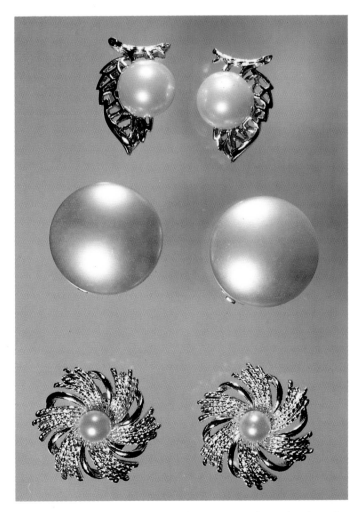

Top. Simulated pearl and rhodium earrings with small simulated pearls. $45-55.
Center. Bold Button Pearl clip-on earrings with simulated pearls. $35-45.
Bottom. Simulated pearl and rhodium clip-on earrings with medium size stimulated pearls. $45-55.

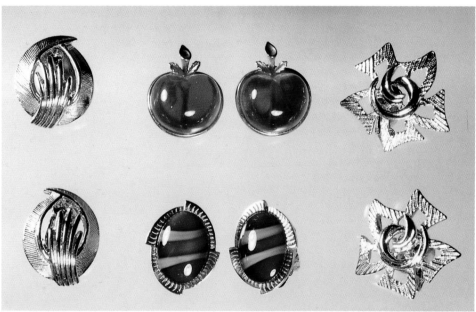

Left. Gold metal earrings with turquoise and amber colored plastic cabochons. $55-65.

Center. Angel Pink gold metal earrings with green, pink, and yellow plastic cabochons. $45-55.

Right. Aztec earrings with rhodium and turquoise plastic cabochons. $55-65.

Left. Flair gold metal clip-on earrings. $45-55.
Top center. Burgundy pink plastic apple shaped clip-on earrings. $35-45.
Bottom center. Carameltone gold metal clip-on earrings with genuine agate stones. $95-125.
Right. Oriental rhodium earrings with circular design in center. $55-65.

Left. Florentine gold metal clip-on earrings. $45-65.
Right. Florentine rhodium clip-on earrings. $45-65.

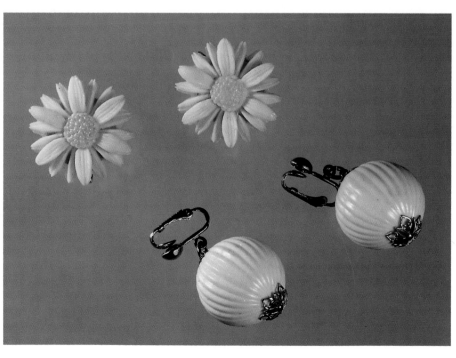

Top. Clip-on plastic earrings with floral motif. $25-35.
Bottom. Plastic clip-on ball earrings. $25-35.

Chapter Five

BROOCHES

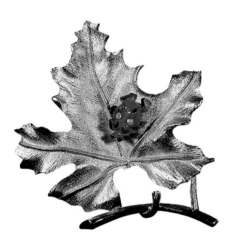

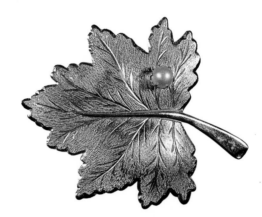

Left. Gold metal leaf brooch with plastic red ladybug and small clear "stones." $65-75.
Right. Gold metal leaf brooch with simulated pearl. $75-85.

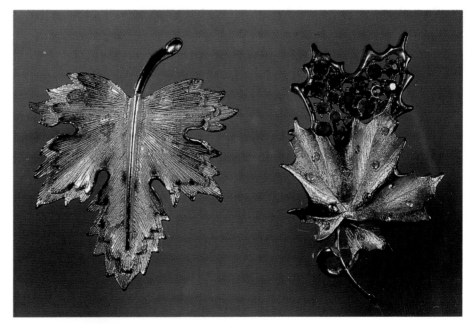

Left. Gold metal and rhodium leaf brooch. $65-75.
Right. Gold metal leaf brooch with rhinestones and faux amethyst "stones." $75-85.

Left. Rhodium and enameled metal shell brooch. $45-55.
Right. Gold metal starfish brooch with plastic and simulated seed pearls. $65-75.

Pair of wreath shaped rhodium brooches with simulated pearl balls and turquoise plastic beads. $95-125 for the pair.

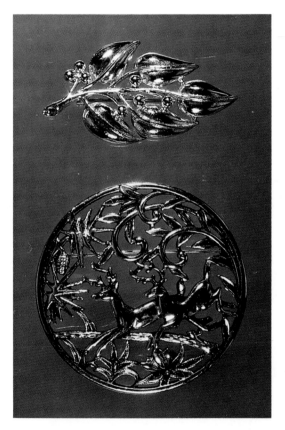

Top. Rhodium brooch with leaf motif. $45-55.
Bottom. Round rhodium brooch with deer motif. $75-95.

Left. Silver metal brooch with rhinestones in flower motif. $35-45.
Center. Floral silver metal brooch with clear stones and faux ruby "stone" in center. $65-75.
Right. Brooch with rhinestones and faux onyx "stone." $45-55.

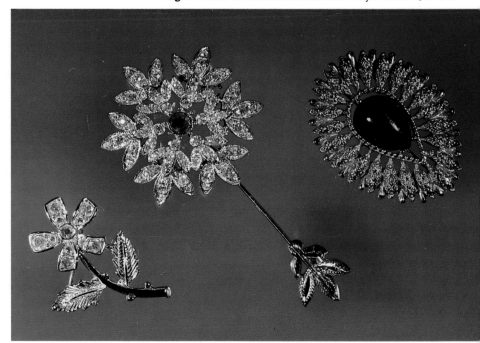

Top left. Circular gold metal brooch. $25-35.
Top right. Gold metal leaf motif brooch. $25-35.
Bottom left. Gold metal leaf brooch. $25-35.
Center right. Gold metal, plastic, and simulated pearl brooch. $35-45.
Bottom right. Gold metal floral brooch. $35-45.

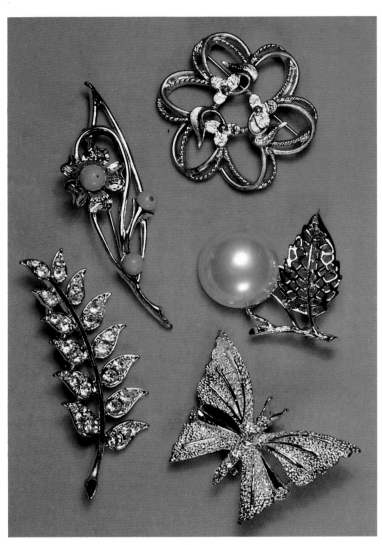

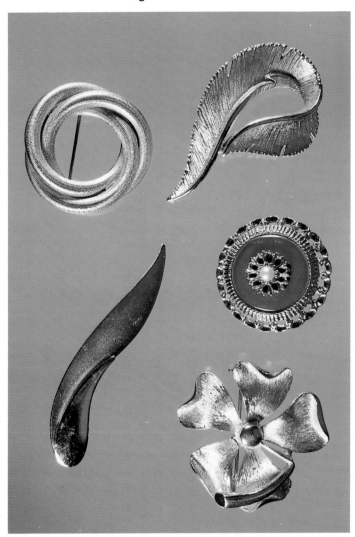

Top. Rhodium and rhinestone floral motif brooch. $45-55.
Center left. Rhodium floral brooch with rhinestones and turquoise plastic "stones." $45-55.
Center right. Rhodium and simulated pearl brooch. $35-45.
Bottom left. Rhodium and rhinestone leaf brooch. $55-65.
Bottom right. Rhodium and rhinestone butterfly brooch. $45-55.

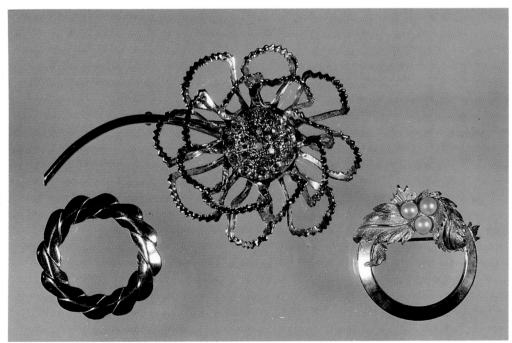

Top. Gold metal flower brooch with aurora borealis stones in center. $75-95.
Bottom left. Circular gold metal brooch. $25-35.
Right. Gold metal brooch with simulated pearls. $45-55.

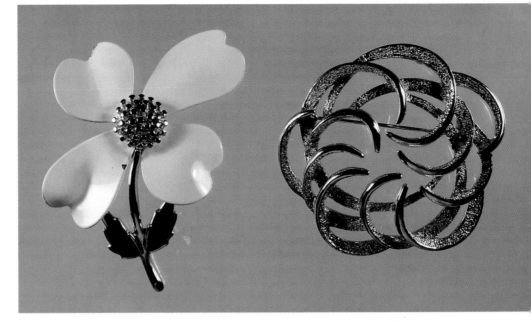

Left. Gold metal and enameled floral brooch with gold metal balls at center. $55-65.
Right. Gold metal swirl brooch. $75-85. The brooches are *Courtesy of Mary G. Moon.*

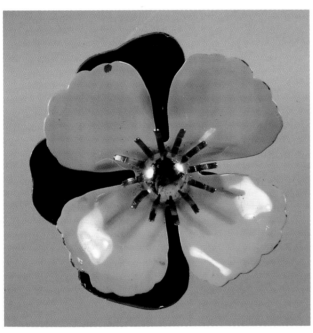

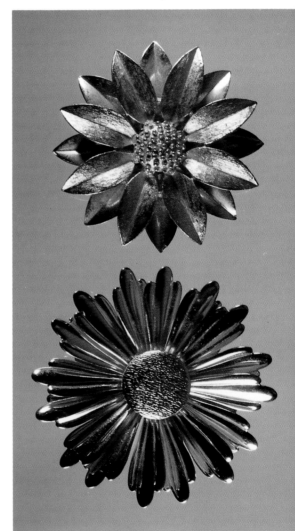

Left: Gold metal and enameled flower brooch. $65-75.

Left. Silver metal brooch with rhodium and enameled white petals (white plastic ball is missing from center). $35-45 as is.
Right. Gold metal brooch with white enameled metal petals. $55-65.

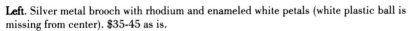

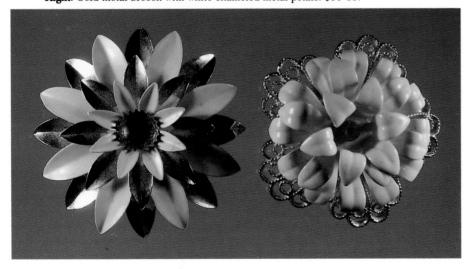

Top. Gold metal floral brooch with gold metal balls at center. $65-75.
Bottom. Gold metal floral motif brooch. $75-85.

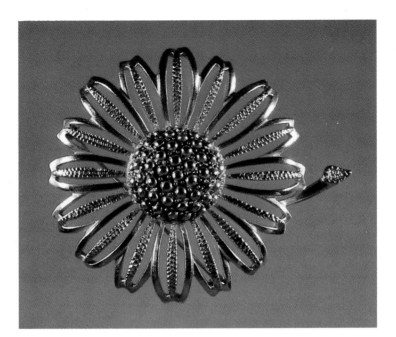

Gold metal floral brooch. $55-65.

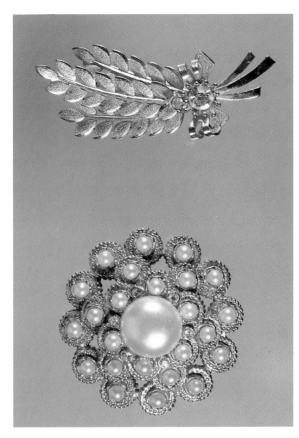

Top. Gold metal brooch with gold colored leaves and
clear "stone." $65-75.
Bottom. Gold metal brooch with simulated pearls and
clear "stones." $75-85.
The jewelry is *Courtesy of Kenneth L. Surratt, Jr.*

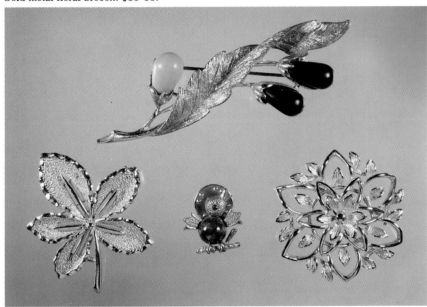

Top. Gold metal brooch in leaf design with
orange and black plastic cabochons. $65-85.
Bottom left. Joy rhodium leaf brooch. $35-45.
Bottom center. Tie tac bird with red plastic
"stone" eye and faux lapis "stone." $20-30.
Bottom right. Gold metal leaf design brooch.
$45-55.
The jewelry is *Courtesy of Kenneth L. Surratt,
Jr.*

Left. Rhodium apple brooch. $45-55.
Right. Rhodium strawberry brooch. $45-55.
The jewelry is *Courtesy of Kenneth L. Surratt, Jr.*

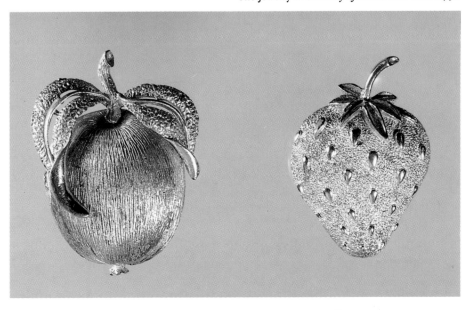

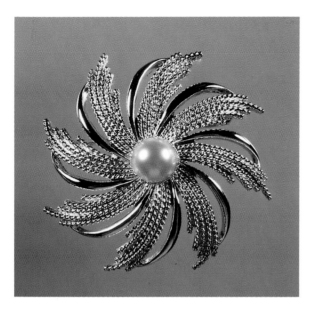

Rhodium swirl brooch with simulated pearl center. $65-75.

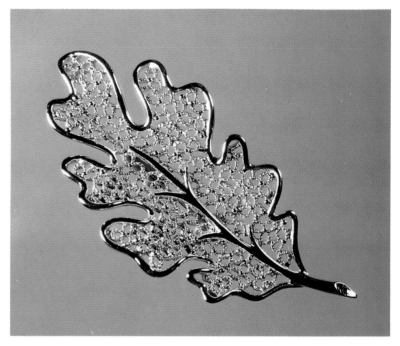

Rhodium leaf brooch with filigree work. $45-55.

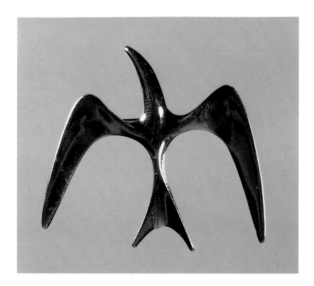

Gold metal bird brooch. $45-55.

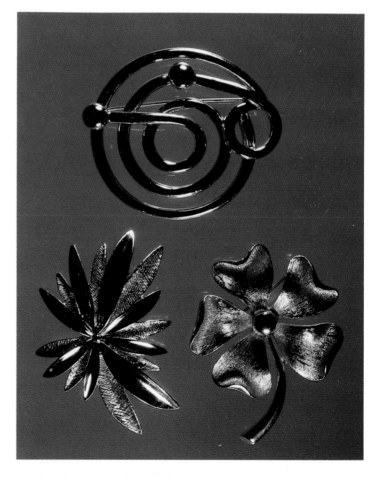

Top. Circular gold metal brooch. $35-45.
Bottom left. Rhodium flower brooch. $45-55.
Bottom right. Gold metal flower brooch with gold metal ball at center. $45-55.

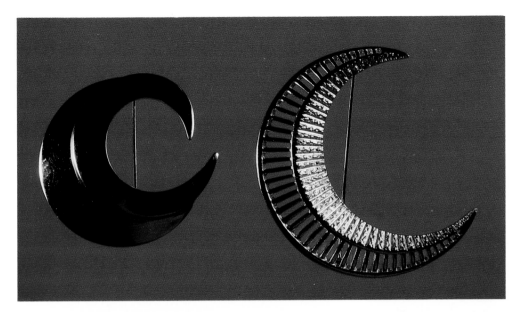

Left. Rhodium crescent shaped brooch. $35-45.
Right. Gold metal crescent shaped brooch. $40-50.

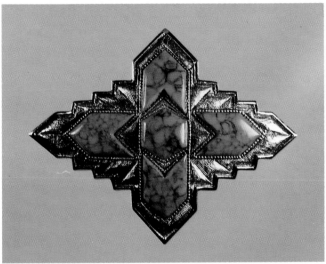

Rhodium cross brooch with faux turquoise pieces. $65-75.

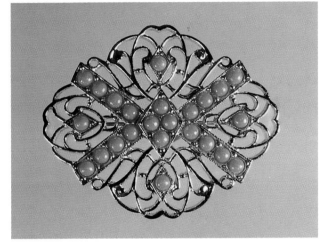

Gold metal brooch with orange plastic beads. $65-85.

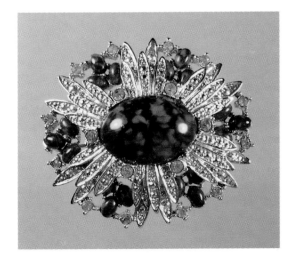

Anniversary rhodium brooch with iridescent blue plastic "stones" and clear "stones." $85-95.

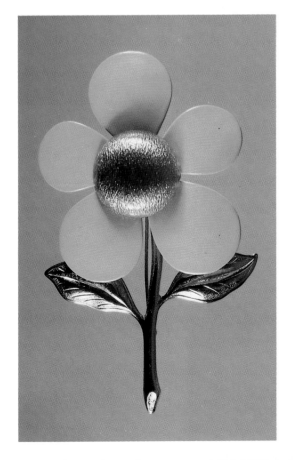

Gold metal flower brooch with plastic yellow petals. $45-55.

Fashion in Motion rhodium brooch with
4-inch tassels and metal balls. *Courtesy
of Wanda Goodmon.* $55-65.

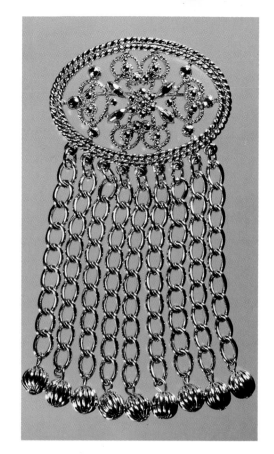

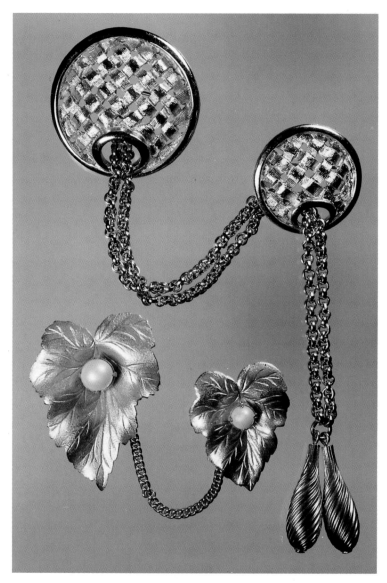

Top. Gold metal 9-inch chatelaine with criss cross design. $45-55.
Bottom. Gold metal 5-inch chatelaine with simulated pearls. $65-75.
The chatelaines are *Courtesy of Wanda Goodmon.*

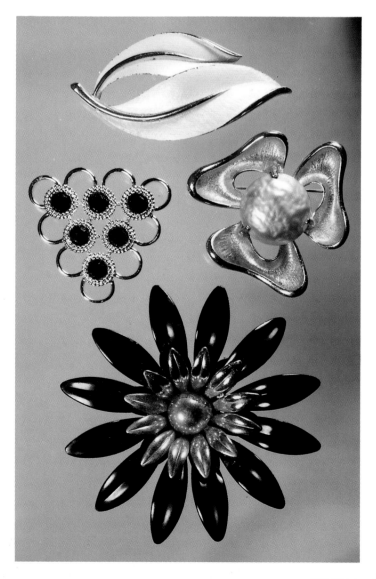

Top. Gold metal with white enameled
leaf brooch, 2.75". $45-55.
Center left. Rhodium brooch with faux
onyx cabochons, 1.75". $35-45.
Center right. Gold metal brooch with
pearlized center, 2". $35-45.
Bottom. Black flower with gold metal
center and gold metal and enameled
petals, 3". $35-45.

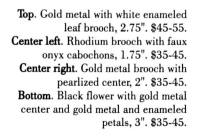

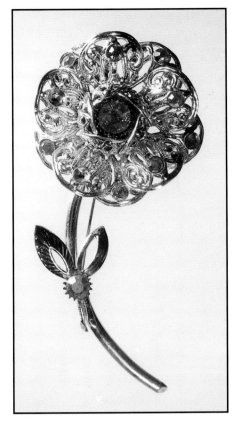

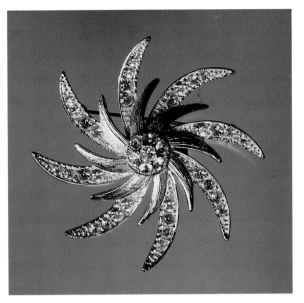

Rhodium swirl brooch with rhinestones. $75-95.

Gold metal flower brooch with faux ruby and faux topaz "stones." *Courtesy of Mary Liles.* $55-65.

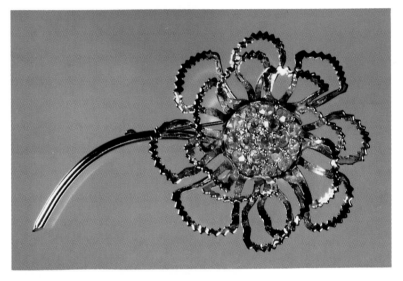

Gold metal flower brooch with aurora borealis stones. *Courtesy of Kenneth L. Surratt, Jr.* $65-75.

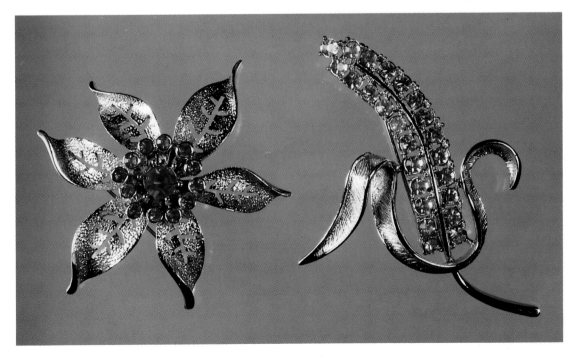

Left. Gold metal leaf brooch with rose zircon stones and gold metal balls at center. $65-75. **Right**. Radiance gold metal brooch with clear stones. $75-85. The brooches are *Courtesy of Kenneth L. Surratt, Jr.*

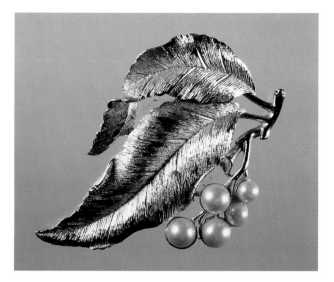

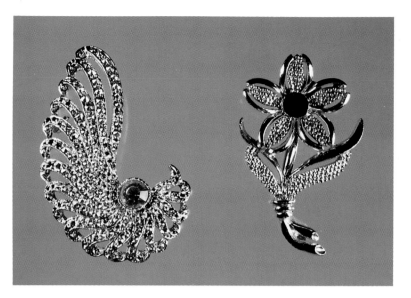

Rhodium leaf shaped pin with simulated pearls. *Courtesy of Mary Ellen DeLaughter*. $85-95.

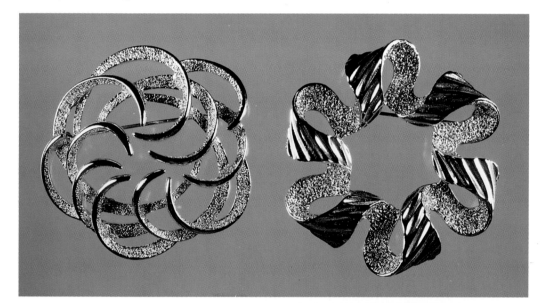

Left. Rhodium brooch with clear stone. $45-55.
Right. Rhodium flower brooch with faux onyx stone at center. $35-45.
The brooches are *Courtesy of Kenneth L. Surratt, Jr.*

Left. Ribbonette rhodium brooch. $45-55.
Right. Rhodium swirl brooch. $50-60.
The brooches are *Courtesy of Kenneth L. Surratt, Jr.*

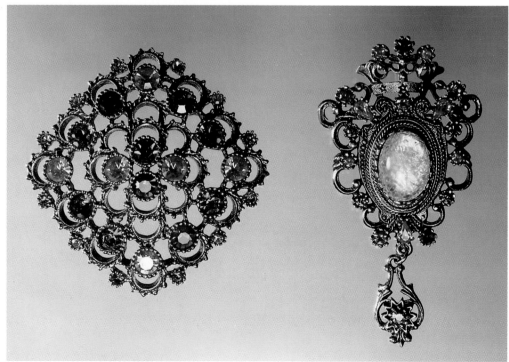

Left. Gold metal brooch with colored glass stones. $55-65.
Right. Gold metal brooch with colored glass stones and opalescent stone. $95-125.
The brooches are *Courtesy of Sarah Newton*.

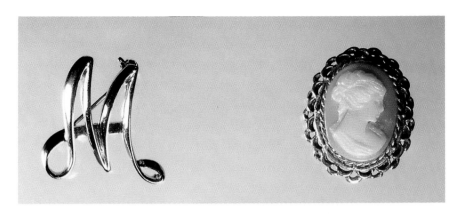

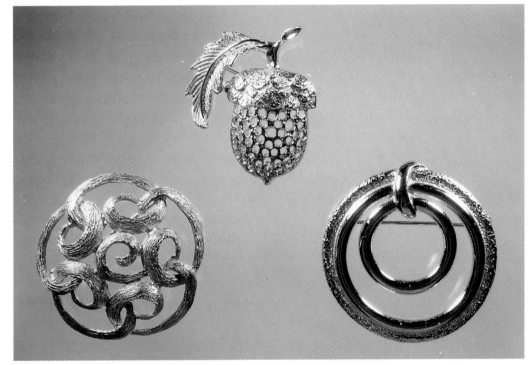

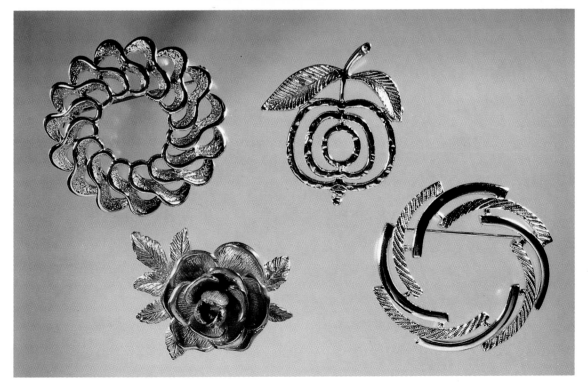

Left. "M" initial brooch. $25-35.
Right. Plastic cameo brooch depicting portrait of woman. $55-65.
The jewelry is *Courtesy of Debbie Page*.

Left. Gold metal brooch. $45-65.
Center. Gold metal acorn brooch. $55-65.
Right. Circular rhodium brooch. $45-55.
The jewelry is *Courtesy of Phyllis Sparks*.

Top left. Fashion Round gold metal brooch. $45-55.
Top right. Rhodium apple brooch. $25-35.
Lower left. Gold metal rose brooch. $55-65.
Lower right. Silvery Swirl rhodium brooch. $50-60.

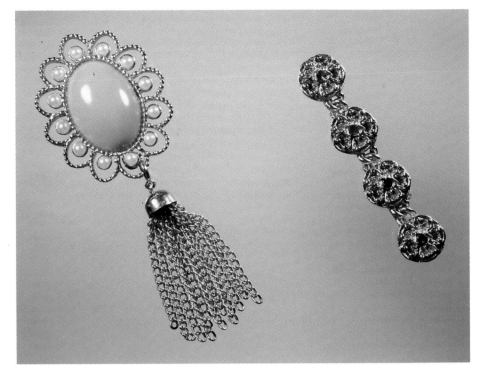

Left. Gold metal brooch with simulated pearls, plastic turquoise "stone," and tassel. $65-85.
Right. Gold metal bar brooch with colored plastic "stones." $55-65.
The jewelry is *Courtesy of Phyllis Sparks*.

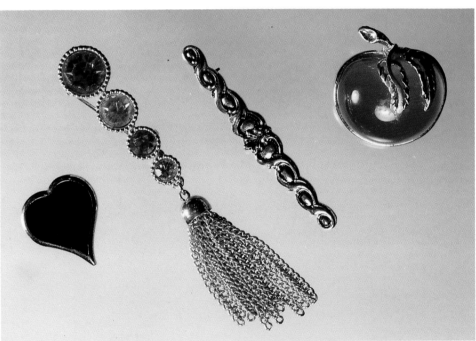

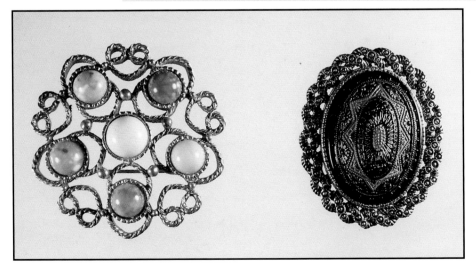

Above:
Left. Heart shaped gold metal and faux onyx brooch. $30-40.
Center left. Gold metal brooch with glass stones and tassel. $45-55.
Center right. Gold metal bar brooch. $35-45.
Right. Gold metal and plastic apple brooch. $25-35.
The jewelry is *Courtesy of Mary Ellen DeLaughter.*

Left:
Left. Gold metal brooch with plastic. $65-75.
Right. Gold metal enameled brooch. $55-65.
The jewelry is *Courtesy of Mary Ellen DeLaughter*

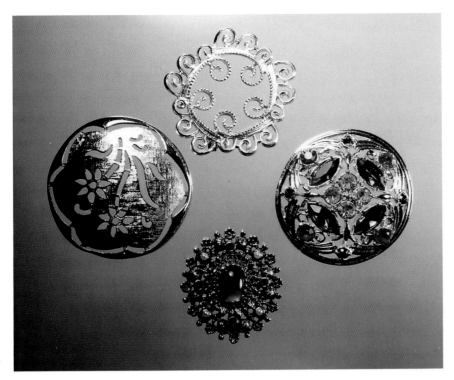

Top. Rhodium pin. $25-35.
Center left. Rhodium pin with flower design. $35-45.
Center right. Rhodium pin with glass stones. $65-75.
Bottom. Catherine rhodium pin with simulated pearls and faux amethyst stone. $65-75.
The jewelry is *Courtesy of Mary Ellen DeLaughter*.

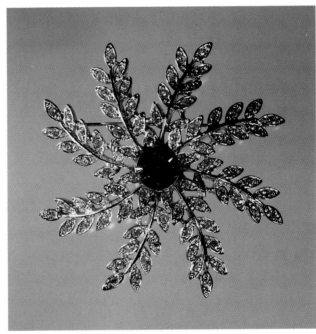

Snowflake brooch with rhodium, rhinestones, and smoky colored glass at center. *Courtesy of Mary Ellen DeLaughter.* $95-125.

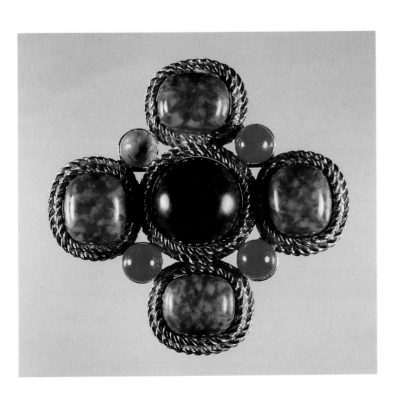

Maltese cross with gold metal and colored plastic (red "stone" missing from top left). *Courtesy of Mary Ellen DeLaughter.* $50-60 as is.

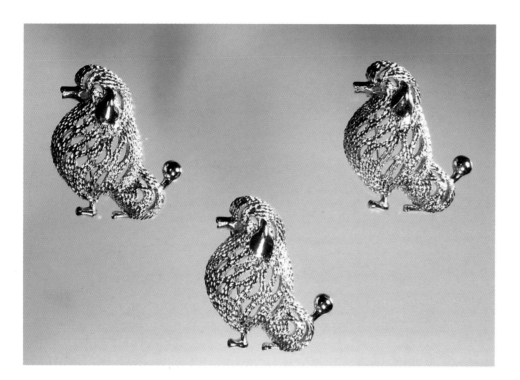

Three Suzette rhodium brooches with faux ruby eyes. *Courtesy of Marshall A. Gordon*. $35-45 each.

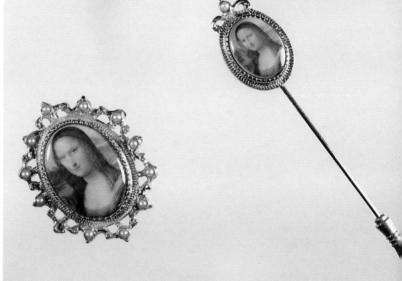

Left. Masterpiece portrait gold metal brooch with simulated seed pearls (one pearl is missing) $20-30 as is.
Right. Stickpin with simulated seed pearl. $25-35.
The brooch and stickpin are *Courtesy of Marshall A. Gordon*.

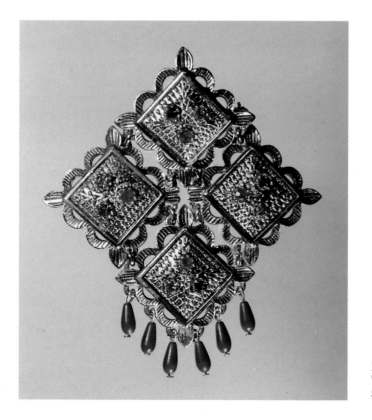

Rhodium brooch with colored plastic "stones" and green plastic dangles. $65-75.

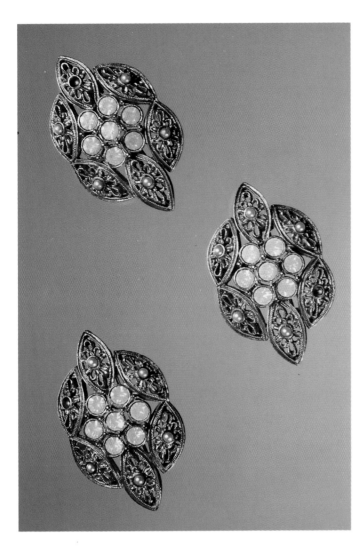

Three Victoria gold metal brooches with simulated pearls and opals. $55-65 each.

Top. Golden Mum gold metal brooch with faux amber stone. $65-75.
Bottom. Gold metal leaf shaped brooch. $75-85.

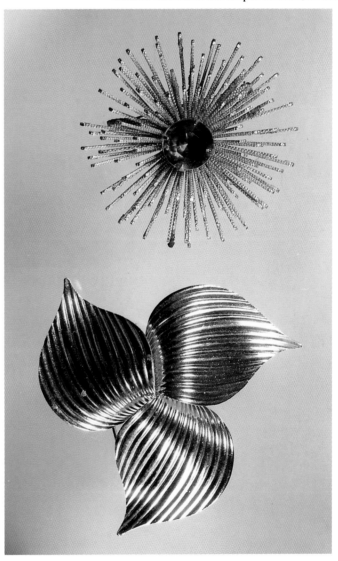

Brooch/pendant with genuine jade stone and 1/20-12KGF frame, 1.5" x 1.12". $175-195.

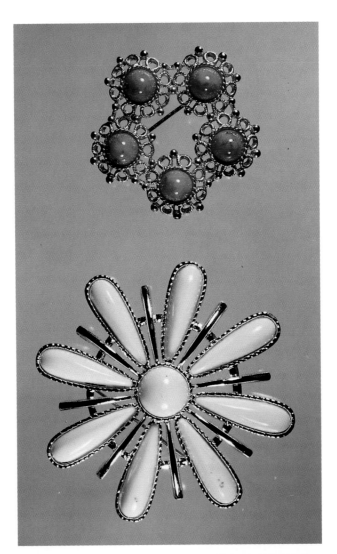

Top. Valencia gold metal brooch
with five cabochons. $35-45
Bottom. Rhodium and white plastic
brooch. $45-55.

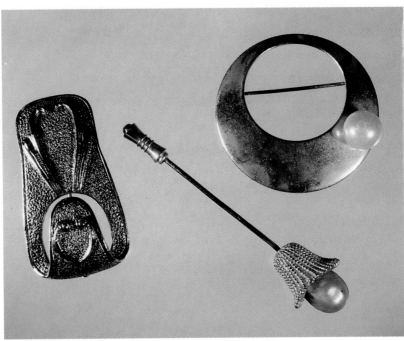

Left. Rhodium brooch. $35-45.
Center. Fashion Parade gold metal stickpin with simulated pearl. $35-45.
Right. Space Age round gold metal brooch with simulated pearl. $45-55.

BRACELETS

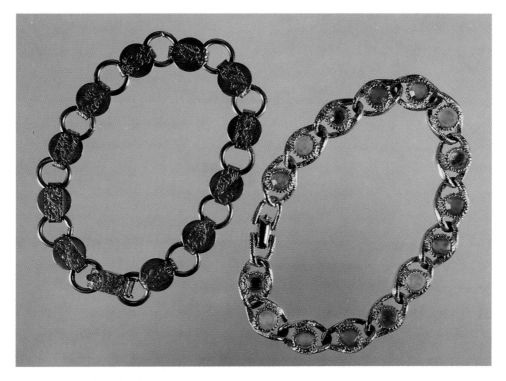

Left. Rhodium bracelet. $45-55.
Right. Moon Lites gold metal bracelet with colored plastic
cabochons. *Courtesy of Kim Griffin*. $50-60.

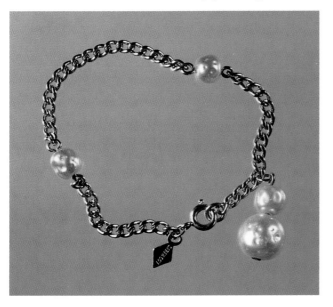

Gold metal bracelet with white
plastic beads. $35-45.

Gold metal bracelet with
simulated pearls. $45-55.

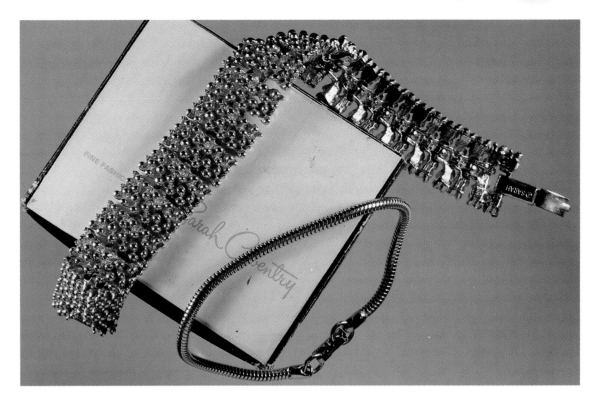

Top. Large gold metal bracelet with gold metal balls. $55-65.
Bottom. Gold metal bracelet. $35-45.

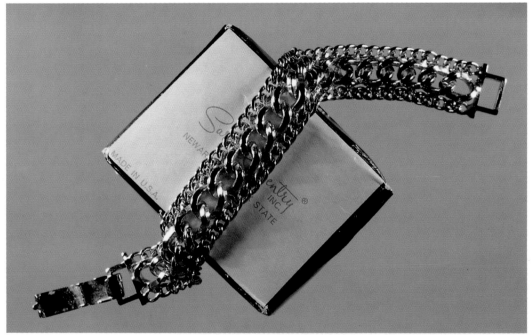

Rhodium link bracelet. $45-55.

Top. Silver mesh bracelet with silver owl clasp with plastic ruby red "stone" eyes. $45-55.
Bottom. Rhodium link bracelet with filigree work. $65-75.

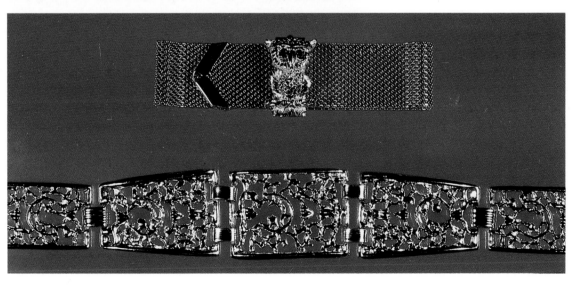

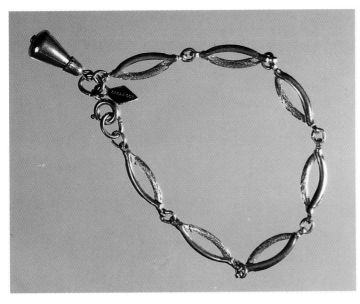

Gold metal bracelet with loops. $45-55.

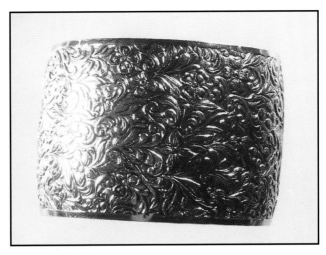

Rhodium cuff bracelet. *Courtesy of Phyllis Sparks.* $75-85.

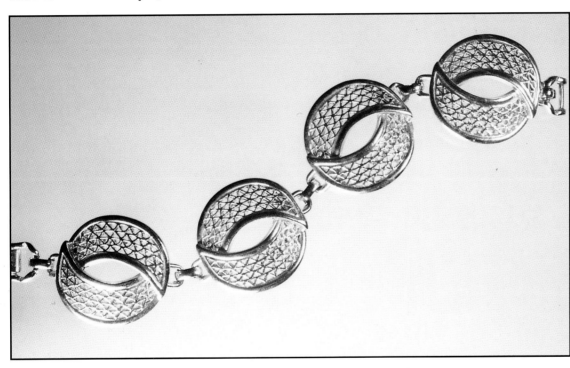

Rhodium bracelet with filigree work. *Courtesy of Mary Liles.* $65-75.

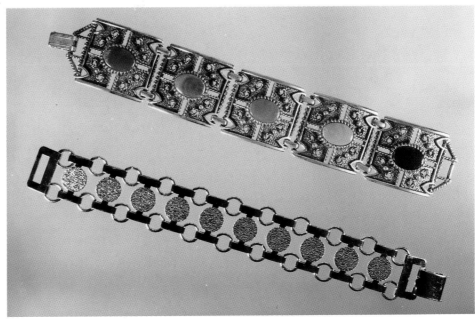

Top. Gold metal bracelet with colored plastic
cabochons. $65-75.
Bottom. Rhodium bracelet. $45-55.
The bracelets are *Courtesy of Phyllis Sparks.*

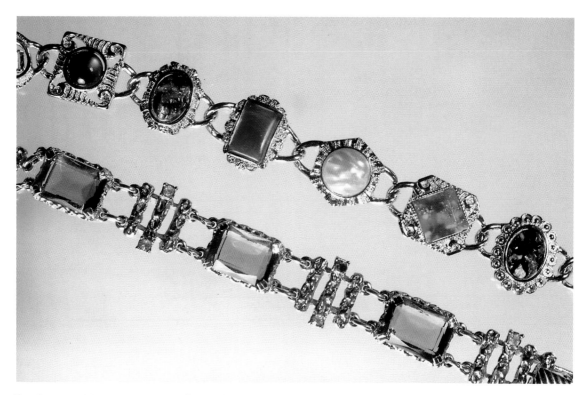

Top. Gold metal bracelet with plastic "stones" and simulated pearl.
$95-125.
Bottom. Gold metal bracelet with prong set faux amethyst "stones."
$150-175.
The bracelets are *Courtesy of Mary Liles*.

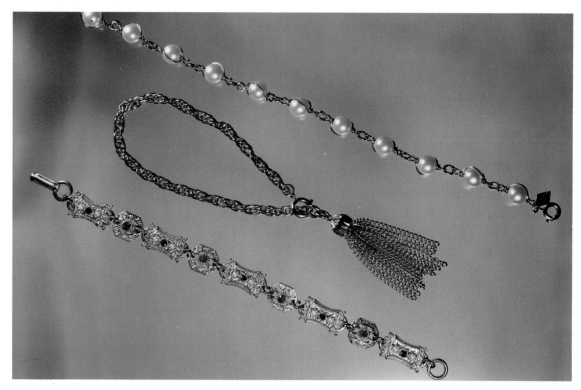

Top. Gold metal bracelet with simulated pearls. $45-55.
Center. Golden Tassel gold metal bracelet with tassel. $35-45.
Bottom. Minuet gold metal bracelet with colored glass "stones" and seed pearls. $65-75.
The bracelets are *Courtesy of Phyllis Sparks*.

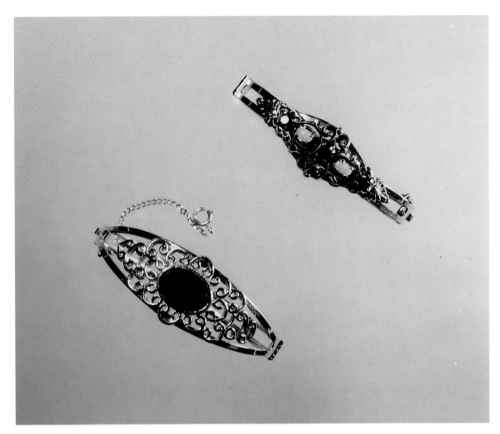

Top. Rhodium bracelet with opals and faux rubies. $65-75.
Bottom. Rhodium bracelet with faux onyx. $45-55.
The bracelets are *Courtesy of Mary Ellen DeLaughter*.

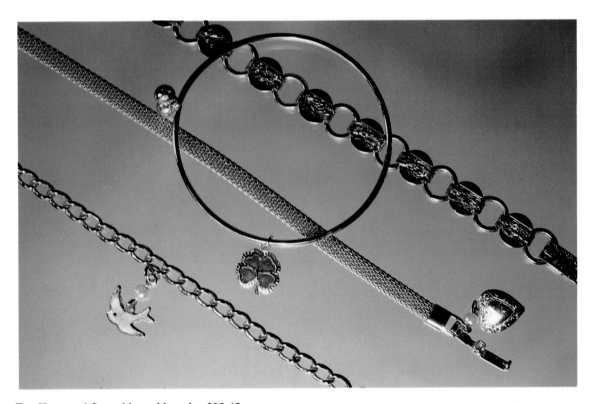

Top. Young and Gay gold metal bracelet. $35-45.
Top center. Lucky round gold metal bracelet with enameled clover. $25-35.
Center. Little Love bracelet with gold metal heart. $35-45.
Bottom. Gold metal and blue enameled Bird of Happiness bracelet. $35-45.

Navy, green, and purple interchangeable plastic bangles. *Courtesy of Mary Ellen DeLaughter.* $20-30 each.

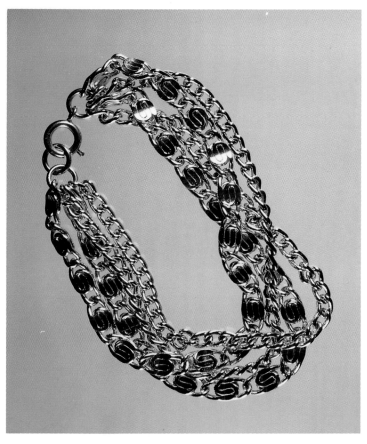

Gold metal multi-strand bracelet. *Courtesy of Mary Ellen DeLaughter.* $45-55.

Gold metal bracelet with opals, pink glass "stones," and rhinestones. *Courtesy of Debbie and Wendy Page.* $55-65.

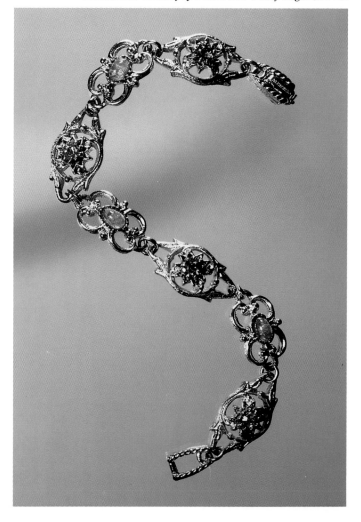

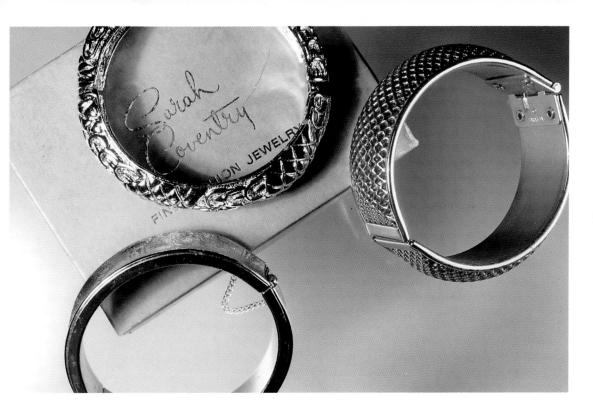

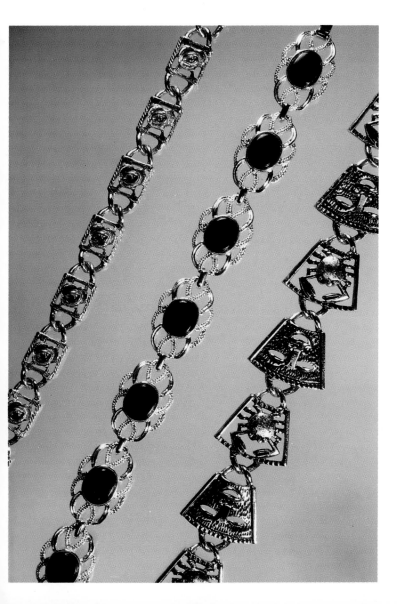

Lower left. Rhodium bracelet. *Courtesy of Jessica J. Gordon.* $65-75.
Top left. Rhodium bracelet. *Courtesy of Marshall A. Gordon.* $45-55.
Right. Gold metal bracelet. *Courtesy of Marshall A. Gordon.* $55-65.

Matching plastic bangle bracelets. $75-95 each.

Left. Rhodium bracelet with rose design. $40-50.
Center. Black Reflections rhodium bracelet with faux onyx. $45-55.
Right. Rhodium bracelet. $55-65.
The bracelets are *Courtesy of Marshall A. Gordon.*

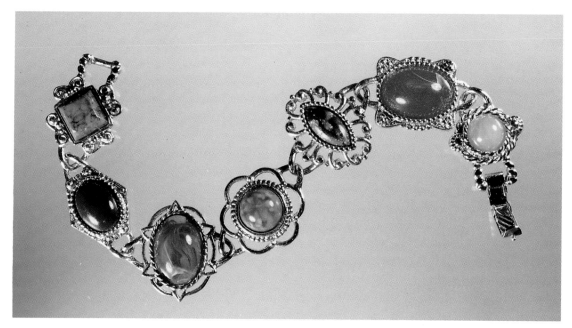

Frolic gold metal bracelet with plastic "stones." *Courtesy of Mary Lloyd.* $65-75.

Gold metal bracelet with simulated pearls. $55-65.

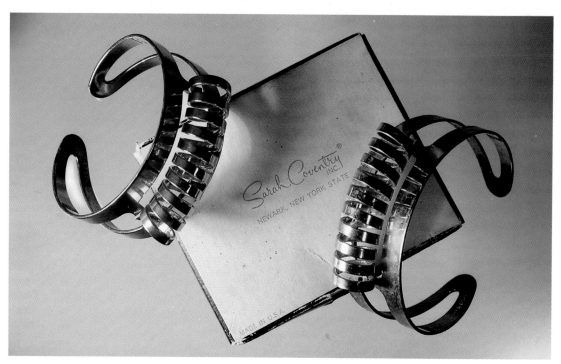

Left. Copper cuff bracelet. $55-65.
Right. Brass cuff bracelet. $45-55.

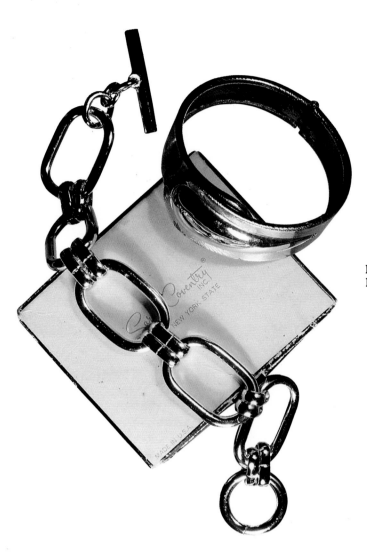

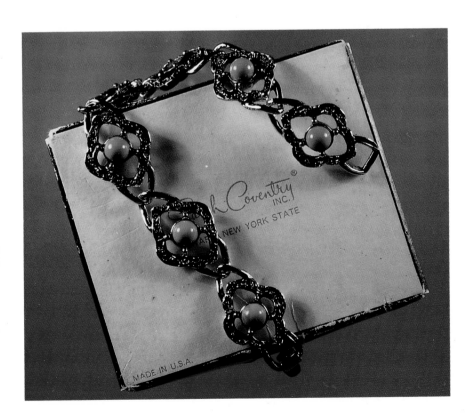

Left. Rhodium link bracelet. $45-55.
Right. Rhodium bracelet with spring clasp. $35-45.

Blue Lady rhodium bracelet with turquoise stones. $65-75

NECKLACES AND PENDANTS

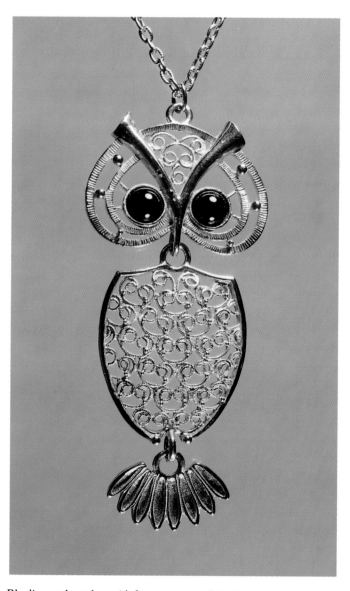

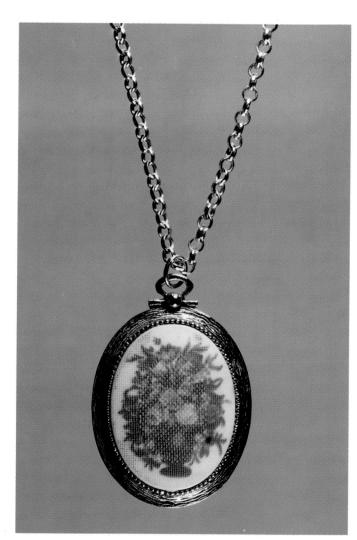

Silver metal pendant with floral motif. $55-65.

Rhodium owl pendant with faux onyx eyes. $55-65.

Opposite page:
Gold metal necklace
with plastic. $65-75.

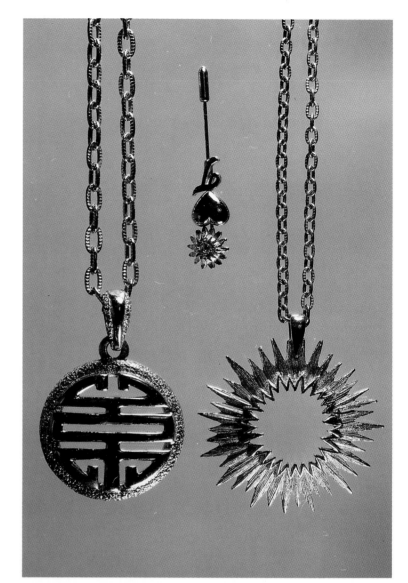

Left. Gold metal pendant. $55-65.
Center. Gold metal stickpin with initial "T," heart, and
flower with clear "stone." $30-40.
Right. Gold metal starburst pendant. $50-60.

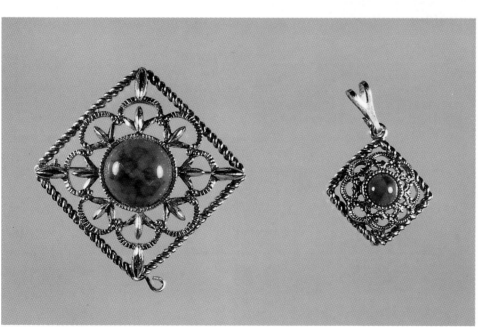

Left. Large rhodium pendant with plastic "stone." $45-55.
Right. Small rhodium pendant with plastic "stone." $35-45.
The pendants are *Courtesy of Kenneth L. Surratt, Jr.*

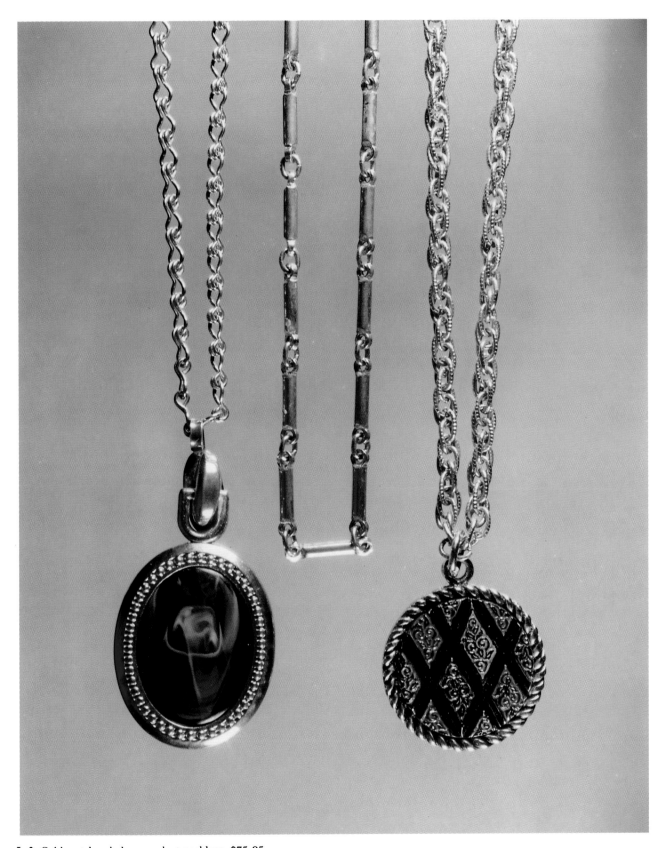

Left. Gold metal and glass pendant necklace. $75-85.
Center. Gold metal chain necklace. $20-30.
Right. Gold metal enameled pendant and chain. $65-75.

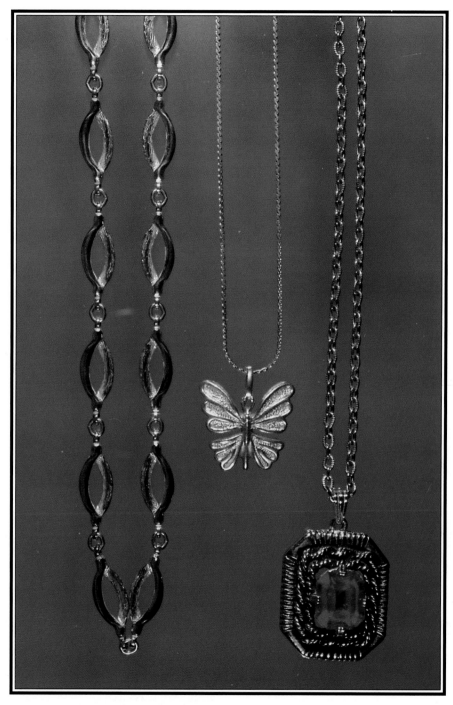

Left. Gold metal necklace with loops. $25-35.
Center. Gold metal butterfly pendant. $55-65.
Right. Gold metal pendant with prong set faceted faux ruby. $45-55.

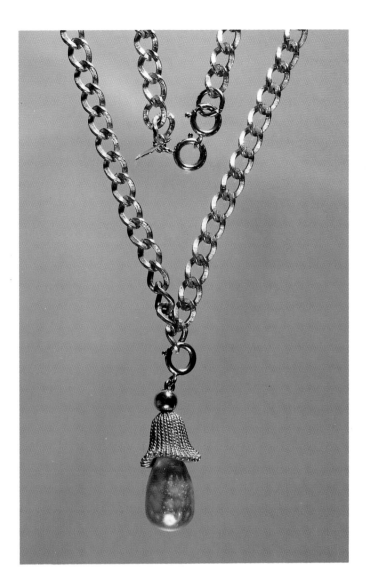

Pearlized pendant on 28-inch chain. $55-65.

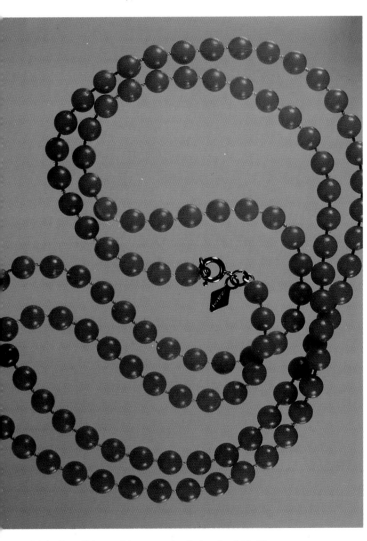

32-inch necklace with green plastic beads. $45-55.

Portrait pendant with gold metal,
pearlized stones, and clear
"stones." *Courtesy of Virginia
Young.* $65-75.

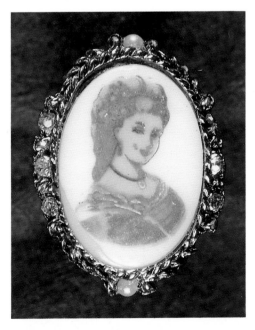

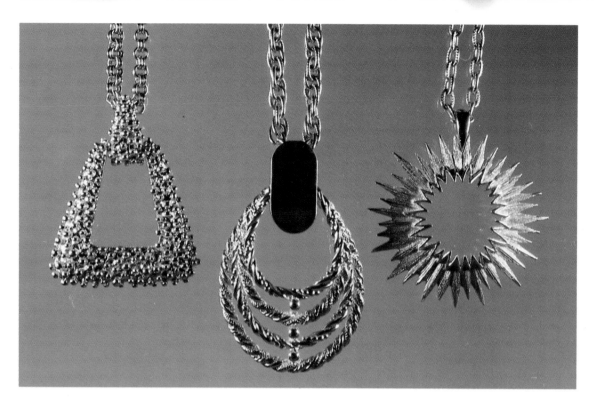

Left. Gold metal pendant with gold metal balls. $55-65.
Center. Circular gold metal pendant. $55-65.
Right. Gold metal starburst pendant. $45-55.

Left. Rhodium necklace. $55-65.
Right. Rhodium silver link necklace. $45-55.

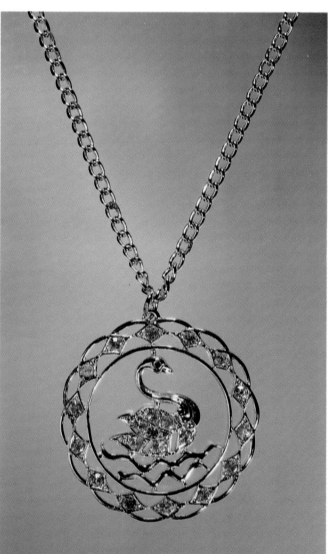

Rhodium swan necklace with rhinestones and 24-inch chain. $75-85.

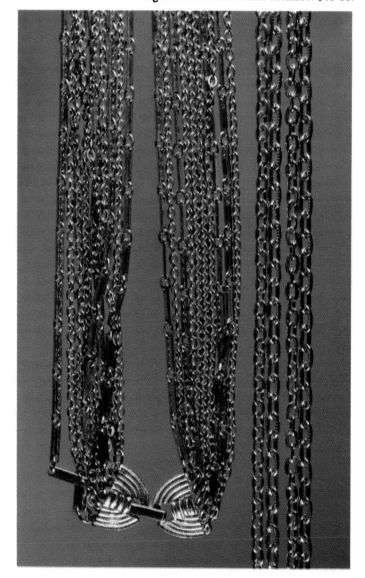

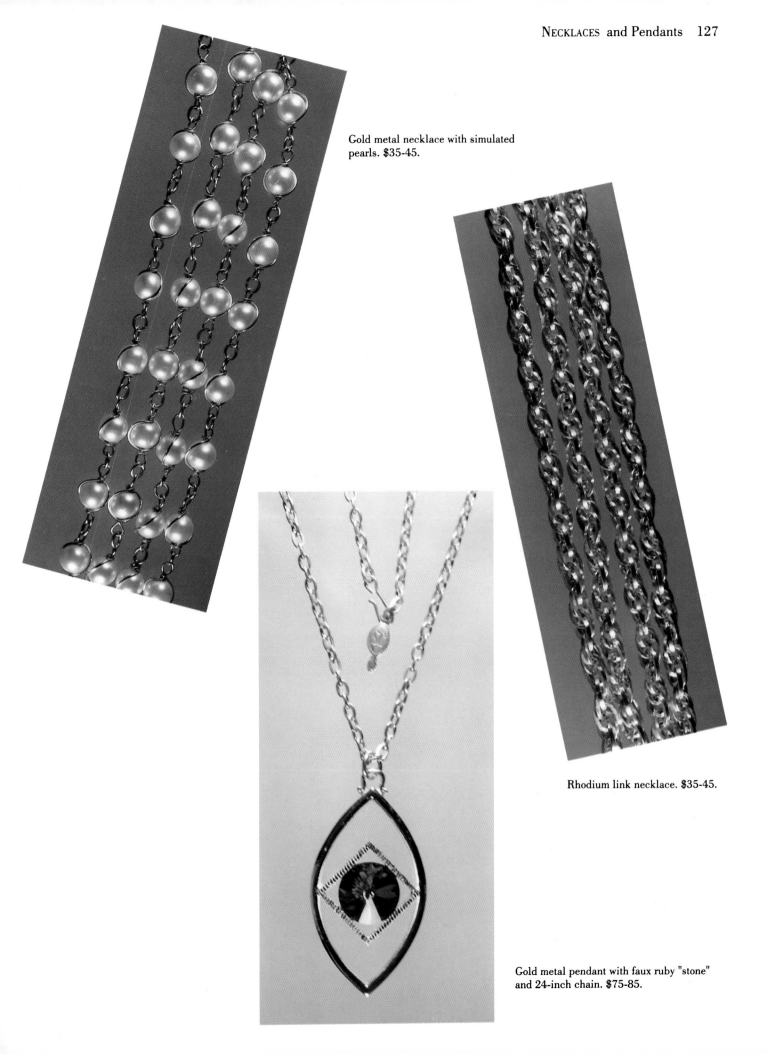

Gold metal necklace with simulated pearls. $35-45.

Rhodium link necklace. $35-45.

Gold metal pendant with faux ruby "stone" and 24-inch chain. $75-85.

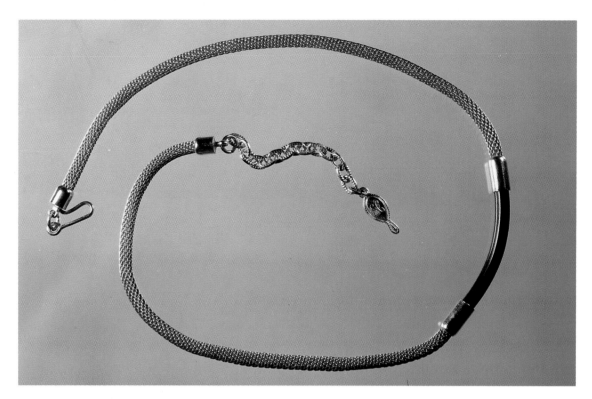

16-inch gold mesh choker with navy blue plastic section in center. $65-75.

Silver metal necklace with amber colored plastic. $55-65.

Opposite page:
52-inch three strand gold metal necklace with seven smoky colored glass faceted "stones." *Courtesy of Mary G. Moon.* $75-85.

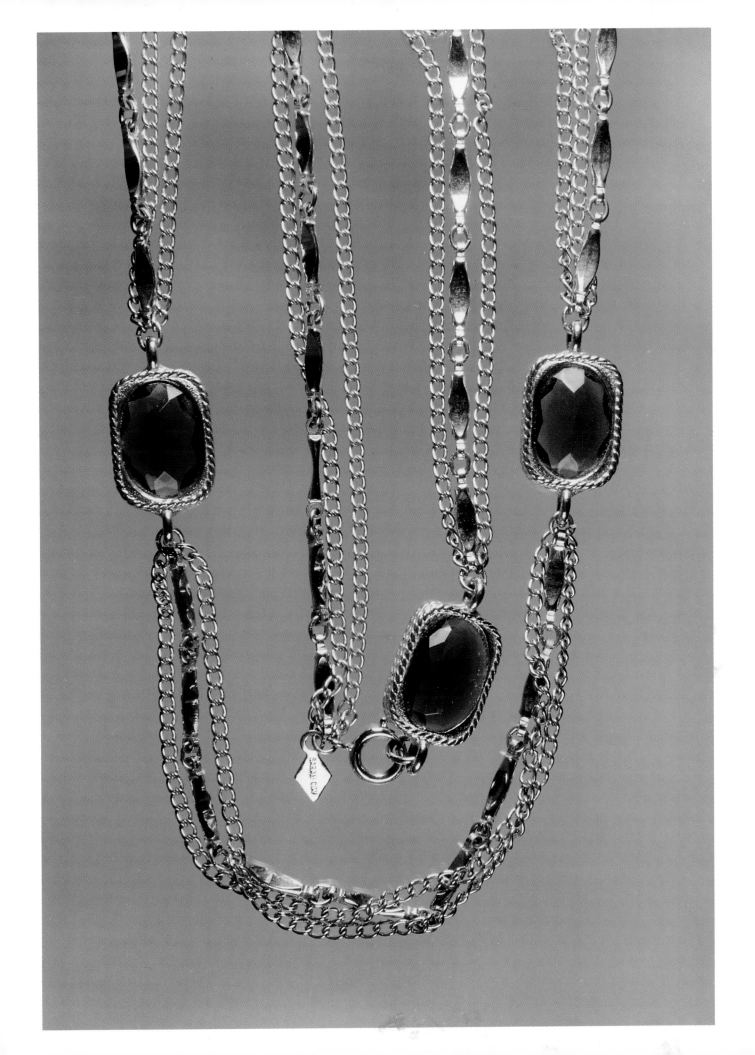

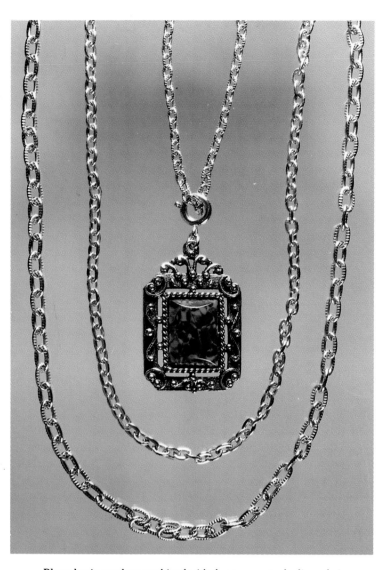

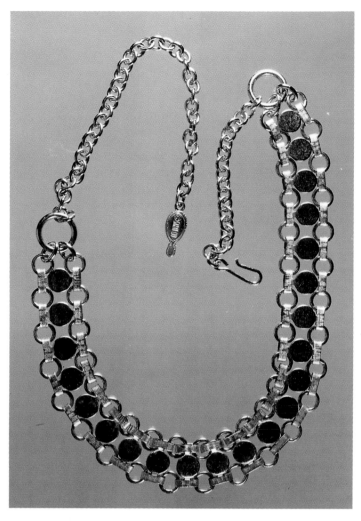

Blue plastic pendant combined with three separate rhodium chains, 36", 29", and 22". *Courtesy of Kenneth L. Surratt, Jr.* $70-80.

Rhodium 16-inch necklace. $55-65.

Gold metal chain. $15-25.

Opposite page:
25-inch plastic bead necklace. $65-75.

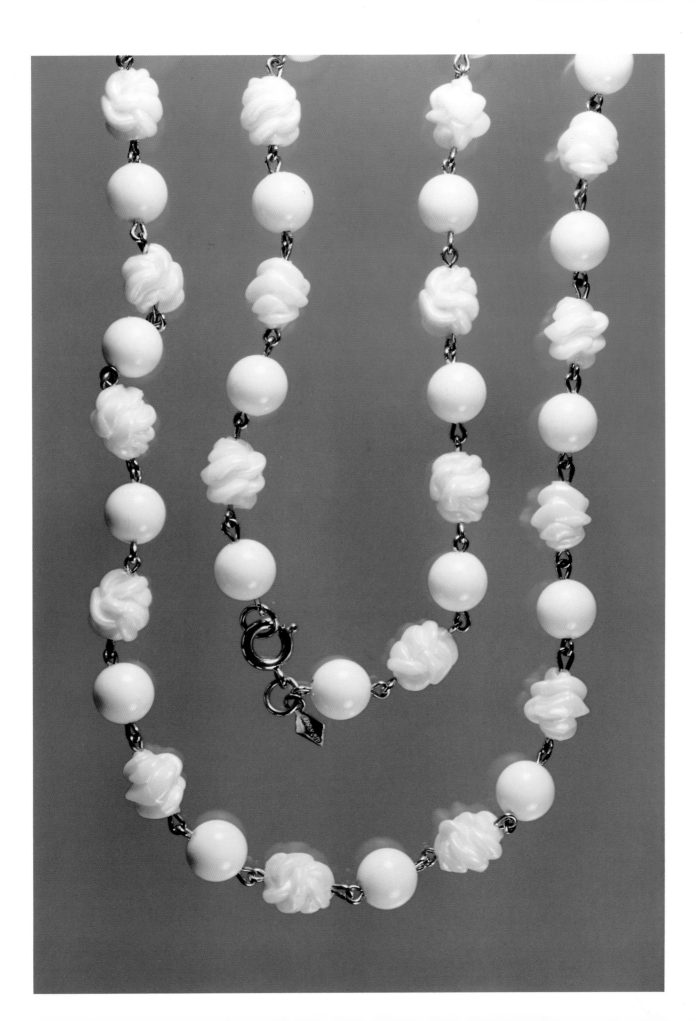

One 32-inch necklace consisting of two joined necklaces, one gold metal necklace with simulated pearls and one gold metal necklace with links. $55-65.

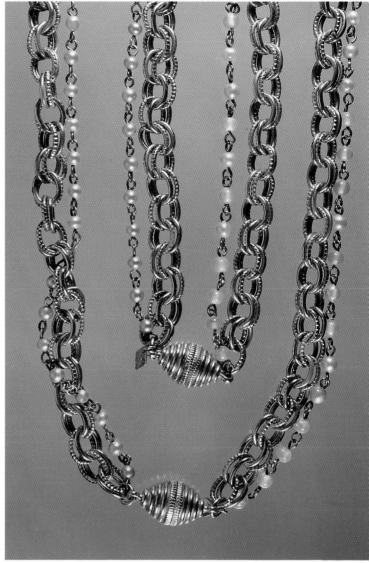

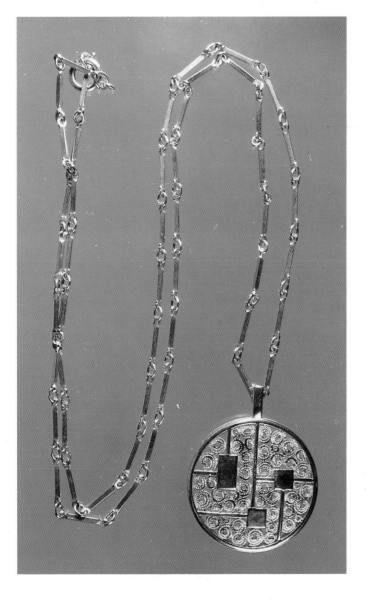

Gold metal filigree pendant with 29-inch chain. *Courtesy of Mary G. Moon.* $35-45.

Opposite page:
Beaded necklace. $65-75.

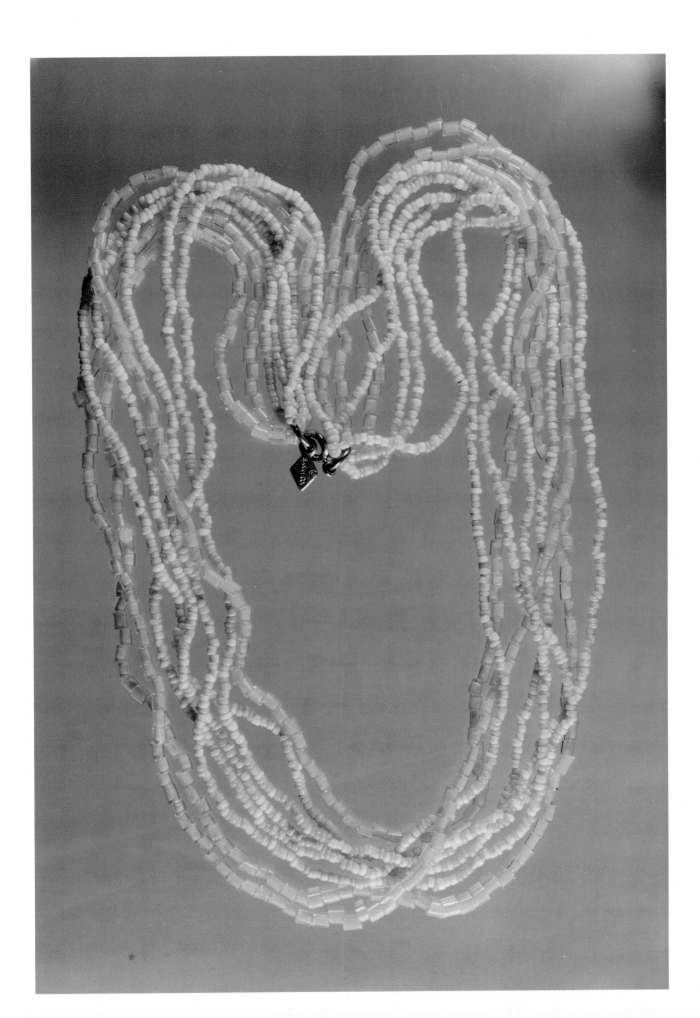

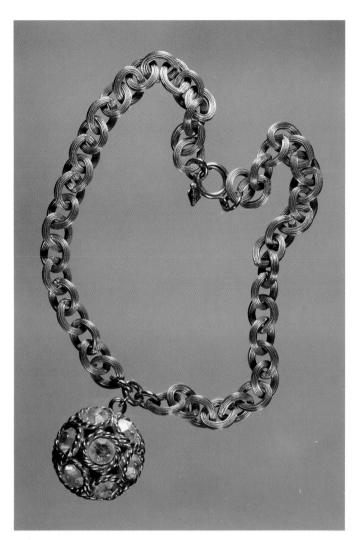

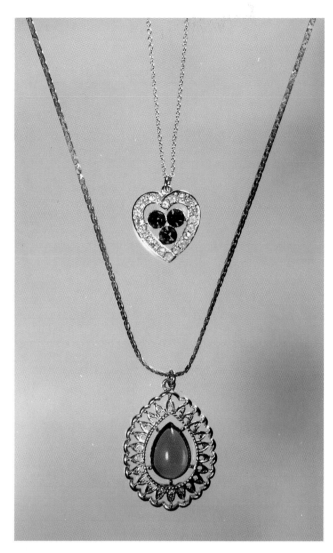

Top. Heart pendant with rhinestones and faux emeralds on 14-inch chain. $55-65.
Bottom. Gold metal pendant with faux amber "stone" on 17-inch chain. $65-75.
The pendants and necklaces are *Courtesy of Wanda Goodmon.*

Gold metal pendant with aurora borealis stones on 16-inch chain. *Courtesy of Kenneth L. Surratt, Jr.* $65-75.

Top. 17-inch gold metal necklace. $45-55.
Bottom. 16-inch gold metal link necklace. $30-40.
The necklaces are *Courtesy of Wanda Goodmon.*

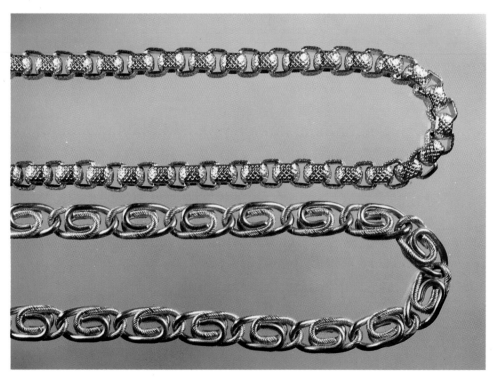

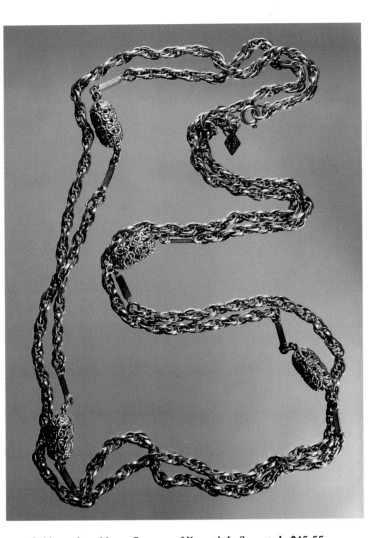

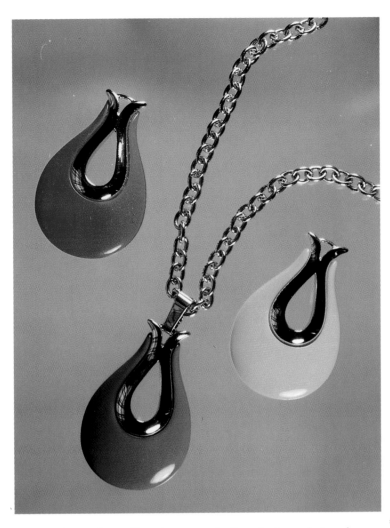

Gold metal necklace. *Courtesy of Kenneth L. Surratt, Jr.* $45-55.

2.25-inch interchangeable red, green, and yellow plastic pendants and 26-inch gold metal chain. *Courtesy of Phyllis Sparks.* $65-75.

Fashion Rite simulated pearl and gold metal necklace. $65-75.

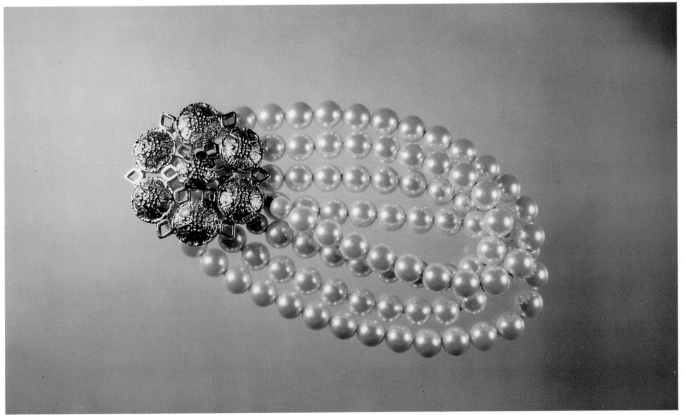

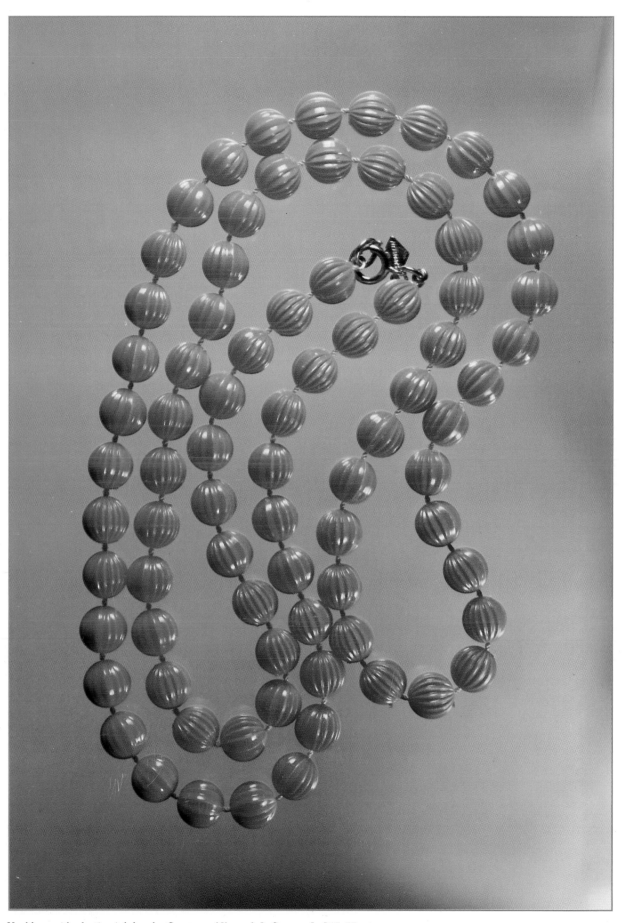

Necklace with plastic pink beads. *Courtesy of Kenneth L. Surratt, Jr.* $45-55.

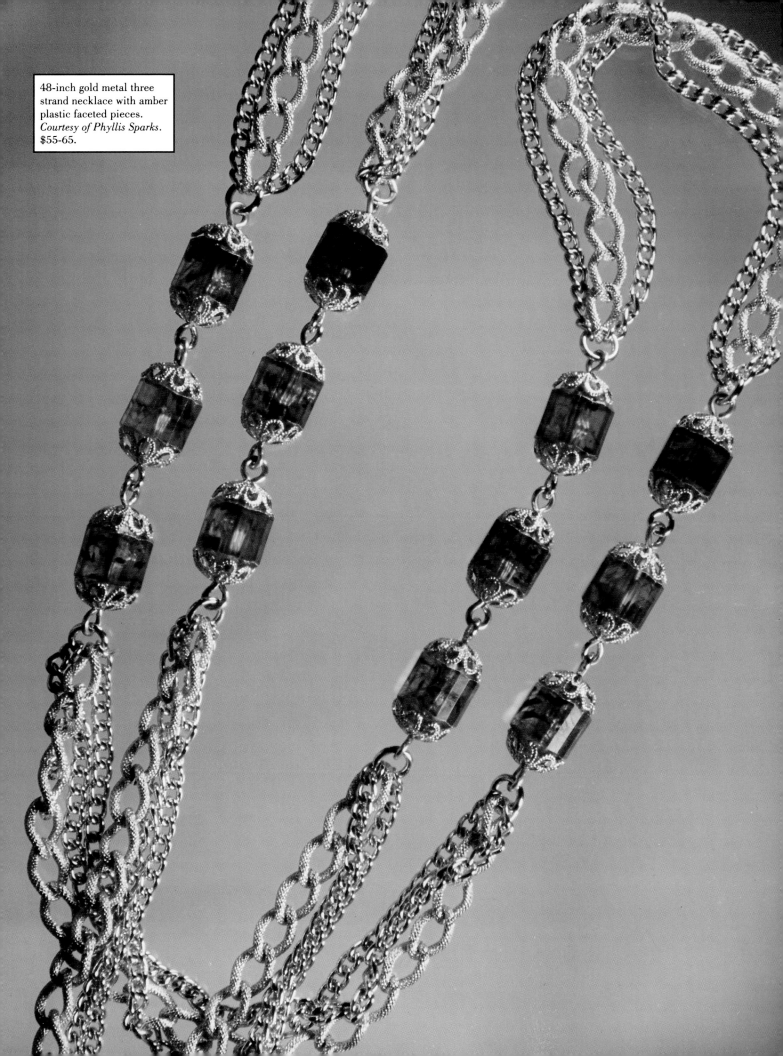

48-inch gold metal three strand necklace with amber plastic faceted pieces. *Courtesy of Phyllis Sparks.* $55-65.

Assortment of necklaces ranging in price from $15 to $40. The necklaces are *Courtesy of Phyllis Sparks*.

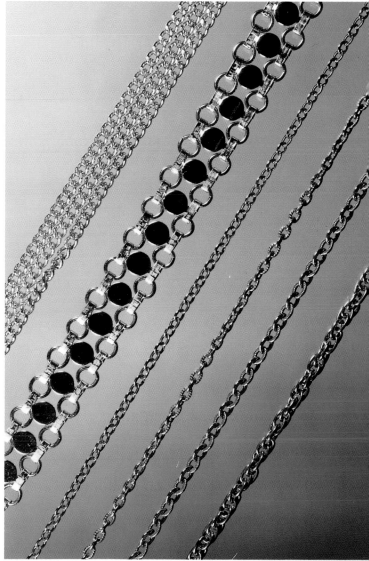

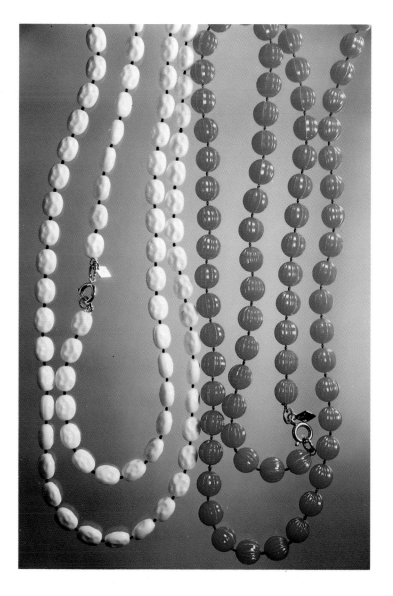

Left. 52-inch necklace with white plastic beads. $40-50.
Right. 36-inch necklace with round green plastic beads. $40-50.
The necklaces are *Courtesy of Phyllis Sparks*.

Opposite page:
Top left. Angel Pink gold metal pendant necklace with simulated pearls and plastic. $45-55.
Lower left. Gold metal pendant locket with heart motif which holds perfume glacé. $55-65.
Center. 24-inch gold metal pendant necklace with pink plastic and tassel. $65-75.
Right. Gold metal butterfly pendant necklace. $20-30.
The pendants and necklaces are *Courtesy of Phyllis Sparks*.

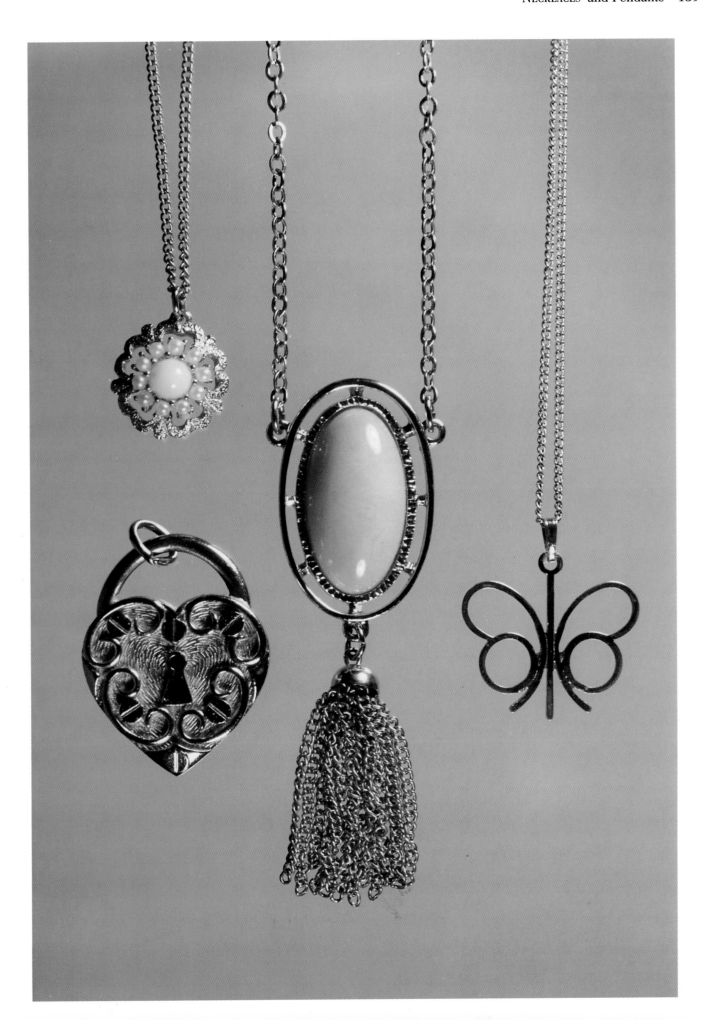

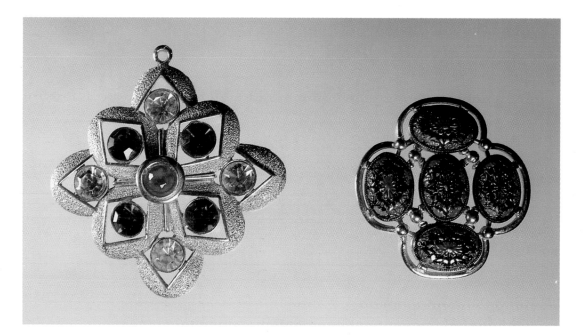

Left. Gold metal pendant with colored glass "stones." $65-75.
Right. Light of the East gold metal cross with colorful mosaic design. $65-75. The jewelry is *Courtesy of Mary Ellen DeLaughter*.

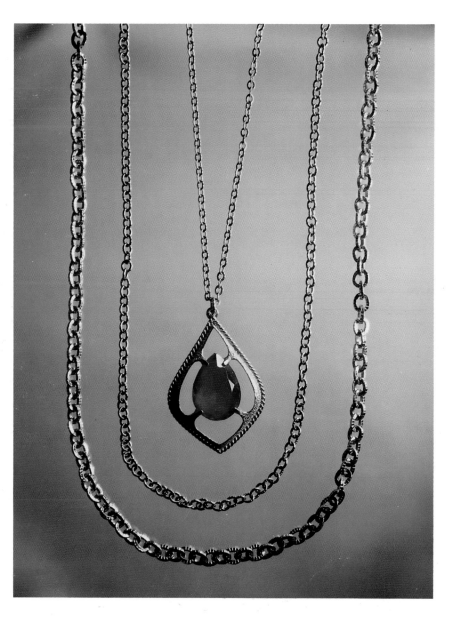

Gold metal 24-inch chain with 2-inch gold metal pendant and prong set faux ruby. *Courtesy of Phyllis Sparks*. $75-85.

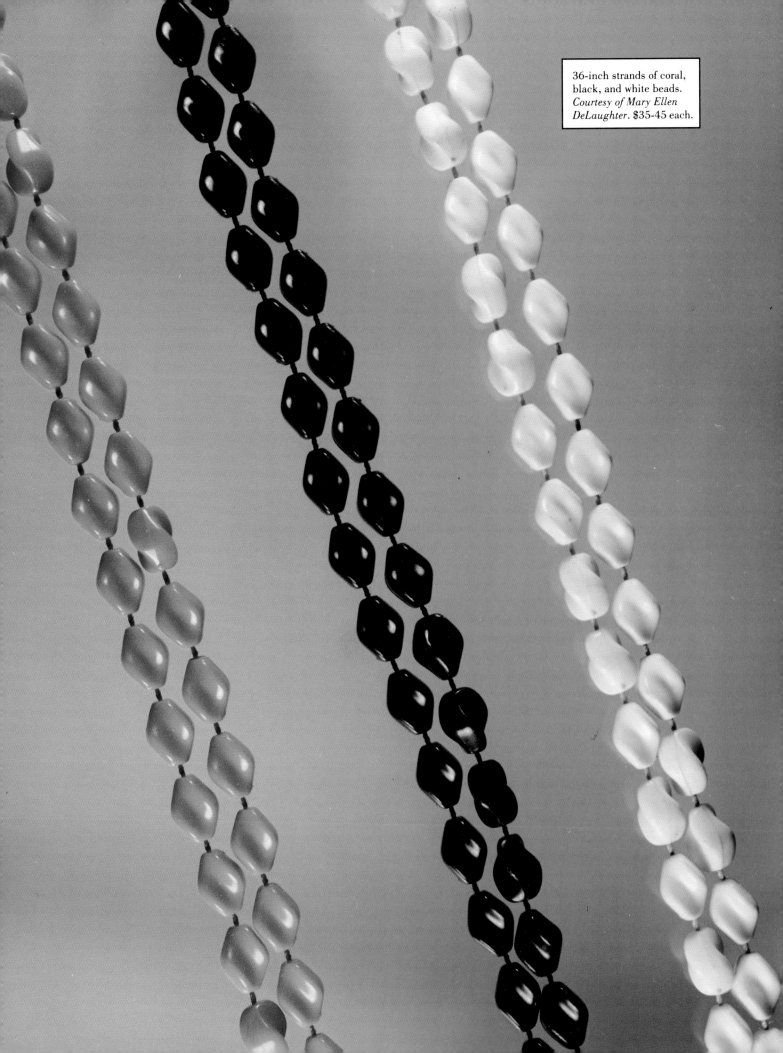

36-inch strands of coral,
black, and white beads.
*Courtesy of Mary Ellen
DeLaughter.* $35-45 each.

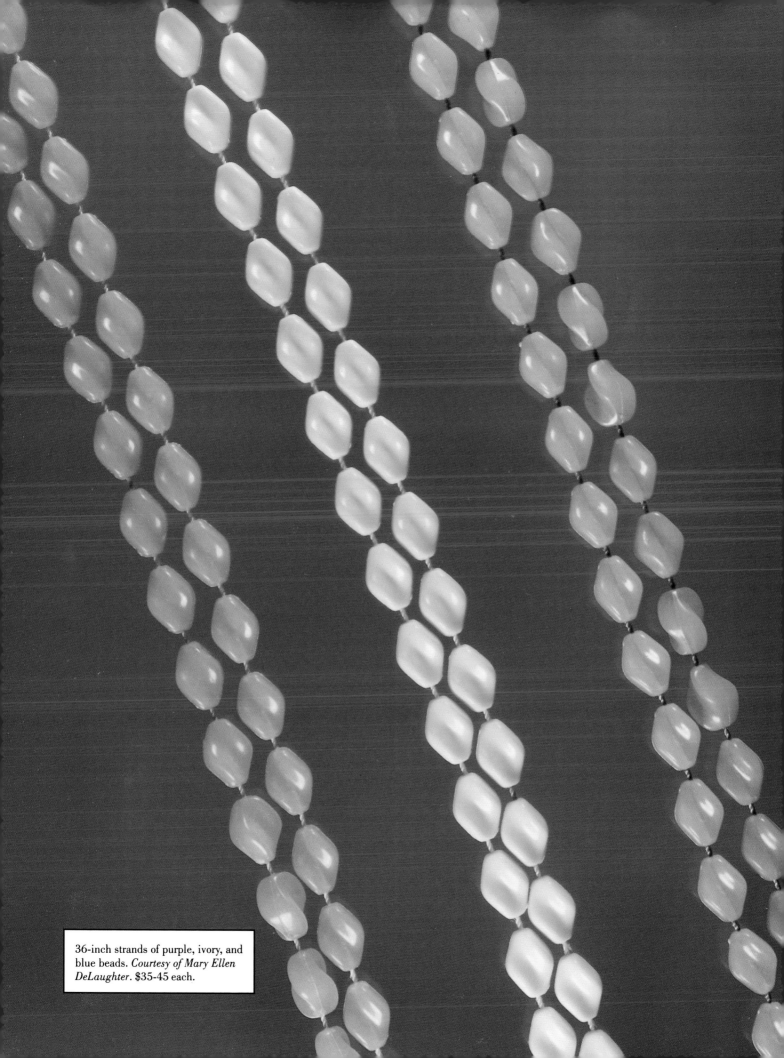

36-inch strands of purple, ivory, and blue beads. *Courtesy of Mary Ellen DeLaughter*. $35-45 each.

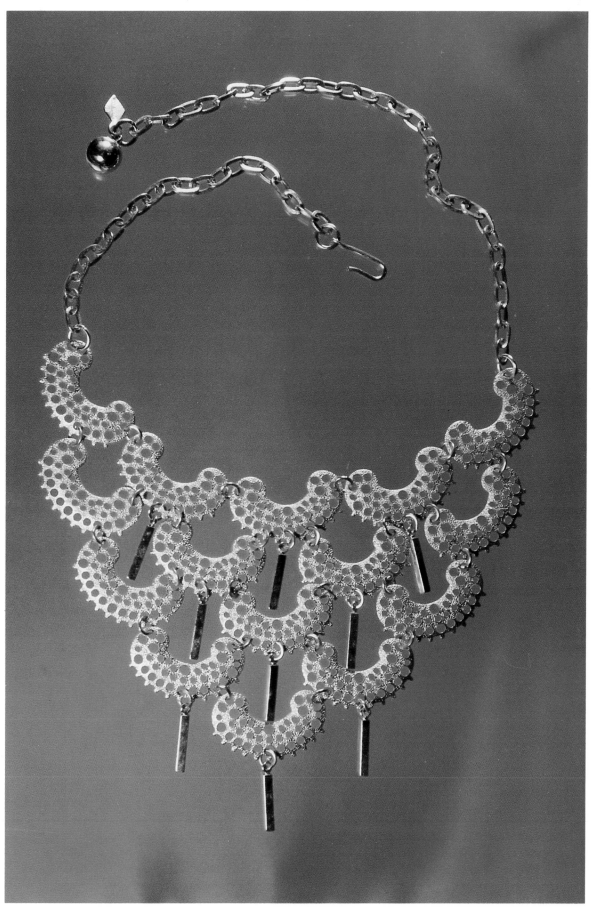

18-inch rhodium bib necklace. *Courtesy of Mary Ellen DeLaughter*. $75-85.

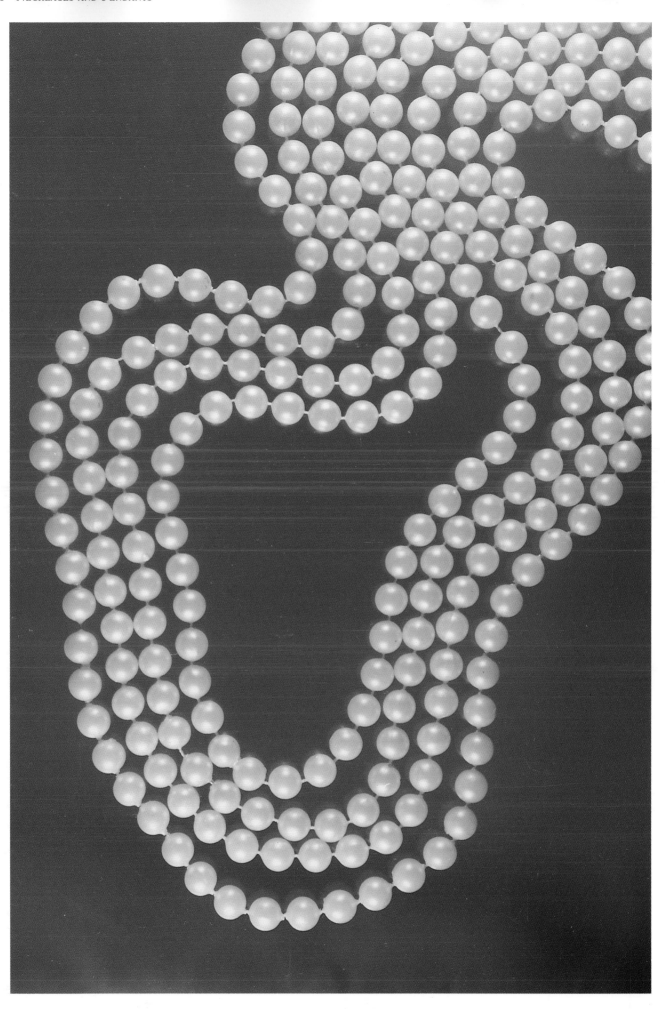

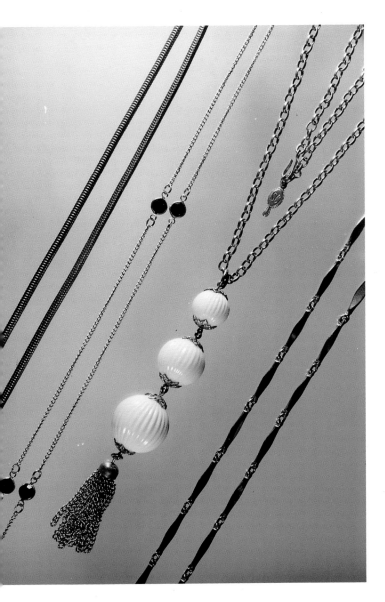

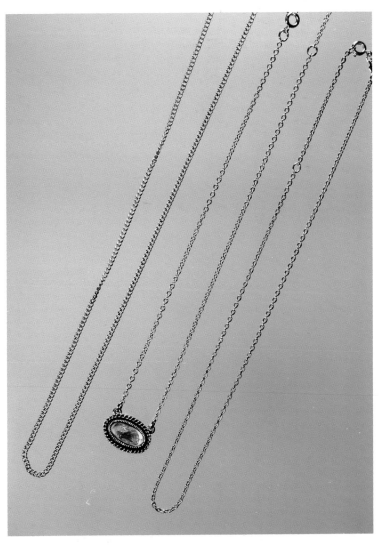

Opposite page:
124-inch simulated pearl necklace. *Courtesy of Mary Ellen DeLaughter*. $75-85.

Left. 38-inch gold metal necklace. $20-30.
Center left. 48-inch gold metal necklace with faux onyx stones. $35-45.
Center right. 24-inch gold metal necklace with three plastic beads and tassel. $45-55.
Right. 35-inch gold metal necklace. $35-45.
The necklaces are *Courtesy of Mary Ellen DeLaughter.*

Left. 16-inch gold metal chain. $15-25.
Center. 16-inch abalone pendant and gold metal chain. $45-55.
Right. 23-inch gold metal chain. $20-30.
The necklaces are *Courtesy of Mary Ellen DeLaughter.*

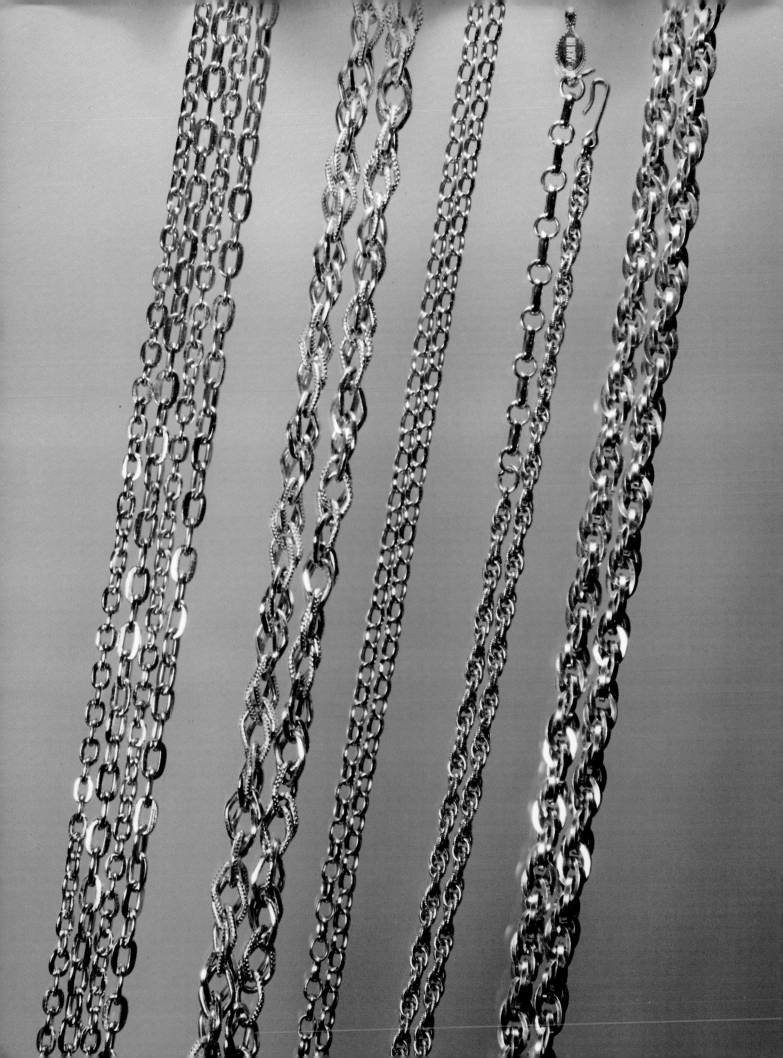

Opposite page:
Various rhodium chains, ranging in measurement from 20" to 37". *Courtesy of Mary Ellen DeLaughter.* $35-45 each.

52-inch gold metal necklace with simulated pearls. *Courtesy of Mary Ellen DeLaughter.* $55-65.

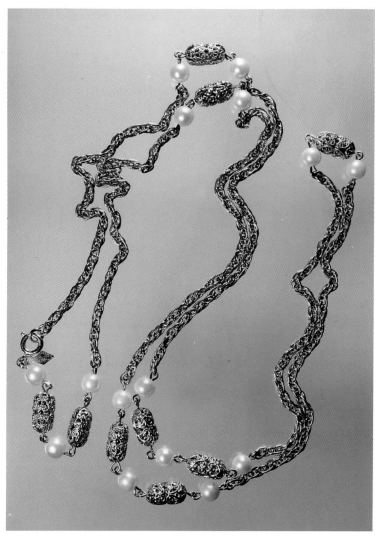

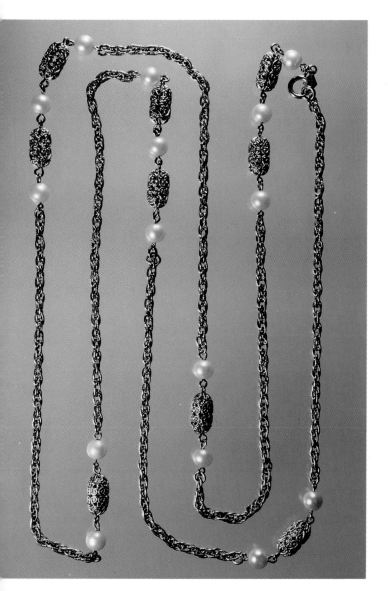

52-inch rhodium necklace with simulated pearls. *Courtesy of Mary Ellen DeLaughter.* $55-65.

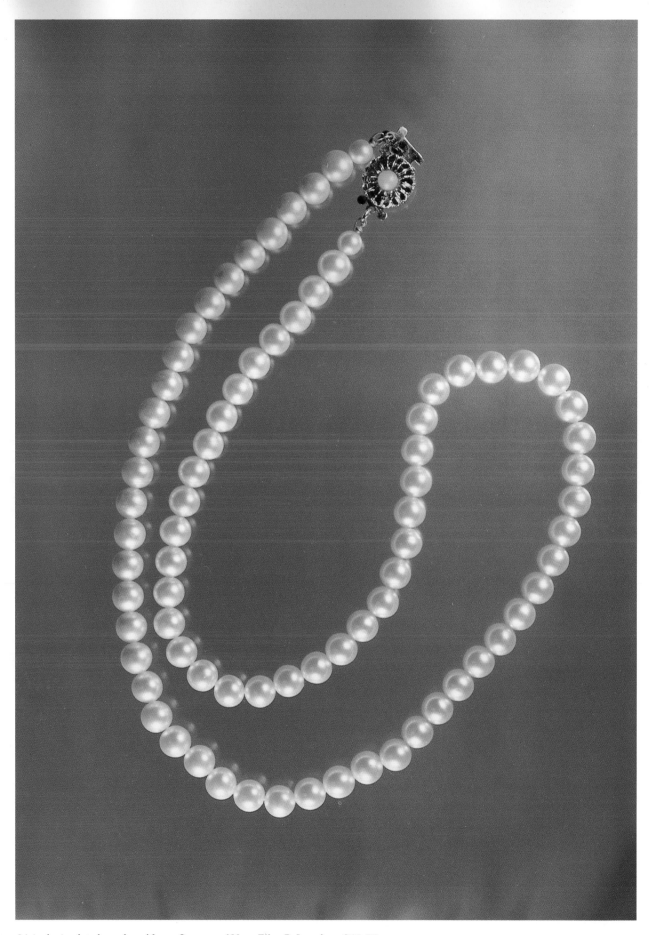

24-inch simulated pearl necklace. *Courtesy of Mary Ellen DeLaughter.* $45-55.

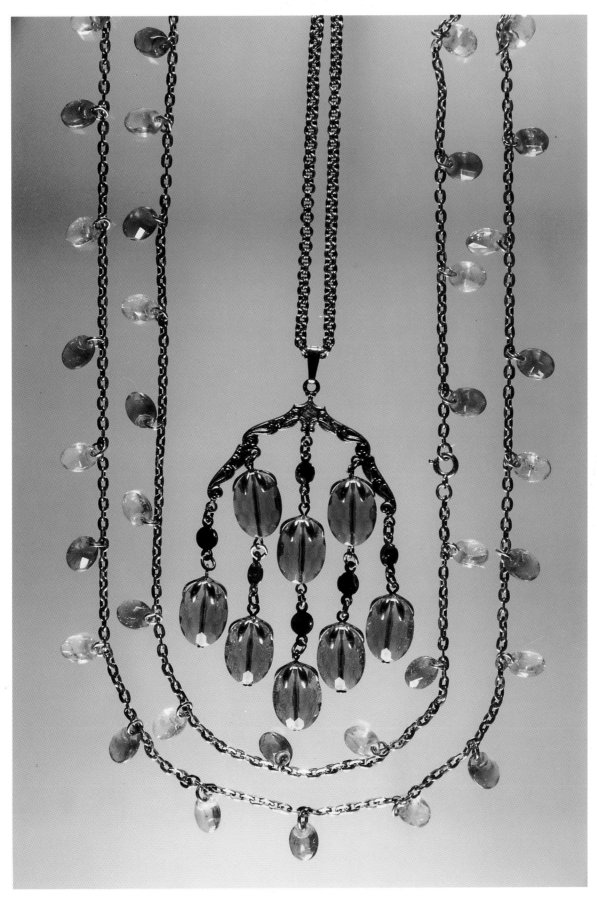

Outside. Wisteria rhodium pendant with pink plastic "stones." $65-75.
Center. Rhodium chain with pink plastic "stones." $55-65.
The necklaces are *Courtesy of Mary Ellen DeLaughter*.

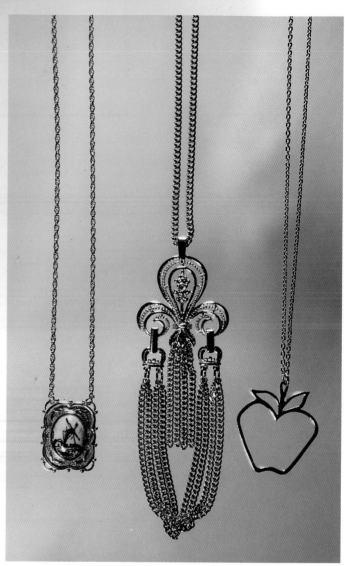

Left. 16-inch gold metal necklace with pendant of blue and white windmill scene. $75-85.
Center. 28.5-inch multi-strand rhodium pendant necklace with tassel. $65-75.
Right. 16-inch rhodium apple pendant necklace. $25-35.
The necklaces are *Courtesy of Debbie Page.*

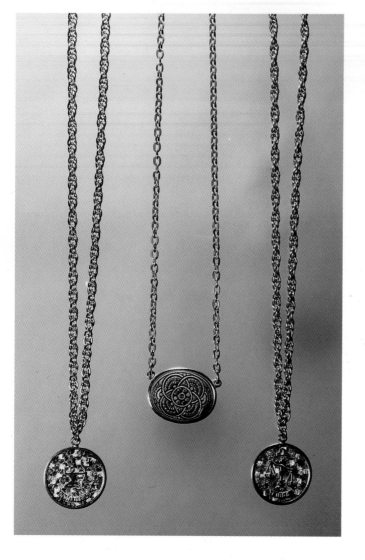

Left. Gold metal Sagittarius pendant with 20-inch chain. $35-45.
Center. Gold metal mosaic pendant with 18-inch chain. $30-40.
Right. Gold metal Libra pendant with 20-inch chain. $35-45.
The pendant necklaces are *Courtesy of Debbie Page.*

Opposite page:
Inside. 34-inch double stranded gold metal necklace with faux ivory and faux tortoiseshell. $55-65.
Outside. 16-inch gold metal and faux tortoiseshell necklace. $65-75.
The necklaces are *Courtesy of Debbie Page.*

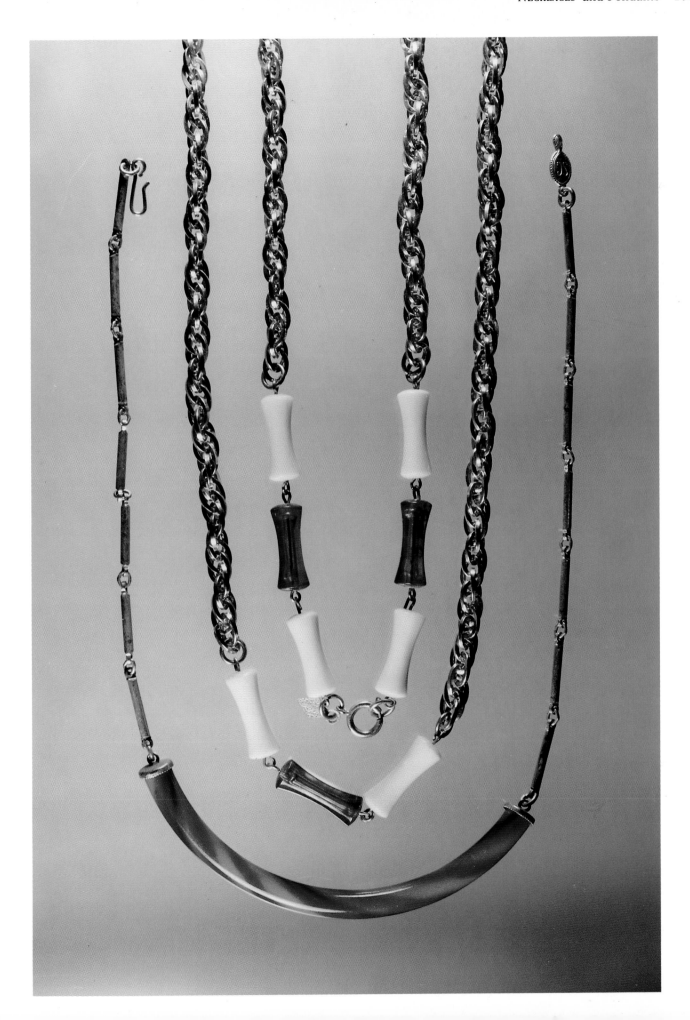

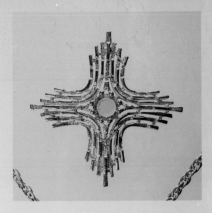

1.88-inch gold metal cross with faux topaz. $45-55. *Courtesy of Debbie Page.*

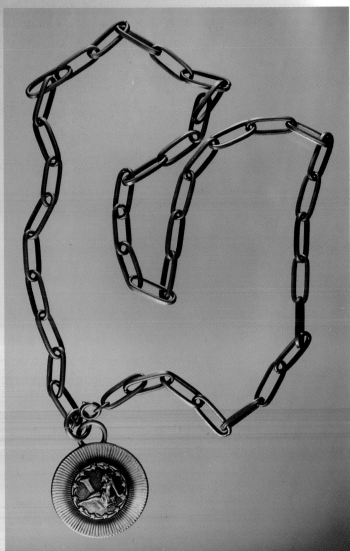

Virgo pendant necklace. *Courtesy of Debbie Page.* $45-55.

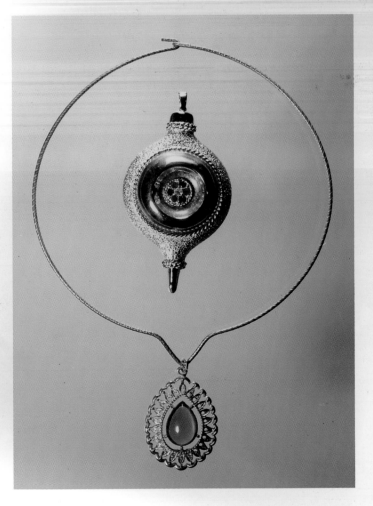

Inside. Rhodium and gold metal Christmas pendant with colored plastic "stones." $45-55.
Outside. Gold metal wire necklace with faux amber and gold metal pendant. $55-65.
The pendant and pendant necklace are *Courtesy of Debbie Page.*

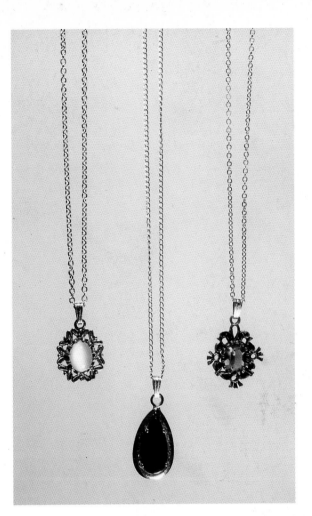

Left. Rhodium necklace with moonstone pendant. $55-65.
Center. Rhodium pendant with prong set genuine onyx stone. $65-75.
Right. Gold metal necklace with genuine amethyst pendant. $55-65.
The pendant and necklaces are *Courtesy of Carol Gordon*.

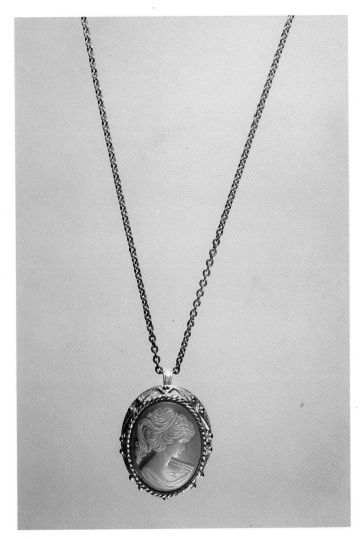

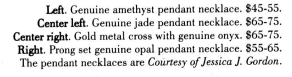

Plastic cameo brooch/pendant set in gold metal with
17.5-inch chain. *Courtesy of Carol Gordon*. $65-75.

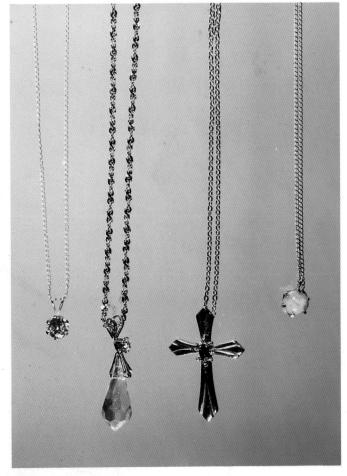

Left. Genuine amethyst pendant necklace. $45-55.
Center left. Genuine jade pendant necklace. $65-75.
Center right. Gold metal cross with genuine onyx. $65-75.
Right. Prong set genuine opal pendant necklace. $55-65.
The pendant necklaces are *Courtesy of Jessica J. Gordon*.

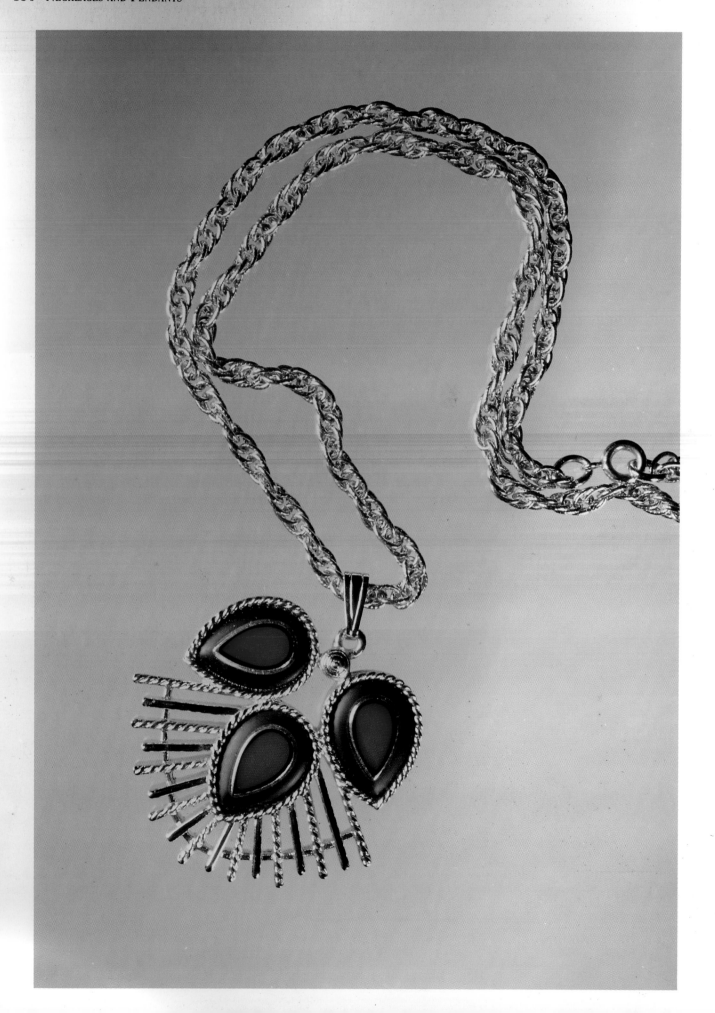

Opposite page:
Gold metal necklace with faux ruby flat
"stone" pendant and 22-inch chain. $75-85.

Gold metal Hawaiian Fantasy necklace
with faux ruby "stones" and 16-inch
chain. $85-95.

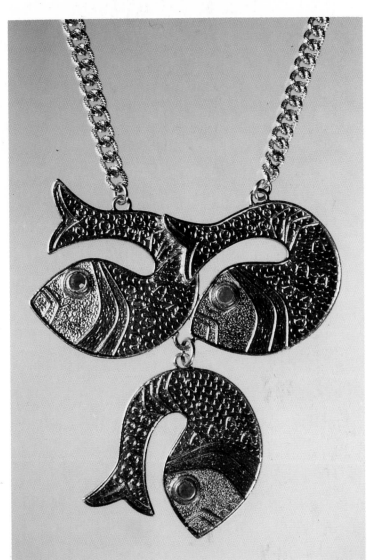

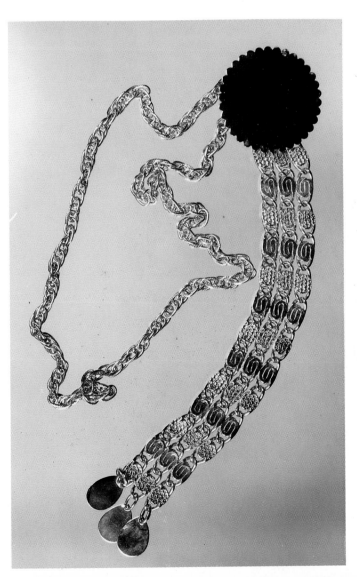

Gold metal Swing Along necklace with
separate parts, 15-inch dangle, 1.5-inch
brooch, and 19-inch chain. $45-55.

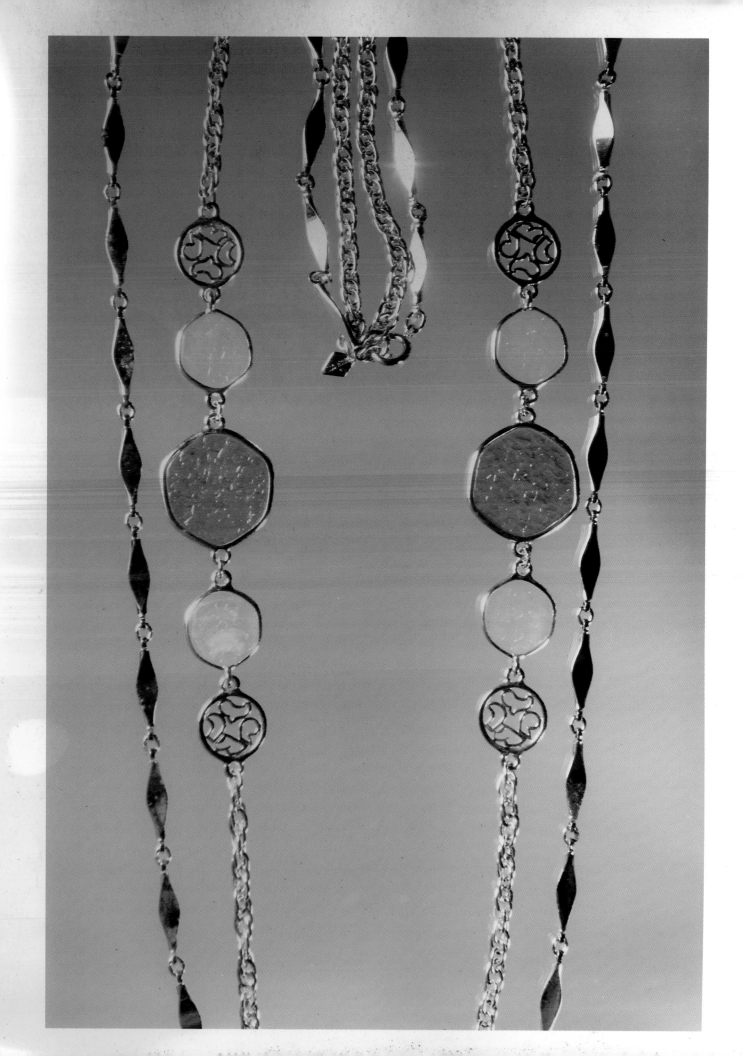

Opposite page:
Taste of Honey necklace with 38-inch chain and 42-inch chain. $55-65.

Rhodium pendant with colored and clear plastic "stones." *Courtesy of Mary Liles.* $55-65.

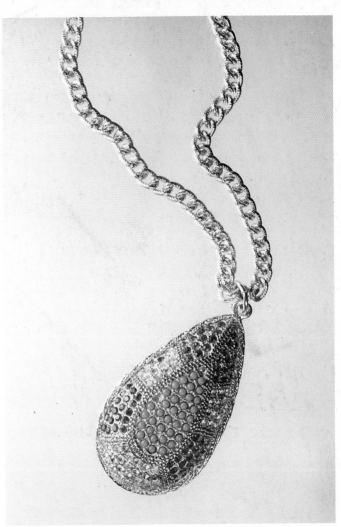

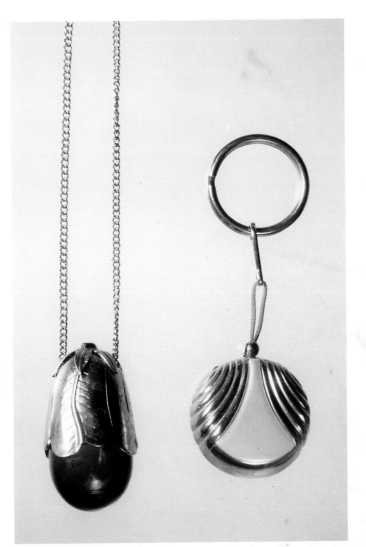

Left. Gold metal and plastic perfume holder. $45-55.
Right. Gold metal key ring with loop and clip-on back. $35-45.
The items are *Courtesy of Mary Liles.*

Left. Gold metal and enameled poodle pendant. $45-55.
Right. Rhodium and red and blue enameled fish pendant. $65-75.

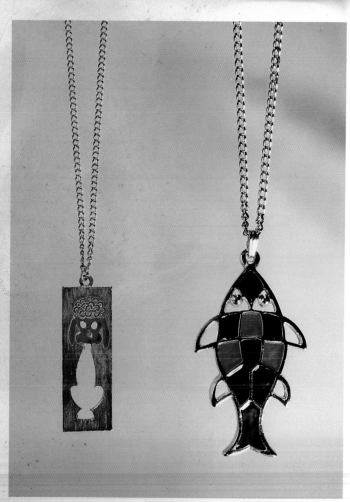

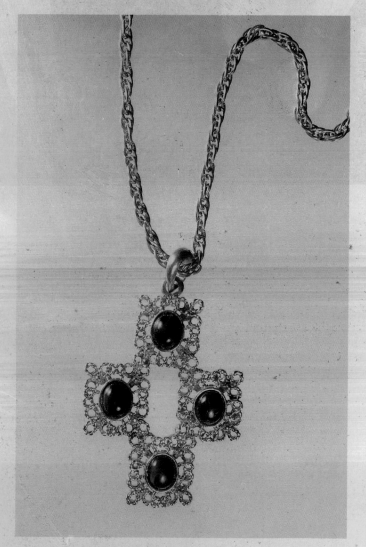

Gold metal cross with navy blue plastic and 18-inch chain. *Courtesy of Mary Liles*. $65-75.

Left. Gold metal necklace with faux amber surrounded by simulated seed pearls and 18-inch chain. $55-65.
Top left center. Little Sweetheart gold metal necklace with simulated pearl and 13-inch chain. $45-55.
Top right center. Froggy gold metal necklace with frog and enameled red mushroom pendant on 16-inch chain. $45-55.
Right. Necklace with 16-inch chain and rhodium, rhinestones, and faux emerald "stones." $55-65.

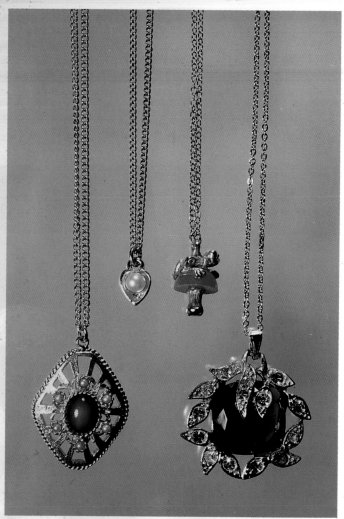